COMPENDIUM OF DRAWING AND DRAWING INSTRUMENTS

*The Modern Carpenter Joiner
and Cabinet-Maker*

COMPENDIUM OF DRAWING AND DRAWING INSTRUMENTS

G. Lister Sutcliffe, Editor

Associate of the Royal Institute of British Architects,
member of the Sanitary Institute, editor and joint-author of
Modern House Construction, author of *Concrete:
Its Nature and Uses*

Roy Underhill, Consultant

Television host of "The Woodwright's Shop",
author of *The Woodwright's Shop, The Woodwright's
Companion,* and *The Woodwright's Workbook,* and
Master Housewright at Colonial Williamsburg

A Publication of
THE NATIONAL HISTORICAL SOCIETY

Library of Congress Cataloging-in-Publication Data
Compendium of drawing and drawing instruments / G. Lister
 Sutcliffe, editor; Roy Underhill, consultant.
 p. cm. — (The Modern carpenter joiner and cabinet-maker)
 ISBN 0-918678-57-9
 1. Measured drawing—Technique. 2. Geometrical
 drawing—Technique. 3. Artists' tools.
 I. Sutcliffe, G. Lister. II. Underhill, Roy. III. Series
 NA2712.C66 1990
 720'.28'4—dc20

CONTENTS

DIVISIONAL-VOL. III

CONTENTS

ILLUSTRATIONS

DIVISIONAL-VOL. III

ILLUSTRATIONS IN TEXT

PREFACE

Robert Mady slammed another shell into the cannon of his tank as it passed beneath the Arc de Triomphe. He would have time for only one shot, for the German Panther tank at the far end of the Champs-Elysees had just missed him with an armor-piercing shell. Mady's tank commander Paul Quinion sighted the Panther through his field glasses and shouted out the range, "1,500 meters!" Mady set his gunsight, took aim at the German tank parked beside the great Obelisk, and suddenly remembered a piece of useless information.

A Parisian, Mady cherished the architectural splendor of his city. Perhaps this is why he suddenly remembered having read in an almanac that the distance down the Champs-Elysees from the Arc de Triomphe to the Obelisk was 1,800 meters. Mady corrected the range, aimed, and fired. Flames shot up from the German tank as his shell struck home. Mady's relief was interrupted by the curious realization that if his shot had been off by two meters to the right, he would have knocked down and destroyed one of the great landmarks of his beloved city.

Perhaps you doubt that this obscure incident during the liberation of Paris in August 1944 was the crowning moment in the long history of geometry and mensuration. Consider then, that the ancient obelisk standing in the Champs-Elysees was taken from the temple of Luxor, Egypt, the traditional birthplace of the science of geometry. As early as Herodotus, historians have claimed that the geometry that we use today was developed so that boundary markers washed away by the annual flooding of the Nile could be reestablished from reference points on dry land. Just such a practical application was embodied in the mechanics of the gunsight used by tanker Mady. True, Mady relied on memory rather than geometric calculation to find the correct basic distance, but this represents an even stronger connection to this volume. It represents the ultimate triumph (the Arc de Triomphe?) of arcane cultural information over the forces of evil and ignorance.

This volume is a perfect mix of the dated and the timeless. The drawing instruments now gather rust and dust. Like slide rules, they are too recently abandoned to be historically valued. Drafting and design work is now done with mice, workstations, and plotters. The mathematical information to solve the geometrical problems are now carried in the software of the machine rather than in human memory or on the bookshelf of the worker. But the principles remain unchanged. The mathematics that guided the builders of the pyramids, the movers of the obelisk, and the designers of Robert Mady's gunsight remain eternally true. New uses founded on ancient geometry abound. Even the scalable fonts within modern computers owe their versatility to the geometric formulae that correctly describes each letter regardless of size.

This volume of builder's geometry is the perfect set of creative mind-tools for those who want to think for themselves. Some of the practical applications are as simple and everyday as laying out an elliptical tabletop. Here we learn more than a dozen methods of constructing ellipses, including the venerable string and pin method. The copyist never needs to understand these underlying principles of design. But if you want to build a spiral staircase shaped like a gigantic wooden screw, or calculate the covering of a dome intersected by a cylinder, here are the tools with which to do the job.

As sophisticated and complex as our abstract abilities can become, they never made an adequate substitute for common sense. Concerned with the size of vacuum pumps needed along a new light bulb production line, Thomas Edison asked a young assistant to measure the precise interior volume of one of the glass bulbs prior to evacuation and sealing. When the assistant had not returned after a day, Edison called to find out what was taking him so long. The assistant finally appeared, sweating and frazzled with a sheaf of drawings and calculations and explanations of how impossibly complex was the problem before him. Edison listened as well as he could, and then took the unsealed bulb from his defeated assistant. He filled it with water from the tap, poured the water into a graduated cylinder, and read off the measurement that he had asked for on the previous day.

ROY UNDERHILL
MASTER HOUSEWRIGHT
COLONIAL WILLIAMSBURG

Section IV
DRAWING AND DRAWING-INSTRUMENTS

BY

THE EDITOR

Section IV
DRAWING AND DRAWING-INSTRUMENTS

CHAPTER I

DRAWING-INSTRUMENTS, &c.—1, COMPASSES; 2, ELLIPSOGRAPHS, &c.; 3, DRAWING-
PENS AND PRICKERS; 4, BOARDS, SQUARES, &c.

1. COMPASSES

Compasses are of different kinds, viz.:—Dividers, compasses with removable legs, bow‑compasses, spring‑bows, directors, proportional‑compasses, and beam‑compasses. Brass was formerly the metallic compound chiefly used in their construction, but all good instruments are now made of a white amalgam known as electrum or German silver. This is harder and more durable than brass, and therefore less likely to bend, and also keeps cleaner—an important advantage. Of course the blades of the pens, and the springs of spring-bows, are made of fine steel, as also are the joints. Compasses made of aluminium have recently been introduced, but whether the innovation is an improvement or not cannot yet be decided. Aluminium-bronze and silver have also been used.

Dividers are used for taking off and transferring measurements. The common dividers are compasses without removable legs, working somewhat stiffly in the joint, and having fine, well-tempered points of equal length, lying fairly upon each other when closed. When dimensions are to be taken with extreme accuracy, these dividers will not, under the most skilful manipulation, work with the delicacy and certainty that are required. In such cases the draughtsman resorts to his *hair*-dividers; these are compasses (fig. 195) in which one leg is acted upon by a spring; a finely-threaded screw, A, pressing upon this spring, changes the direction of the point to the nicety of a hair's-breadth. The distance to be measured is first taken as accurately as possible between the points of the compasses, and the screw is then turned until the dimension is obtained with positive exactness. This instrument is useless unless of the very best quality: it must work firmly and steadily; and the points need to be exquisitely adjusted, exceedingly fine, and well-tempered. The joint at the head of the instrument shown in fig. 195 is known as the "Sector" joint, and is a great improvement on the old-fashioned "Long" joint.

Fig. 195.—4- or 5-inch Hair-divider

It is, of course, necessary to work the compasses in such a manner that, when the dimension is taken, it may suffer no disturbance in its transfer from one drawing or scale to the other drawing. To secure this, the instrument must be held by the head or joint, the forefinger resting on the top of the joint, and the thumb and second finger on either side. When held in this way, there is no pressure except on the head and

centre, and the dimension between the points cannot be altered; but if the instrument is clumsily seized by a thumb on one leg, and two fingers on the other, the pressure, in the act of transference, must inevitably contract, in some small degree, the opening of the compasses; and if the dimension has to be set off several times, the probability is that no two transfers will be exactly the same. It is also desirable to manipulate the instrument in such a way, when setting off the same dimension a number of times, that the point of position is never lost. Persons unaccustomed to the use of compasses are very apt to turn them over and over in the *same* direction, when laying down a number of equal measures, and this necessitates a frequent change of the finger and thumb, which direct the movement of the instrument: the consequence is, that the fixed leg is either driven deep into the drawing, or loses position. But if the movement is alternately above and below the line on which the distances are being set off, the compasses can be worked with great freedom and delicacy, and without any liability to shifting. If a straight line is drawn, and semicircles are described alternately above and below the line, it will show the path of the traversing foot.

There is a third sort of dividers, named the spring-compasses or spring-bows, in which steadiness is combined with the delicacy of adjustment of the "hair"-compasses. The last-named are liable to error, in consequence of the weakness of the spring leg; and

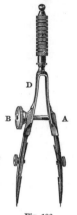

Fig. 196
Spring-bows

without very careful handling, the dimension, though taken with extreme exactness, cannot be laid down correctly. The spring-compasses, however, have, from their principle of construction, great steadiness. The legs are fixed to a steel spring D (fig. 196), whose elasticity keeps the points extended: the screw A B is fastened by a pivot-joint at A, and passes through a slot in the other leg; the opening of the instrument is adjusted by a nut, B, working upon the fine thread of the screw. The legs are sometimes jointed below the screw, but, as this increases the possibility of movement after the screw has been set, it is best to have the legs unjointed. The instrument is worked by the fore-finger and thumb on the head; and, in setting off, the alternate motion before-mentioned is to be observed. When purchasing spring-compasses, the draughts-man must select only those in which the screw works on a pivot, since, if it is fixed immovably at A, it cannot adapt itself to the various extensions of the legs, and the fine thread is then much injured by the unequal pressure of the nut.

Compasses with Removable Legs.—Nearly every case of instruments is provided with a pair of compasses having one removable leg, which may be replaced by others carrying a pen or pencil. This instrument serves, in the first instance, as a divider; and the additional legs enable the draughtsman to describe arcs and circles temporarily in pencil, or permanently in ink. As it is advantageous to effect the change of leg with little loss of time, some attention must be paid, when selecting the drawing-case, to the con-trivance for removing and securing the legs. The worst construction is that wherein

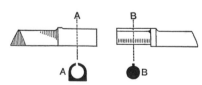

Fig. 197.—Bayonet-joint—Elevations and Sections

the leg is secured by a screw, since it involves a tedious process of fixing and unfixing; and the best is, perhaps, the bayonet-joint (fig. 197), which, although completed in an instant, is in good instruments quite firm. In working with the pencil and pen legs, it is desirable to keep them vertical to the drawing; and indeed, with the last, it is absolutely necessary, as otherwise the arc or circle would be described with the side of the pen, and the result would be either no mark at all, or a ragged, unsightly line. These legs should, therefore, be jointed, as at A A in fig. 198, so that, in proportion as the compasses are extended, they may be bent inward, and brought to a vertical position.

It is found, on trial, that if we attempt to describe an arc of more than a certain radius, we require to throw the "centre" leg into a very oblique position, with the

certainty of making a large hole in the paper, or of losing the exact centre and so making
a false line. To meet this difficulty, a *lengthening bar* (No. 2, fig. 198) is provided, which
receives the pencil-leg or pen-leg in the one end, and joins to the compasses, by a bayonet-
fixing, at the other. When thus lengthened, the instrument will command a radius
of 6 or 8 inches with ease and security.
A pair of compasses of this sort, with
lengthening bar, pen-leg, pencil-leg, and
knife-key, is known as a "half-set". The
knife-key has a knife at one end, a file (for
sharpening pencils, &c.) in the middle, a
screw-driver for tightening the screws at
A A, and a pair of prongs at the other end
for tightening the joint at the head of the
compasses.

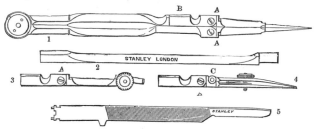

Fig. 198.—Half-set of Double-jointed Compasses

1, Compasses or Dividers; 2, Lengthening Bar; 3, Pencil-leg; 4, Pen-leg; 5, Knife-
key; A A, Knee-joints; B, Bayonet-joint for Removable Legs; C, Joint of Pen-blade.

The pen-leg (No. 4, fig. 198) is formed of two blades of steel, terminating in thin,
rounded, and well-adjusted points. A spring is inserted between the blades, to separate
them; and they are brought together by a screw which passes through them, and which
is capable of adjusting the pen for a strong line, or for one as fine as a hair. In using
this leg, the screw is slackened, and ink inserted between the blades with a writing-pen,
or brush, or a narrow scrap of drawing-paper, and the blades are then brought gradually
together, until they will produce a line of the desired quality. The draughtsman will, of
course, try the line on his waste-paper before he ventures to describe it on his
drawing. In the illustration, one of the blades is jointed at C to facilitate cleaning.
Sometimes, however, in small instruments, the joint is omitted, and the blades them-
selves furnish the necessary "spring".

The pencil-leg (No. 3, fig. 198) is now almost invariably made to receive a piece of
lead without any wood casing. This is a great improvement on the old fashioned method
of using wood-cased pencils. The lead is secured between two half-cylinders, which
can be drawn closely together by means of the set-screw.

A third removable leg, named the dotting-pen, is sometimes included in the drawing-
case. It is jointed in the same manner as the pen and pencil legs, and consists of two
blades terminating in a small revolving wheel E (fig. 199), which is retained in its
position by the screw D. The one wheel might, of course, be permanently fixed,
but usually three or four are supplied with the pen, to produce dots of greater
or less strength; the contrivance of the screw, therefore, admits the ready substi-
tution of one wheel for another. When this pen is used, ink must be inserted
between the blades over the wheel; and the latter should be run several times
over the waste-paper, until, by its revolution, it takes the ink freely, and leaves
a regularly-dotted line in its course. It often fails in its duty, leaving either
blots or blank spaces, and is seldom used by the experienced draughtsman.
Various modifications have been introduced, but do not call for particular notice.

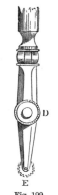

Fig. 199.
Dotting-pen
for Compasses

The compasses with removable legs have frequently to describe an entire
circle, and an inexperienced hand finds some difficulty in carrying the traversing
leg neatly round the circumference without the other leg losing position. Some
persons have recommended the movement of the dividers, that is, to form half the
circle in one direction, and half in a reverse direction; and this may answer very well with the
pencil-leg, but not with the pen-leg; since it is almost impossible, in the latter case, to unite
the two semicircles without leaving marks of junction, which very much injure the continuity
of the line that forms the circle. This being the case, it is preferable to adopt a method that
shall answer equally well with either leg, and which, by one continued sweep, shall complete
the figure. A little practice will enable the draughtsman to do this without much difficulty.

Bow-Compasses.—This instrument may be described, generally, as a pair of small compasses suited for describing arcs and circles of rather short radii. The essential difference between it and the compasses already described is that a handle is provided at the head.

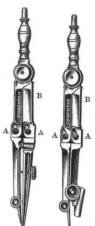

In using the instrument, the handle is held by the thumb and forefinger, and a complete circle can be turned with the greatest ease, especially if the line is commenced at a point corresponding with the figure representing 4 or 5 o'clock on the dial of a watch, and continued in the direction taken by the hands of the watch. At one time neither of the legs of the bow-compasses was jointed; a joint about half-way up the pen-leg or pencil-leg is a great improvement, but it is much the best to have the "centre" leg also jointed, as shown at A A in the illustration. It will be noticed that the legs at B B are hollowed; this is a great improvement, as it facilitates the opening of the instrument.

Fig. 200.—Bow-compasses for Ink and Pencil. A A, Joints

The pen and pencil bow-compasses are by far the most useful compasses required by the draughtsman. They are light (and consequently not so likely to damage the paper), accurate, and easily manipulated. For some years I have almost exclusively used a modification of the bow-compasses, combining the advantages of these and of the ordinary compasses already described. The compasses are $4\frac{1}{2}$ inches long, including the handle at the head, and have a removable pencil-leg and a fixed centre-leg, both jointed. A jointed pen-leg is supplied to take the place of the pencil-leg, and a lengthening bar completes the set. If to these a drawing-pen and two pairs of spring-bows (one for pencil and the other for ink) are added, the draughtsman will have sufficient compasses for ordinary purposes. They can all be fitted into a case measuring only $5\frac{1}{2}$ inches by 3 inches by $\frac{3}{4}$ inch, which can easily be carried in the pocket of one's coat. Fig. 201 shows a case of this sort fitted with all the instruments mentioned, except the knife-key.

Spring-bow Compasses, or, as they are usually termed, "Spring-Bows" (fig. 202),

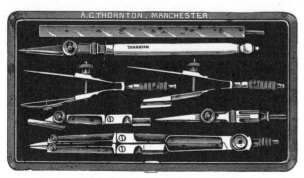

Fig. 201.—Useful Pocket Case of Drawing-instruments

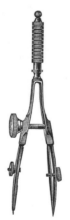
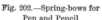

Fig. 202.—Spring-bows for Pen and Pencil

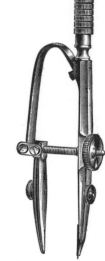

Fig. 203.—Thornton's "Parallel" Spring-bow Pen

are limited in their application to small curves and circles, but are very delicate and exact instruments, so far as their range extends. They are in principle identical with the spring-dividers, which we have already described, and one leg is provided with a pen or with a holder for a pencil. The advantages of this construction can be appreciated only by those who know the difficulty of drawing a small circle with perfect exactness by compasses that are extended and closed in the ordinary manner. Thornton's "parallel" spring-bow pen is a new and improved form, so arranged that the pen remains vertical throughout its range; it is shown in fig. 203.

For drawing very small circles the "patent rotating compass" is extremely useful.

It is shown in fig. 204, and can be obtained in a small box fitted with pen and pencil points and a case for leads. In using it the forefinger should be placed lightly on the knob, so as simply to steady the needle-point, and the compass should then be turned quickly by the second finger and thumb.

The points of Compasses merit consideration. The simplest and cheapest form is merely a point ground on the steel end of the compass-leg, but as the point may be broken by accident, or gradually worn away by use, repeated sharpening is necessary, until the leg

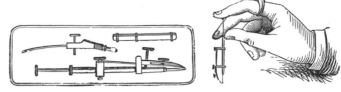

Fig. 204.—Patent Rotating Compass

becomes too short for convenience and accuracy. A loose needle is therefore preferable, as this can nearly always be replaced by a piece broken from an ordinary sewing-needle of suitable size. There are several methods of securing the needle, as shown in fig. 205. That marked A is Stanley's patented spring-point. To insert the needle, the lower extremity of the leg is unscrewed, and the needle is then pushed through the hole from the top; on screwing up the needle-holder, the head of the needle comes in contact with a sort of piston behind which is a spring. Excessive pressure on the needle is relieved

by the spring, and serious perforation of the paper is thus prevented. I used this point for some time, but as special needles must be employed, of the exact length and diameter required to fit the instrument, I found it troublesome, and discarded it. The bolt-and-nut point marked B is much better; the pointed end of the needle passes through a hole in the leg of the compass, while the upper end is secured by a bolt, which is tightened by means of a screw. The needle must accurately fit

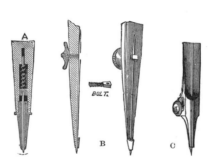

Fig. 205.—Compass-points

A, Section of Stanley's patent spring-point; B, Section and view of bolt-and-nut needle-point; C, View of clamp needle-point; D, Thornton's improved needle-point

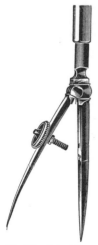

Fig. 206.—Patent Screw for Pen-point

the hole at the end of the compass-leg, or a certain amount of movement will occur, which will render accurate draughtsmanship impossible. The third form is generally used for spring-bows, and is simple and convenient, but is not as well adapted as the B form for larger instruments. The leg of the compass is split, and two semicircular grooves are formed in the adjacent faces to receive the needle; the faces are then drawn together by means of the screw, until the needle is securely held. Thornton's "improved" needle-point is shown at D; $4\frac{1}{2}$-inch and 6-inch compasses are made to receive ordinary No. 5 needles, and bows to receive No. 7 needles.

The loose screws of compasses are often lost, and it is therefore worth while drawing attention to new forms of screws which are permanently attached to the instrument. Fig. 206 shows a new form of screw for a jointed pen; the novelty consists in the small nut or collar fitted on the screw under-neath the jointed nib. The pen can therefore be opened for

Fig. 207.—Patent Screw for Pencil-point

cleaning without having to remove the screw. In fig. 207 the improved screw for the pencil-leg of a pair of compasses is shown to an enlarged scale. The inner end of the screw is fixed, and the outer end is flanged so that the milled nut cannot be withdrawn, although it can be unscrewed sufficiently to allow the lead to be inserted.

Directors, or Triangular Compasses.—This instrument is used for taking three angular points at once, or for laying down correctly a third point with relation to other two. One form of construction is that of an ordinary pair of compasses, with an additional leg attached by a universal joint; another contrivance, much recommended for simplicity and facility in its use, is a solid plate of three arms, each arm carrying a movable limb, into which a short-pointed needle is inserted at right angles. In using the first, the compasses are opened, and two points taken, and the additional leg is extended in any direction to take up the third point; the management of the second is equally easy, the needle-points are successively adjusted to the angles by the flexure of the movable limbs. With either instrument, the draughtsman is saved the tedious process of constructing triangles, and determining the relative position of neighbouring points in his drawing.

Proportional Compasses.—These are used for the enlargement or reduction of drawings. The simplest form is that named *wholes-and-halves*, or *bisecting compasses*, which may be described as two bars pointed at each extremity, and working transversely on a box-screw joint, and forming, as it were, two compasses, the legs of the one being twice the length of those of the other. If any distance is taken between the points of the longer legs, half that distance will be contained at the other end. The application of the instrument to the reduction or enlargement of any drawing one-half is sufficiently obvious.

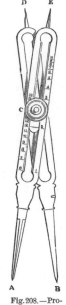

Fig. 208.—Proportional Compasses

The proportional compasses, properly so called, is a more complicated contrivance, and admits of more varied application. Its form and general construction are seen in the annexed illustration (fig. 208). It is in principle the same as the wholes-and-halves, with this difference, that the screw-joint c passes through slides moving in the slots of the bars, and admits of the centre being adjusted for various relative proportions between the openings A B and D E. Different sets of numbers are engraved on the outer faces of the bars, and by these the required proportions are obtained. The instrument must be closed for adjustment, and the nut c loosened; the slide is then moved in the groove, until a mark across it, named the index, coincides with the number required; which done, the nut is tightened again. An improved form is now made, having a "bar" adjustment worked by a screw; this renders it more easy to set the instrument accurately.

The scales usually engraved on these compasses are named Lines, Circles, Planes, and Solids.

The scale of lines is numbered from 1 to 10, and the index of the slide being brought to any one of these divisions, the distance D E will measure A B in that proportion. Thus, if the index is set at 4, D E will be contained four times in A B.

The line of circles extends from 1 to 20; if the index is set at (say) 10, and the circumference of a circle is drawn with radius A B, the circumference can be divided into ten equal parts by setting off the distance D E around it.

The line of planes, or squares, determines the proportion of similar areas. Thus, if the index is placed at 3, and the side of any one square is taken by A B from a scale of equal parts, D E will be the side of another square of one-third the area. And if any number is brought to the index, and the same number is taken by A B from a scale of equal parts, D E will be the square root of that number. And in this latter case, D E will also be a mean proportional between any two numbers whose product is equal to A B.

The line of solids expresses the proportion between cubes and spheres. Thus, if the index is set at 2, and the diameter of a sphere, or the side of a cube, is taken from a scale of equal parts by A B, then will D E be a diameter of a sphere or side of a cube of half the bulk. And if the slide is set at 8, and the same number is taken from a scale of equal parts, then will D E measure 2 on the same scale, or the cube root of 8.

The scale of lines and that of circles are those of most value to the draughtsman. The first enables him to reduce or enlarge in any required proportion, and the second gives him the side of the square or polygon that can be inscribed in a given circle. The instrument needs to be used carefully, since its accuracy depends on the preservation of the points. If these are broken, or diminished in length, the proportions cease to be true. In place of using the proportional compasses in setting off a number of times, which would soon wear the points, it is better to take the distance in the dividers.

Beam-Compasses.—The draughtsman has frequently to measure and lay down distances, and to sweep with radii, which the ordinary instruments cannot reach. In these cases, he resorts to the beam-compasses, which are usually made of well-seasoned mahogany or ebony; sometimes a slip of holly or box-wood is let into the face to carry the scale. Two metal boxes with points are fitted to the beam, one of which moves freely along the beam, the other being connected with a slow-motion screw working in the end of the beam, so that the compasses can be adjusted with extreme delicacy to any measure or radius. Reading-plates, on the Vernier principle, subdivide the divisions of the scale on the beam, and by them any measure to two places of decimals can be taken. In fig. 209 c c is the wood beam, whose length may be taken at pleasure, although it is not advisable to extend it beyond 4 or 5 feet, lest it bend by its own weight: *a a* is the strip of holly or box-wood on which the scale is engraved: B is the metal box, which moves freely along the beam, and is secured in position by the clamp-screw F: A is the other box,

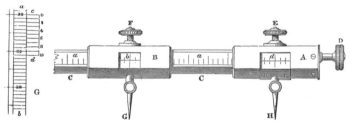

Fig. 209.—Beam-compasses and Vernier Scale

Fig. 210 —Electrum Fittings for Beam-compasses

made fast to the slow-motion screw D, which works in the end of the beam, and winds it into or out of the box A, to obtain perfect adjustment; and *d b* are the Vernier scales, or reading-plates. Fig. 210 shows a more modern set of fittings for a pair of beam-compasses, including needle-points and pen and pencil legs. The wood beam is sometimes replaced by a series of metal tubes sliding into each other and secured by screws, but the tubes when extended "sag" with their own weight, and consequently this form of beam-compasses cannot be recommended.

Before describing the method of setting the instrument, we must explain the nature of a Vernier scale. Take any primary division of a scale, and divide it into ten parts, then take eleven such parts and divide the line which they form into tenths likewise; this last then becomes a Vernier or reading-scale. The diagram at G (fig. 209) shows the Vernier *c d* attached to the scale *a b* of the ordinary barometer. Here *a b* is divided into inches and tenths of inches; and *c d*, consisting of eleven subdivisions of *a b*, is divided into tenths. Now the *zero*, or commencement of notation, on the Vernier is, in this case, adjusted to 30 inches on the scale; and its division 10 coincides with 28 inches 9 tenths; hence every division of the Vernier is seen to be one and one-tenth of the scale divisions. To read off, therefore, the hundredths of an inch that the zero of the Vernier may be in advance of a tenth, observe what division of the Vernier coincides most nearly with any division of the scale, and that will indicate the hundredths. Thus, taking the adjustment of the figure, the zero corresponds exactly with 30 on the scale, and we therefore read 30 inches. But if the zero were so posited between 29 and 9 tenths

and 30, that the 8 of the Vernier should correspond exactly with a tenth of the scale, we should read 29 inches, 9 tenths, and 8 hundredths. And this is evident, for if zero be 8 hundredths in excess of a tenth, it is only the eighth division of the Vernier that will be found to coincide exactly with a tenth of the scale.

To adjust the beam-compasses for a distance or radius of 13 inches, 5 tenths, 3 hundredths, the box A is to be moved by the screw D until the zero of its Vernier corresponds with the zero of the beam, and is then to be secured in position by the clamp E: this done, the box B is slid along the beam until the zero of *its* Vernier coincides with 13 inches 5 tenths: lastly, the box A is moved by the slow-motion screw, and the third division of the Vernier brought to correspond with the third tenth of the scale, which consequently adds 3 hundredths to the distance or radius previously taken. The slightest sagging of the beam will, however, vitiate the accuracy of the adjustment, and it is always advisable to check the radius of the circle by means of a scale laid on the drawing. This is particularly necessary in plotting the long lines of a small-scale survey. In the case of tubular beam-compasses, or compasses with plain wood beams, the required radius must be taken from another scale or from a line laid down on the drawing.

Mr. Brunel introduced what are called *Tubular-Compasses*, in which the upper parts of the legs lengthen out like the slide of a telescope, thus giving greater extent of radius when required. The movable legs are double, having points at one end, and a pencil or pen at the other; and move on pivots, so that the pen or pencil can be instantly substituted for the points, or *vice versa*. The design is ingenious, and offers many conveniences, but the instrument is too delicate for ordinary hands. Unless very well made, tubular-compasses are unsteady.

The Portable or Turn-in Compass, now generally known as the "pillar"-compass, is a contrivance which combines dividers, compasses with removable legs, and bows,

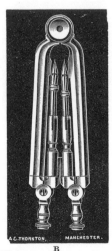

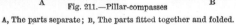

Fig. 211.—Pillar-compasses

A, The parts separate; B, The parts fitted together and folded.

Fig. 212.—Napier Compasses (full size)

A, Open; B, Closed.

in a pocket instrument, folding up to a length of 3 or 3½ inches. The upper legs are hollow, and admit either leg of the pen and pencil bows. When closed for the pocket, one leg of each bow slides into the upper legs, and the other is turned inward towards the head. This description will be better understood by reference to the illustrations in fig. 211. This instrument can now be obtained with "clamp" needle-points—a great improvement. Lengthening bars are supplied with the instrument if desired.

Napier Compasses are also designed for carrying in the pocket, and combine in one instrument dividers and pen and pencil compasses as shown in fig. 212.

2. ELLIPSOGRAPHS, &c.

Instruments for Drawing Ellipses are very useful for drawing arches and circles in perspective and for other purposes. They are known as ellipsographs or elliptographs. Some are on the principle of the joiner's trammel, as shown in fig. 213. This is an instrument consisting of two principal parts, the fixed part in the form of a cross E F G H, and the movable piece or tracer *k l m*. The fixed piece is made of two rectangular bars or pieces of wood or metal, of equal thickness, joined together so as to be in the same plane. On one side of the frame so formed, a groove is made, forming a right-angled cross. In the groove two studs, *k* and *l*, are fitted to slide freely, and carry attached to them the tracer *k l m*. The tracer is generally made to slide through a socket fixed to each stud, and

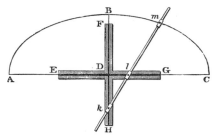

Fig. 213.—The Trammel for drawing Ellipses

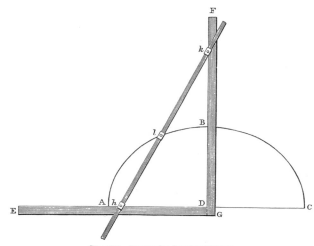

Fig. 214.—Square for drawing Ellipses

provided with a screw or wedge, by which the distance apart of the studs may be regulated. The tracer has another slider *m*, also adjustable, which carries a pencil or point. The instrument is used as follows:—Let A C be the major, and H B the minor axis of an ellipse: lay the cross of the trammel on these lines, so that the centre lines of it may coincide with them; then adjust the sliders of the tracer, so that the distance between *k* and *m* may be equal to the semi-axis major, and the distance between *l* and *m* equal to the semi-axis minor; then, by moving the bar round, the pencil in the slider will describe the ellipse.

In fig. 214 a modification of the instrument is shown. Here a square E D F is used to form the elliptical quadrant A B instead of the cross, and the studs *h l k* may be simply pins, which can be kept pressed against the sides of the square while the tracer is moved. In this case the adjustment is obtained by making the distance *h l* equal to the semi-axis minor, and the distance *l k* equal to the semi-axis major.

Stanley's "Simple Elliptograph" is shown in fig. 215. This instrument consists of a slide-rule in box-wood. At one end of the instrument there is a fixed stud, and on the slide-rule is another stud, which can be moved with the rule to any

Fig. 215.—Stanley's Simple Elliptograph

distance along the scale according to the size of the required ellipse. A cord is passed over these two studs and to the revolving socket, which carries the pen or pencil. The complete ellipse is drawn with the exception of a small portion equal to the width of the rule. There is, of course, a little difficulty in adjusting the length of the cord.

More expensive instruments can be obtained, such as Burstow's or Grace's, the latter being capable of describing ellipses of all sizes up to 20 inches by 11 inches.

Instruments are also made for drawing parabolas, hyperbolas, helices, circular arcs of high radii, &c., but are not of much service to the architect or builder.

3. DRAWING-PENS AND PRICKERS

The Ordinary Drawing-Pen differs from the pen-leg of a pair of compasses chiefly in having a long straight handle, usually of bone or ivory, but occasionally of steel. The nibs are of fine steel firmly secured to an electrum socket into which the handle is fixed. The best pens usually have the front nib jointed at the top, so that it can be opened for cleaning the pen, and the back nib of thicker substance, so that the screw may have sufficient hold; if the back nib is thin, the screw-thread in it is soon stripped. Fig. 216 A shows a pen of this kind fitted with the safety-screw already described. Small pens for fine work (B) are not usually jointed. Sometimes (C) the milled nut of the screw is placed between the nibs, so as to be out of the way of the draughtsman as much as possible. A special pen is now made for drawing curved lines, as shown at D. The "bordering"-pen (E) is for drawing thick lines, and differs from the ordinary pen in having a central nib in addition.

Dotting-Pens, with three or four different dotting-wheels, can be obtained, but are not of much service.

The nibs of a drawing-pen gradually wear away with use, until it becomes impossible to obtain a satisfactory line. The pen must then be re-set. With a little practice the draughtsman can do this for himself on a small hone or whetstone covered with fine oil. The pen must be held nearly flat, and moved to and fro on the hone in a segment of a circle, the convexity of which is towards the hand holding the pen. When both nibs have been sharpened to uniform thickness, they should be brought together by means of the screw, and the pen held parallel to the length of the hone and drawn along it, the handle being gradually raised until the pen is vertical; by this operation the length of the nibs and the curve of one half of the point are adjusted. On turning the pen over, the other half can be treated in the same way. If the pen is jointed, the nibs should be opened, and the burr, which may have been formed by these operations, removed by a very light rubbing on the hone. Trial lines should be made, and if these are not satisfactory, the setting must be continued. After a little practice, a pen can be "set" in a minute or two.

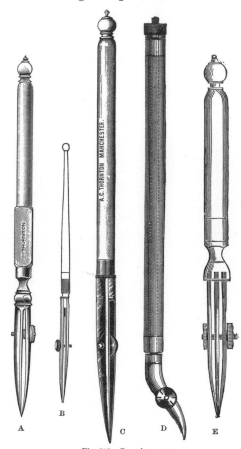

Fig. 216.—Drawing-pens

A, Ordinary pen with extra strong back nib and safety-screw; B, Pen for fine work; C, Pen with screw-nut between the nibs; D, Pen for curves; E, Bordering-pen.

The Pricker is a simple instrument, consisting of a fine needle-point firmly fixed into the end of a wooden or ivory holder, and is used for pricking off distances, the positions of lines, &c., upon the paper. It is also used in copying drawings, by placing the drawing on the top of the sheet upon which the copy is to be made, and pricking through upon the vacant sheet the positions of the lines, angles, and centres of the drawing. The removable leg of a pair of dividers, or the needle-point of any other compasses, will serve as a pricker if a special instrument has not been obtained.

4. BOARDS, SQUARES, &c.

Drawing-Boards are made truly rectangular, and for common use may be of two sizes—41 by 30 inches, to carry double-elephant paper, with a margin; and 31 by 24 inches, for imperial and all smaller sizes. Boards much smaller than this are unsuited for ordinary work, but may be necessary for particular purposes. Drawing-boards are now almost invariably made of the best red deal or yellow pine, free from knots and well-seasoned, and with battens behind, which should be of mahogany or other hardwood. One or more edges should have a strip of ebony inserted, along which the T-square can slide truly and freely, as shown in fig. 217. Cheap boards are simply made with longitudinal boards fixed to clamps at the end with tongue-and-groove joints.

Special boards are now made so that drawing-paper can be stretched on them without the use of paste or glue—for example, Thornton's and Stoney's.

The Stanley-Fieldwick board has a projecting steel slip fixed in the working-edge, and a special T-square is made for it with a projecting brass slip in the working-edge of the stock, so that the two metals slide upon each

Fig. 217.—Back View of Drawing-board, with Saw-cuts to allow for shrinkage and expansion, Battens fixed with Brass Clips, projecting Ebony Slip along the Working-Edge, rounded Corners, &c.

other. This ensures more accurate work. The Stanley-Howard board has a groove in which the stock of the T-square slides, and a locking arrangement is provided by means of which the T-square can be fixed in any position.

Boards are occasionally made as loose panels placed in a frame, all flush on the drawing surface, and bound together by bars on the other side.

Drawing-paper may be fixed down upon the ordinary board, either by damping, and gluing or pasting its edges, or by simply fixing it at the corners (and at intermediate points, if necessary) with pins. The latter fixing is sufficient for all ordinary work. It has the advantage, too, of preserving to the paper its natural quality of surface. With mounted paper, indeed, there is no other proper way of fixing. For large coloured or elaborate drawings, however, a damp-stretched sheet is preferable. Damp-stretching is done in the following way: lay the sheet flat on the board, with that side undermost which is to be drawn upon, and pare the thick edges from the paper; draw a wet sponge freely and rapidly over the upper side beginning at the centre, damping the entire surface, and allow the sheet to rest for a few minutes, till it is damped through and the surface-water disappears. Those parts which appear to revive sooner than others should be retouched with the sponge. The damping should be done as lightly as possible, as the sponge always deprives the paper of more or less of its sizing. The sheet is now turned over and placed fair with the edges of the board—sufficiently clear of the working-edges to permit the free action of the T-square. The square, or an ordinary straight-edge, is next applied to the paper, and set a little within one edge, say about $\frac{3}{16}$ of an inch, which is then turned up over the square, and smeared all along with melted glue or paste. The paper is then folded back and pressed down by the square, after which the end of a paper-folder, or other smooth article, is rubbed along the "lap", with a piece of stiff paper interposed, to press out the superfluous glue and bring the paper into intimate contact with the board. The

same operation being rapidly applied in succession to the other edges, the sheet is left to dry, and ultimately, by the contraction, turns out perfectly flat and tense. When melted glue is not to be had conveniently, a cake of glue may be dipped in water and rubbed on the margins of the board at the proper places. Lip glue, or artists' glue, which dissolves very readily, may be used in this case.

With loose-panelled boards, as described, the panel is taken out and the frame inverted; the paper, being first damped on the back with a sponge slightly charged with water, is laid over the opening to leave equal margins, and is pressed and secured into its seat by the panel and bars. This is a ready enough way of laying a sheet, and for damp sheets is more expeditious than the gluing system. But the large margin required diminishes the size of the sheet, and for general use plain boards are sufficient.

The T-*square* is a blade or "straight-edge", usually of mahogany, fitted at one end with a stock at right angles to it. The stock is intended to slide against one edge of the board, while the blade reaches over the surface, and parallel straight lines can by its aid be drawn with great facility. To suit a 41-inch board, the blade should measure 40 inches long clear of the stock, or 1 inch shorter than the board, to remove risk of

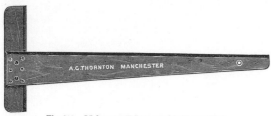

Fig. 218.—Mahogany T-Square with Ebony Edge

injury by overhanging at the end. The old-fashioned form of T-square has the two edges of the blade parallel, and has the blade sunk flush into the stock. Greater rigidity, without any increase of weight, is obtained by making the blade to taper, as shown in fig. 218. It is also a very great advantage to have the blade fixed on the top of the stock and not let into it at all; if the blade is let into the stock, the free move-

ment of the set-square along the T-square is prevented. A bevelled slip of ebony should be secured along the working-edge of the blade, and another slip should be let into a saw-cut at the free end of the blade to prevent splitting. A hole should be made in the blade near the end, by which the square may be hung up out of the way when not in use.

One-half of the stock *c* (fig. 219) is in some cases made loose, to turn upon a brass pin to any angle with the blade *a*, and to be clenched by a screwed nut and washer.

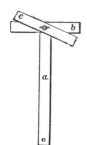

Fig. 219.—Drawing Square with Swivelling Stock

The turning stock allows the instrument to be used for drawing parallel lines obliquely to the edges of the board; when the whole is turned over and the fixed stock used, the instrument becomes an ordinary T-square. Sometimes the fixed stock is omitted, and the instrument consists simply of the movable stock fixed with a bolt and screwed nut and washer to the blade, which can be used as a straight-edge when the stock is removed.

Cory and Barczinsky's "Technical drawing apparatus" is a combination of a T-square with fixed stock, a T-square with movable

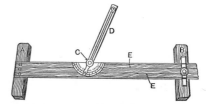

Fig. 220.—Cory and Barczinsky's Technical Drawing Apparatus

stock, set-squares of all angles, and a protractor. It is shown in fig. 220. A is the fixed stock at right angles to the blade, B the movable stock, C the brass dial or protractor with brass arm or ruler D. The dial slides along two inverted T-shaped grooves, E E, in the blade, and the edge of the ruler can thus be brought to any point on the paper. The dial is graduated into half-degrees, and the ruler carries an indicator, by which it can be set to any angle; at the important angles—30°, 45°, 60°, 67½°, and 90°—there are small holes in the dial, into which a point in the indicator drops and so fixes the arm at the required angle. Contrivances like this have their uses, but are unnecessary for ordinary purposes.

No varnish of any description should be applied to the T-square, or indeed to any of the wood instruments employed in drawing. The best and brightest varnish will soil the paper long after it has been applied and furbished up. The natural surface of the wood, cleaned and polished occasionally with a dry cloth, is sometimes preferred, but if the wood is well French-polished, it is more easily kept clean.

Straight-edges should be of close-grained hardwood, such as mahogany, well-seasoned, with ebony edges; or, when 5 feet long and upwards, they may be of ribbon-steel. Steel straight-edges are very useful for running the knife along when cutting off the margins of a drawing, as the knife cannot injure them, but wood is more easily kept clean, and therefore less likely to soil the paper. They should be just broad and thick enough for the necessary stiffness, and bevelled a little at one edge.

Triangles, or *set-squares* as they are now generally called, are thin, flat triangles for use in drawing lines perpendicular to the T-square, or at a certain inclination to it. The two most important are right-angled, one of them, *a* (fig. 221), being made with two equal sides, and two angles of 45° each; the other, *b*, with angles of 90°, 60°, and 30°. The former is useful in constructing square figures by means of diagonals, and the 60° set-square is equally useful in constructing equilateral triangles, hexagons, &c. Special set-squares are now made for the most common pitches of roofs, the batters of retaining-walls, &c. Set-squares were at one time made almost exclusively of pearwood, but they can now be obtained of framed sycamore with pearwood edges, framed mahogany with ebony edges, vulcanite, transparent celluloid, and aluminium.

Fig. 221.—Straight-edge and Set-squares

I have found the transparent celluloid by far the best; specks of dirt and blots of ink are easily seen, and, as the material is very smooth and hard, it is easily cleaned. A further advantage is that the material is transparent, and the lines of the drawing can therefore be seen through it. Set-squares are made of various sizes, the usual range being from 4 inches to 14 inches in length.

Curves.—For drawing circular arcs of large radius, beyond the range of the ordinary compasses, thin slips of wood, cardboard, or vulcanite, termed sweeps or railway curves, are usefully employed, of which one or both edges are cut to the required circle. For curves which are not circular, but variously elliptic or otherwise, "universal sweeps", or "French curves" (made of thin wood, vulcanite, or celluloid), of variable curvature, are very serviceable. Two examples are given in fig. 222. Whatever may be the nature of the curve, some portion of the universal sweep will be found to coincide with its commencement, and it can be continued throughout its

Fig. 222.—Variable Curves, one-fourth full size

extent by applying successively such parts of the sweep as are suitable, taking care, however, that the continuity is not injured by unskilful junction. For drawing small ellipses accurate elliptic "curves" are now made, and are very convenient for perspective-drawing.

Parallel rulers are of considerable utility. The old type has two rulers connected by bars moving on pivots, and so adjusted that, at every opening of the instrument, the rulers and the bars form a parallelogram. In use the edge of the upper ruler is made to coincide exactly with the line to which others are to be drawn parallel: the lower

ruler is then held firmly down, and the upper one raised to any required distance, when a line drawn along its edge will be parallel to that from which it started. Fig 223 shows a parallel ruler of this type fitted with a simple arrangement, by means of which

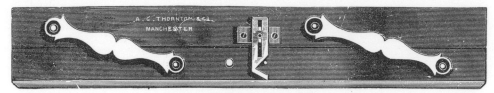

Fig. 223.—Thorton's Sectional Parallel Ruler

equidistant parallel lines may be ruled; it is chiefly used by surveyors for "hatching" buildings.

Parallel rulers are now made to roll on milled wheels connected by a spindle, so that they move with exact uniformity. They are usually of ebony, with brass wheels,

Fig. 224.—Roller Parallel Ruler with Inlaid Scales

but may be of solid brass or electrum. That shown in fig. 224 has ivory scales inlaid along the edges, but the instrument is too clumsy to take the place of an ordinary scale.

Drawing-pins for securing the paper to the drawing-board are indispensable. The usual form has a circular head of brass or German silver (rounded or bevelled so as to permit the squares to slide easily over it), and a stem of steel, riveted into the head. Fig. 225 shows a good form of pin. The stem is in some cases screwed in, but is then liable to wear loose. The taper of the stem

Fig. 225.—Ordinary Drawing-pin

should be moderate; so as not to work out when fixed into the board. A new form of drawing-pin, "made in Germany", is in one piece of steel, the stem being cut out of the top and bent down, as shown in fig. 226. These are made in three sizes, with heads varying from about $\frac{11}{32}$ to $\frac{15}{32}$ inch in diameter, and are nickel-plated. They

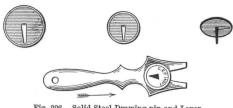

Fig. 226.—Solid Steel Drawing-pin and Lever

are cheap in first cost, but as the stems are very apt to snap off, it is doubtful if they are really economical. A lever for raising pins is supplied with each box. In the latest forms the head is covered with a thin piece of metal.

Choice and Care of Instruments.—The young draughtsman will find it best to acquire at first only such instruments as are absolutely essential. As occasion requires, he can add to his stock. Cheap foreign instruments must be avoided. English instruments, though more expensive, are, as a rule, better made, and will last, with care, a lifetime or longer. Without good tools it is impossible to do good work. If a large case of instruments cannot be afforded, separate instruments can be obtained and carefully rolled in wash-leather when not in use, or a case can be obtained with spaces for numerous instruments, so that, as these are purchased, they can be put in their proper places. It is useless buying good instruments if reasonable care is not taken of them. Cleanliness is most important. All drawing-pens should be cleaned by means of a piece of rag immediately after use, while the ink in them is still moist. Instruments should be rolled in wash-leather or placed in a covered case as soon as the draughtsman ceases to use them, and not left lying about in the dust of the office or workshop. The edges of T-squares and set-squares should never be used as straight-edges for cutting off the margins of drawings, as a slip of the knife may cut out a piece which will ruin them.

Drawing-boards, in like manner, should never be used for cutting upon, as the grooves made by the knife will render neat drawing impossible and necessitate the replaning of the board. If the needle-point of a compass is broken, it is a mistake to go on working with the stump, as this will make unsightly holes in the paper; it is best to replace it at once with a new needle of proper size.

CHAPTER II

SCALES AND PROTRACTORS, &c.

1. SIMPLY-DIVIDED SCALES.

The Plane Scale is a series of measures laid down on the face of *one* small flat ruler, and is thus distinguished from the sector, or double scale, in which two similarly-divided rulers move on a joint, and open to a greater or less angle. In the construction of scales, the subdivision must be carried to as low a denomination as is likely to be required. Thus, for a drawing of limited extent, the primary divisions may represent feet, and the subdivisions inches; but for one of larger area, and without small details, the primaries may represent 10 feet, and the subdivisions tenths, or 1 foot each (fig. 227). In the

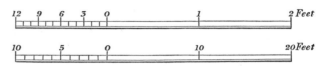

Fig. 227.—Scales of 1 Foot to 1 Inch and 10 Feet to 1 Inch

case of very large surveys, the primaries may be miles, and the lesser divisions furlongs. The plane scale is usually of boxwood, steel, or ivory. Steel scales are made of thin, flexible steel, and are exact and durable, but the divisions are difficult to see, especially by gas-light, and the material, notwithstanding the nickel-plating, is apt to rust and disfigure the drawing. Boxwood scales are cleaner, but ivory is undoubtedly the best, although most expensive, material. Paper scales can also be bought, but cannot be recommended. The length of the scale may vary from 2 inches for an offset scale (chiefly used by the surveyor) to 18 or 24 inches, the usual length being 12 inches. In section the scale may be flat on the lower side, and with bevelled edges on the upper side, or may be of the form known as "oval", in which each side is convex, the segments meeting to form a fine arris along each edge of the scale. "Flat" scales are usually divided along the two upper edges only, the back of the scale being quite plain.

Fig. 228.—Section of Triangular Scale

"Oval" scales have the advantage of being divided along all the four edges. Triangular scales of the section shown in fig. 228 are sometimes used, and have the advantage of combining six or twelve scales in one instrument; they are somewhat clumsy, but strong and durable. The divisions most frequently required by the architectural draughtsman are

Fig. 229.—Scale with two open-divided Scales along each Edge

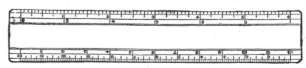

Fig. 230.—Scale with one fully-divided Scale along each Edge

$\frac{1}{8}$ inch, $\frac{1}{4}$ inch, $\frac{1}{2}$ inch, and 1 inch, and all these can be marked on one "oval" scale. On another scale the divisions may be $\frac{3}{8}$ inch, $\frac{3}{4}$ inch, $1\frac{1}{2}$ inch, and 3 inches, the two last being chiefly used for detail-drawings one-eighth and one-fourth full-size. Sometimes two scales are combined along one edge, as shown in fig. 229; thus, $\frac{1}{8}$-inch and $\frac{1}{4}$-inch divisions may go together, $\frac{3}{8}$-inch and $\frac{3}{4}$-inch, $\frac{1}{2}$-inch and 1-inch, and so on; but it is much better to

have one scale only along each edge, and to have this numbered from each end, as shown in fig. 230, so that a measurement can be laid down or taken off from each end of the scale. Scales may be either "open-divided" or "fully-divided". In the former arrangement only one division at each end (see figs. 227 and 229) is subdivided into inches or other parts, while in the latter (fig. 230) the subdivisions are marked throughout the length of the scale. The "open-divided" scales are to be preferred on account of their clearness and the consequent ease with which measurements can be laid down or read.

"Universal scales", containing sixteen or seventeen different scales, can be obtained, but, as they are very confusing, they cannot be recommended for general use.

It is sometimes necessary to construct a special scale for one particular drawing. This can usually be done in a few minutes. Suppose that a scale of 7 feet to 1 inch is required. Take a piece of good stout drawing-paper or Bristol-board and pin it to the drawing-board. Rule on it a line A C, as shown in fig. 231, and divide it into inches, as A B, B C, &c. Below one of these divisions, say, A B, at any convenient distance, rule another line D E, and lay down on it seven equal parts to any convenient scale, so that the seven parts are together greater than 1 inch. Join D A and E B,—and produce them till they meet at F; then join F1, F2, F3, &c., and the points where these lines cross A B will be the required divisions of the special scale. These can be transferred to the remaining inches of the scale by means of hair-dividers, and the scale can then be cut off along the lines A C and G H to the desired breadth.

Fig. 231.—Diagram showing the Construction of a Special Scale, 7 Feet to 1 Inch

Diagonal Scale.—More minute subdivision than is possible with the ordinary scale can be attained by the diagonal scale, which consists of a number of primary divisions, one of which is divided into tenths, and sub-divided into hundredths by diagonal lines (fig. 232). This scale is constructed in the following manner:—Eleven parallel lines are ruled, enclosing ten equal spaces: the length is set off into the desired number of equal primary divisions, as D–E, E–1, 1–2, &c.; and one of these is divided into tenths, as at A B and D E; diagonals are then drawn from the subdivisions between A and B, to those between D and E, as shown in the diagram. It is evident that at every horizontal parallel we get an additional tenth of the sub-divisions, or a hundredth of the primaries, and can therefore obtain a measurement with great exactness to two places of decimals. To take a measurement of 3·76 we place 1 foot of the dividers on the primary 3 at the sixth parallel, as shown at n, and then extend the other foot to the intersection of this parallel with the diagonal which falls from the upper subdivision 7, as shown at o. That this gives us the desired measurement will be better understood by reference to fig. 233, which, in addition to the diagonals, shows the tenths carried across the scale; the angle in the lower part of this figure represents a pair of dividers taking a measurement of 1·68. The primaries may of course be considered as yards, feet, or inches; and the subdivisions as tenths and hundredths of these respective denominations.

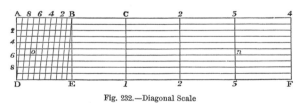

Fig. 232.—Diagonal Scale

Line of Chords.—This is sometimes introduced on the plane scale. It is an unequally-divided scale, giving the length of the chord of an arc, from 1° to 90°. The quadrant, or quarter of a circle, A C (fig. 234), contained between the two radii at right angles,

BA and BC, has its extremities joined by the line AC, to which the measures of the chords are to be transferred. The quadrant is divided accurately into nine equal parts; then from C as a centre, each division is transferred by an arc to the line AC, and the chords of every 10° obtained. These primary divisions can be subdivided into tenths, of 1° each, by division of the corresponding arcs. This is rather an illustration of the construction, than a true method of performing it. A line of chords can be laid down accurately only from the tabular sines, delicately set off by the beam-compasses. In using this scale, it is to be remembered that the chord of 60° is equal to radius. Therefore, to lay down an angle of any number of degrees, draw an

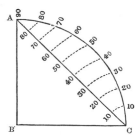

Fig. 234.—The Line of Chords

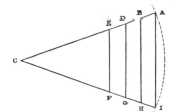

Fig. 233.—Enlarged Plan of Diagonal Scale

indefinite straight line BC; take in the compasses the chord of 60°, and from one termination of the line B, as a centre, describe an arc of sufficient extent, cutting the line at C; then take from the scale the chord of the required angle (in this case 90°), and set it off on the arc from the point C; it will cut the arc at the point A; join AB. The angle ABC will contain 90°. To ascertain the degrees of an angle, extend the angular lines if necessary, that they may be at least equal to the chord of 60°; with this chord in the compasses describe an arc from the angular point; then take the extent of the arc and apply it to the scale, which will show the number of degrees contained in the angle.

The Plane Protractor. — The plane scale is sometimes made of greater width, in order to contain all the preceding lines, and also a protractor for setting off and measuring angles, but the most convenient form for this instrument is the circle or half-circle, and this will be described hereafter.

2. DOUBLE SCALES

Each of the scales we have described has a fixed measure that cannot be varied; but we come now to speak of those double scales in which we can assume a measure at convenience, and subdivide lines of *any* length, measure chords and angles to *any* radius, &c.

The Sector.—This instrument consists of two flat rulers, united by a central joint, and opening like an ordinary 2-ft. rule. It carries several plane scales on its faces, but its most important lines are in pairs, running accurately to the central joint, and making various angles according to the opening of the sector. The principle on which the double scales are constructed is contained in the 4th Prop. of the 6th Book of Euclid, which demonstrates that "the sides about the equal angles of equiangular triangles are proportionals", &c. Now let ACI (fig. 235) be a sector, or, in other words, a portion of a circle contained between an arc and two radii; and let CA, CI, be a pair of sectoral lines, or a double scale. Draw the chord AI, and also the lines BH, DG, EF, parallel to AI. Then shall CE, CD, CB, CA be proportional to EF, DG, BH, and AI respectively. That is, as CA : AI :: CB : BH, &c. Hence, at every opening of the sector, the *transverse* distances from one ruler to another are proportional to the *lateral* distances measured on the lines CA, CI.

Fig. 235.—Diagram explaining the Construction of a Sector

Plane Scales on the Sector.—On the outer edge of the sector is usually given a decimal

scale from 1 to 100; and in connection with it, on one of the sides, a scale of inches and tenths. These are identical with the lines on the plane scale, previously mentioned, but the latter are more commodiously placed for use. On the other side we have logarithmic lines of numbers, sines, and tangents.

Sectoral Double Scales. — These are respectively named the lines of lines, chords, secants, sines, and tangents. These scales have one line on each ruler, and the two lines converge accurately in the central joint of the sector.

The Line of Lines.—This is a line of 10 primaries, each subdivided into tenths, thus making 100 divisions. It can be used to divide a given line into any number of equal parts; to form any required scale; to divide a given line in any assigned proportion; to find third, fourth, and mean proportionals to given right lines; and for other purposes.

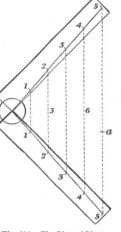

Fig. 236.—The Line of Lines on a Sector

1. To divide a given line into 8 equal parts. Take the line in the compasses and open the sector so as to apply it transversely to 8 and 8, then the transverse from 1 to 1 will be the eighth part of the line. If the line is to be divided into 5 equal parts, apply it transversely by the compasses to 10 and 10, and the transverse of 2 and 2 is the fifth part. When the line is too long to fall within the opening of the sector, take the half or the third of it. Thus, if a line of too great length is to be divided into 10 parts, take the half and divide into 5 parts; or if into 9 parts, take the third and divide into 3 parts And in other cases it may be necessary to divide the portion of the line into the original number of parts, and set off twice or thrice to obtain the required division of the whole.

2. To use the line of lines as a scale of equal measures. Open the sector to a right angle, or nearly so, and obtain dimensions by transverse measures from scale to scale, taking care that the points of the compasses are directed to the same division on both rulers. Thus, the transverse measures to the primaries 1–1, 2–2, &c., will give any denomination, as feet or inches, and similar measures to the *same* subdivisions on both sides will give tenths.

3. To form any required scale—say, one in which 285 yards shall be expressed by 18 inches. Now, as 18 inches cannot be made a transverse, take in the compasses 6 inches, the third part, and make it a transverse to the lateral distance 95, which is the third of 285. The required scale is then made; the transverse measures to the primaries being 10 yards, and to the subdivisions so many additional yards. It is often required to construct a scale of feet equal to a given scale of metres. To do this, take in the dividers the length of a metre on the given scale, place one leg at the point 3·28 (this being the number of English feet in a metre) on the one line of lines, and open the sector until the other leg of the dividers falls exactly on the point 3·28 on the other line of lines; then the transverse from 1 to 1 will equal 1 foot, that from 2 to 2 will equal 2 feet, and so on.

4. To divide a given line in any assigned proportion—say, a line of 5 inches in the proportion of 2 to 6. Take 5 inches in the compasses and apply it to the transverse of 8–8, the sum of the proportions; then will the transverse distances 2–2, 6–6 divide the given line as required.

5. To find a third proportional to the numbers 9 and 3, or to lines 9 inches and 3 inches in length. Make 3 inches a transverse distance to 9–9; then take the transverse of 3–3, and this measured laterally on the scale of inches will give 1 inch. For $9:3::3:1$.

6. To find a fourth proportional to the numbers 10, 7, 3, or to lines measuring 10, 7, and 3 inches respectively. Make 7 inches a transverse from 10 to 10, then the transverse 3–3 will measure on the scale of inches $2\frac{1}{10}$. For $10:7::3:2\frac{1}{10}$.

7. To find a mean proportional between the numbers 4 and 9, or between 2 lines measuring 4 and 9 inches respectively. To perform this operation the line of lines on the one leg of the sector must first be set exactly at right angles to the one on the other leg. This is done by taking 5 of the primary divisions in the compasses, and making this extent a transverse from 4 on one side to 3 on the other; for lines in the proportion of 3, 4, and 5 form a right-angled triangle. The sector being thus adjusted, take in the compasses a lateral distance of 6 primaries and 5 tenths, half the sum of the two lines or numbers, and apply this measure transversely from 2 primaries and 5 tenths (that is to say,—half the difference between the two lines or numbers); the other point of the compasses will reach the primary 6 on the opposite leg of the sector. For 4 : 6 : : 6 : 9.

The line of lines is marked L on each leg of the sector; and it is to be observed that all measures are to be taken from the inner lines, since these only run accurately to the centre. This remark will apply to all the double sectoral lines.

The Line of Chords.—The scale of chords (marked C on the sector) has the same advantage over that on the plane scale that the line of lines has over the simply-divided single scales. With the line of lines we operate on any given line that will come within the opening of the sector; and with the line of chords we can work with any radius of similar extent. This line is constructed by making the lateral distance of the chord of 60°, which is radius, equal in length to the line of lines. All the intermediate degrees between 1 and 60 are then set off laterally from the centre, on both rulers, by taking on the line of lines a measure equal to twice the natural sine of half the angle. Thus, for the chord of 30°, refer to any good mathematical tables, and find the natural sine of 15°, which is 2588190, when radius is 10,000,000, and the double of this sine is 5176380. Now the line of lines as radius is equal to 100, in place of 10,000,000, and the measure of the double sine must therefore be taken from it in two places of figures, instead of seven. The length of the chord is therefore 51·7638 on the line of lines, or as nearly as possible, 51 and three-fourths, and this, measured from the centre on the line of chords, will give the chord of 30°.

The line of chords is principally used to protract and measure angles.

To protract or lay down any angle *less* than 60°, say an angle of 30°. Open the sector at pleasure, and with the transverse distance 60–60 in the compasses as a radius, describe an arc of a circle: take the transverse distance of 30°, and set it up on the arc; then draw right lines from the centre to the points on the arc, and the required angle is formed. When it is desired to measure any angle of not more than 60°, take in the compasses the transverse distance of 60–60 at any opening of the sector, and with this radius describe, from the angular point, an arc across the given angle: take the measure of the arc included in the given angle, in the compasses, and apply this transversely to the line of chords, and the similar divisions on which the points of the compasses fall will express the true measure of the angle.

To protract an angle of *more* than 60°, take as radius the transverse distance of 60–60 at any convenient opening of the sector, and describe an arc as in the former case; then take the transverse distance of one-half or one-third of the given number of degrees, and set off twice or three times on the arc, as the case may be: afterwards form the angle by right lines from the centre to the two outermost points of measure on the arc. Thus if the angle is to contain 100°, having described the arc, set off 50° twice, and thus obtain the required measure.

To lay down an angle of less than 10°, it is more convenient to set off radius on the arc, and form an angle of 60°, and then set off the difference between this angle and the one required. Thus, suppose the angle to be 7°. Protract one of 60°, and set off the complement 53°; then the remainder of the arc will contain 7°, the required angle.

The reason for thus laying down small angles is, that the divisions of the sectoral line of chords are not so readily distinguished when they approach within 10° of the centre of the instrument. To measure any small angle, protract an angle of 60° that shall include it, then take the complement to 60° in the compasses, and this applied transversely to the sector will show the measure of the supplement; deduct this from 60°, and the remainder will express the measure of the given angle.

The Line of Polygons.—This line is placed near the inner edges of the sector, and marked POL on both scales. Its use is to divide the circumference of a circle into a number of equal parts, and to determine the sides of regular figures that can be inscribed within a circle or described about it. It is constructed by setting off, from a line of chords, lateral distances equal to the chords of the central angles of the square, pentagon, hexagon, heptagon, octagon, nonagon, decagon, undecagon, and duodecagon—figures of 4, 5, 6, 7, 8, 9, 10, 11, and 12 sides respectively. The central angle is found by dividing 360° by the number of sides in the figure; and the length of the chord is to be measured on a line equal in length to the sectoral line of chords, but graduated to the full quadrant, or 90°; the reason of which is, that the chords of the central angles of the square and pentagon, the one 90° and the other 72°, could not otherwise be contained in the length of the sector.

To inscribe a regular polygon in any given circle. Make the radius of the circle (fig. 237) a transverse distance to 6–6, the chord of 60°, and the transverse of 5–5 will then give the side of the pentagon. This set off 5 times on the circumference of the circle, and the points connected by chord lines, will complete the figure.

Fig. 237.—The Line of Polygons

To construct an octagon on any given line, make the line a transverse to 8–8 on the line of polygons (8 being the number of equal sides in the figure): with the sector thus set, take the transverse of 6–6 for a radius, and from each termination of the given line describe arcs intersecting each other. From the point of intersection, and with the same radius, describe a circle passing exactly through the terminations of the given line; which thus becomes one side of the required octagon, and is to be set off 8 times round the circumference of the circle to complete the figure. To describe a regular polygon about any circle (that is, *without* the circumference), the *inscribed* figure must first be drawn; then rule lines parallel to the sides of the inscribed figure, so as just to touch the circumference, and their intersections will define the polygon required.

As the remaining lines on the sector—often known as *Gunter's Lines*—are concerned only with trigonometrical ratios and logarithms, and as these can be more conveniently obtained from a book of mathematical tables, it is unnecessary to consider them in detail. They include the line of secants (marked S), the line of tangents (marked T), the line of numbers (N), and the line of sines (S). The last is on the same side of the sector as the line of lines, &c., already described; the others are on the reverse side.

3. PROTRACTORS

Protractors.—We have already referred to the protractor on the plane scale. The semi-circle (fig. 238), though different in form, is the same in principle. It is a half circle of brass or other metal (or sometimes of horn or cardboard), having a double graduation on its circular edge. The degrees run both ways to 180; so that any angle, from 1° to 90°, may be set off on either side. Each graduation marks an angle and its supplement; thus, 10, 20, 30 coincide with 170, 160, 150, and are the supplements of each other. To be of much service, the protractor should be graduated into degrees, and not merely into divisions containing 10°. A fully-divided circular protractor is shown in fig. 239. Sometimes pro-

PLATE XIX

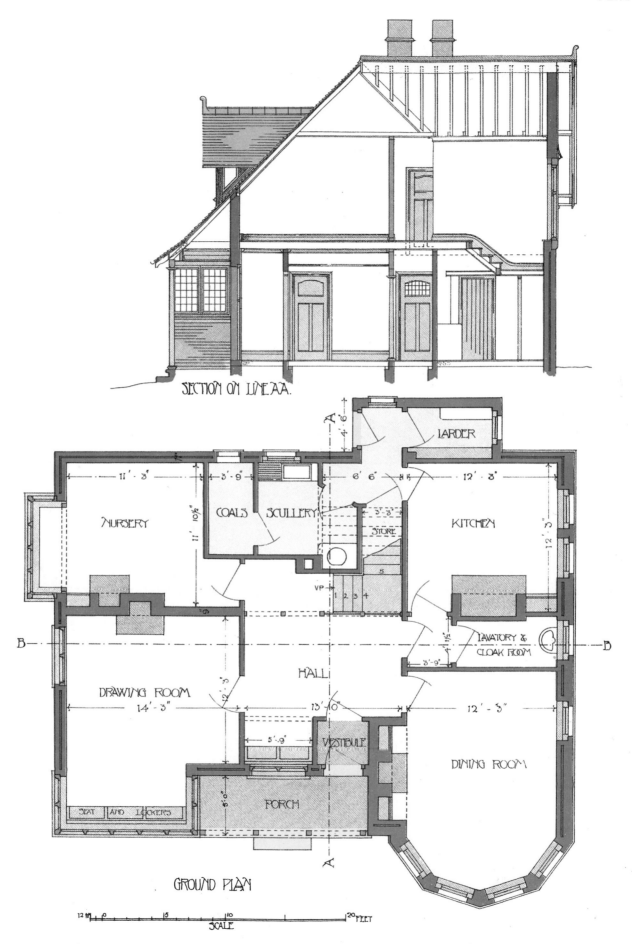

SECTION ON LINE A.A.

LARDER

NURSERY 11'·3" 3'·9" COALS SCULLERY 6'·6" KITCHEN 12'·3"

11'·10½" 12'·3"

STORE

9" 5

VP 1 2 3 4 3'·3"

B — B LAVATORY & CLOAK ROOM 1'·1½" B — B

12'·3" 3'·9"

HALL 13'·10" 12'·3"

DRAWING ROOM 14'·3" 12'·3"

5'·9" VESTIBULE

5'·0" PORCH DINING ROOM

SEAT AND LOCKERS

GROUND PLAN

12 M 0 5 10 20 FEET
SCALE

GROUND PLAN AND SECTION OF SMALL COUNTRY HOUSE

PLATE XIX

The lower illustration is the ground-plan of a small house of the quasi-bungalow type. The wood floors are coloured yellow, and the windows, stairs, and other joiner's work are shaded brown; the brick walls are coloured red, the tiled floors and hearths pink, and the concrete floors green.

The upper illustration is a section on the line A A, which passes through the porch, vestibule, hall, and scullery on the ground floor, and the central bed-room, landing, and staircase on the first floor. The roof is of the trussed-rafter type, the ceiling-joists forming collars. The rafters of the main roof are also supported from the floors by ashlaring, shown in the upper illustration of Plate XX, and in the detail of the porch, Plate XXIV.

tractors are fitted with arms or pointers, and sometimes the cross-piece of the semicircular protractor is made wider and longer, and engraved with a divided scale of the kind shown in fig. 234.

To protract an angle, draw a line, and lay the straight edge of the protractor upon it, with its centre on the point where the angle is to be formed: the required number of degrees is next marked off close to the circular edge: the instrument is then laid aside, and a line drawn from the angular point to the one which measures the extent of the angle. Thus in the figure, B is the centre, or angular point, B C the base, D the measure of an angle of 40°, and B D the line by which it is formed. The converse operation of measuring an angle is equally simple: the angular point and the centre of the protractor are made to coincide, and the straight edge of the instru-

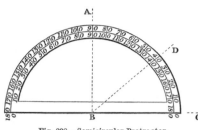

Fig. 238.—Semicircular Protractor

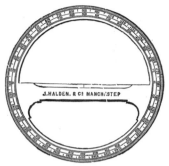

Fig. 239.—Fully-divided Circular Protractor

ment is laid exactly upon one line of the angle, when the other line will intersect the circular edge, and indicate the number of degrees. The plane-scale protractor is used in the same manner; but it is by no means so convenient an instrument as the semicircle. Either of them may be employed occasionally to raise short perpendiculars. For this purpose, make the centre and the graduation of 90° coincide with the line upon which the perpendicular is to be raised.

CHAPTER III

PENCILS, PAPER, COLOURS, &c.

Pencils are of various qualities, distinguished by letter-marks. The H B (hard and black) quality is too soft to retain long the firm point required for the correct execution of mechanical drawings; and, besides, the softer pencils are the more unctuous, and therefore lines made by them do not take ink so well as lines made by the harder pencils. F pencils work pretty well upon smooth paper; but for drawing-paper of a thick and rougher quality, especially after having been damp-stretched, H H and H H H pencils are better suited to retain their sharpness. They are further recommended by the delicacy of the lines that can be made with them—an important point when the lines have to be gone over with the drawing-pen. Much, however, depends upon the lightness of the draughtsman's touch; a hard pencil used with a heavy hand makes an indentation in the paper, which, of course, cannot be removed with india-rubber, and which renders the making of a good ink line almost impossible. Lightness of touch is essential if the drawing has to be subsequently "inked-in". Besides a drawing-pencil for straight lines, it is well to have one a little softer for freehand work, such as the rounding and filling up of corners, enrichments, and the like.

Hexagonal pencils are now usually preferred to round ones, as they are more easily held and do not so readily roll off the drawing-board. Hexagonal wood pencil-holders for receiving solid leads are very convenient and economical. When the pencil is not in use, either on the board or in the pocket, the lead can be protected by the screwed metal point-piece, as in an ordinary silver or gold pocket-pencil, and the lead can be used to the last quarter of an inch; ordinary wood pencils are usually thrown aside before they are half

worn. A further advantage of the holder is, that in sharpening the lead there is no wood to be cut away.

Many good draughtsmen consider the following mode of cutting as the one best calculated to prepare the pencil for straight-line drawing:—In the first place, it should be cut down to the lead, in a plane nearly parallel to the axis; then cut away on the opposite side to a bevel considerably inclined, and cut, likewise, transversely, at equal angles. The lead being thus laid bare, should be pared down gradually on the three inclined sides, till brought to a fine edge viewed laterally, and a flat round point in the other aspect (as in fig. 240). The less inclined side, when applied to a square, admits of the chisel-shaped lead being brought close to the edge, by which the line is more certainly drawn; and the roundness of the point keeps the pencil longer in working order. The sharpening of a sketching pencil is simply conical, and brings it to a fine point, and many prefer the lining pencil cut also in this manner. A very fine flat file (such as that on the knife-key already described), or a piece of pumice-stone, or fine sand-paper, or a sheet of waste-paper is sometimes used to bring up the point of the pencil; this mode of sharpening prevents the rapid blunting of the pen-knife which ensues if this is used to cut hard leads.

Fig. 240.—Drawing-pencil sharpened to a Chisel-shaped "Point"

Drawing-paper, properly so called, is made to certain standard sizes, as follow:—

Demy	20 inches by 15 inches.
Medium	22 „ 17 „
Royal	24 „ 19 „
Super-royal	27 „ 19 „
Elephant	28 „ 23 „
Imperial	30 „ 22 „
Columbier	34 „ 23 „
Atlas	34 „ 26 „
Double Elephant	40 „ 27 „
Antiquarian	53 „ 31 „
Emperor	68 „ 48 „

Of these, Double Elephant is the most generally useful size of sheet. Demy and Imperial are the other useful sizes, but the paper, unless specially ordered otherwise, is thinner than Double Elephant, and therefore not as well adapted for erasure or as durable. Whatman's hand-made white paper is the quality most usually employed for finished drawings; it will bear wetting and stretching without injury, and receives shading and colouring easily and freely. It is made with a variety of surfaces, the two most commonly used being the smooth surface, known as "hot-pressed", and the slightly rougher surface, known as "natural" or "not", *i.e.* "not hot-pressed". For drawings finished entirely in line, the former is the better, but the rougher surface takes colour more freely. A third quality of surface, known as "rough", is also much used for coloured work. "Sand-grain" paper, the surface of which is pitted with minute depressions, is an excellent paper for coloured work. Good drawing-paper improves with age, and it is therefore advisable to keep a good stock in hand.

For ordinary sketching or detail-drawings, where damp-stretching is dispensed with, cartridge-paper, of a coarser, harder, and tougher quality, is to be preferred. This can be obtained in sheets of various sizes, or in rolls up to 62 inches wide and 40 yards long. It bears the use of india-rubber well, receives ink on the original undamped surface freely, shows a good line, and, as it does not absorb very rapidly, tinting lies evenly upon it.

For delicate small-scale line-drawing, Bristol boards are best, although, of course, more expensive than paper. They are made of various sizes, and are known as 2-sheet, 3-sheet, 4-sheet, or 6-sheet, according to the thickness.

Large drawings, destined for rough usage and frequent reference, should be mounted on linen previously damped, with a free application of paste. Or such drawings should be

made directly on "mounted drawing-paper"—*i.e.* paper (either Whatman's or other good paper, or cartridge-paper) mounted on union or on brown holland—which can now be purchased in sheets or rolls. I have used such paper up to 10 feet wide, but of course extreme widths like this must be specially made to order.

Sectional papers are often useful for plotting measurements to scale on the spot, or for enlarging or reducing drawings. They can be obtained in sheets up to about 22 inches by $17\frac{1}{2}$ inches, and in rolls of 11 yards, 26 or 30 inches wide. The special feature of these papers is that they are ruled with faint lines at right angles to each other, forming squares of different sizes from $\frac{1}{16}$ inch to 1 inch. Somewhat strong lines occur at regular intervals, forming larger squares, as shown in fig. 241. To double the size of a drawing, the lines on the sectional paper may be traced on a piece of tracing-paper, and this may be pinned down over the drawing. The enlarged drawing may then be made on sectional paper, two squares of this being given to each line for every single square occupied by the corresponding line on the small-scale drawing. Or sectional papers of different scales may be used, say, $\frac{1}{8}$-inch for the smaller drawing, and $\frac{1}{4}$-inch for the other. The squares should be numbered horizontally and vertically on the tracing-

Fig. 241.—Sectional Paper with $\frac{1}{8}$-inch Squares, showing its use for enlarging or reducing a Drawing

paper, and corresponding numbers should be marked on the sectional paper as shown in the illustration; in the case of large drawings it will be sufficient to number only the strongly-marked squares.

Tracing-paper is a special kind of transparent paper with a hard surface capable of receiving ink and colour with considerable freedom. It is largely used by architects for making copies of detail drawings for builders. The operation is simple. The tracing-paper is pinned down over the drawing to be copied, and as this is clearly visible through the paper, the lines can be "traced" in ink with great facility. The surface of the paper should be dull, as the smooth, glossy paper takes colour very badly. Tracings are very convenient, but are not durable; the paper cracks along the seams where it has been folded, and becomes very brittle with age. They can of course be preserved by mounting them on linen, or on good cartridge-paper; but this is apt to cause them to shrink a little, and thus render scaled measurements slightly inaccurate.

Tracing-cloth, on account of its durability, is now largely used instead of tracing-paper. The best kinds are now made as transparent as paper, and at very little extra cost if "fents"—*i.e.* short lengths—are bought. Tracing-cloth is usually made with a dull side and a glossy side, either of which may be used for drawing upon, according to the predilection of the draughtsman. A common plan is to rule the ink lines on the glossy side and to lay the colours on the dull side, as there is then no danger of the ink "running" by laying the colour over it. Work will be more easily and quickly done if the cloth is first rubbed all over with soft india-rubber or with finely-powdered French chalk. Colour will run more evenly if mixed with a little ox-gall, or, if this is not handy, soap may be used as an inferior substitute. Erasures can be made with a sharp pen-knife, if the tracing is on the smooth side of the paper, or the faulty lines can be washed out with a brush and a little water.

The Reproduction of Drawings.—Many architects and engineers now have their drawings reproduced by a kind of photography. Where several copies are required, this method has great advantages. All the copies are exactly alike, and they are made with much less labour than a number of tracings. A tracing is made in the first instance, but this

can be done from a pencil-drawing, so that it takes no more time than inking-in the drawing. The tracing is then laid in a frame over a prepared sheet of paper, and covered with a sheet of glass, and exposed to the sun. The old cyanotype or blue-print process, discovered by Sir J. F. W. Herschel in 1842, requires an exposure of about ten minutes in a very bright light, and the print must then be washed in water. This process gives white lines on a blue ground, and is only suitable for details; ordinary water-colours cannot be used on the prints, but coloured chalks are sometimes employed on the sectional parts. The ferro-gallic paper gives black lines on a white ground, and is much more suitable for architectural drawings, as water-colours can be used in the ordinary way. The Pellet process produces blue lines on a white ground, and the Marronia brown lines. The Kallitype process gives black lines on a white ground, but the developer required is a complex mixture. As a rule, the architect sends the tracing to a firm of architectural stationers, and instructs them to prepare the prints, but complete instructions can be obtained from the manufacturers of the various papers and chemicals.

Chinese ink, or *Indian ink*, is sold in "sticks" of various sizes. Only the best should be used, as inferior ink is gritty, and consequently does not work freely. To prepare liquid ink for use, it is merely necessary to rub the stick in a small saucer in which the requisite quantity of water has been placed, until the desired shade is obtained. If the liquid ink is required immediately, the stick may be warmed a little at the fire or gas, but this should not become a regular practice, as it injures the stick. The saucer containing the ink should always be covered to prevent rapid evaporation and the access of dust, and should be cleaned after use, as old ink rubbed up again "runs" when the drawing is coloured.

If it is found that the ink rubbed from a particular stick has a tendency to "run", a very minute quantity of bichromate of potash mixed with it will rectify the defect; too much bichromate is, to use a homely phrase, merely jumping from the frying-pan into the fire, for this will then "run" when coloured, and make yellowish-brown stains along the edges of the lines.

Liquid Indian ink in bottles can be obtained, and is at any rate convenient, but it is not so economical or so generally satisfactory as the other. With some kinds of liquid ink it is impossible to rule a fine line on tracing-paper.

"*Indelible*" *inks*—brown, &c.—can also be bought, and are by some preferred to Indian ink, as they work more freely.

The *colours* used for architectural drawings are of course water-colours, and the most convenient dry form is the hexagon stick. Liquid colours can be obtained, but are not so economical. "Moist" colours are not well adapted for the architect. There is no hard-and-fast rule as to the colours to be employed to represent different materials. Speaking generally, some attempt is made to imitate the colour of the material represented, but this is not always the case. The table on page 219 gives a list of the colours which may be used for the principal materials; the column headed "Sectional Parts" applies both to horizontal and vertical sectional parts, for example, to the sections of walls both in "Plans" and "Sections".

Pale green can be obtained by mixing gamboge and Prussian blue, dark green by a mixture of sepia and Prussian blue or burnt sienna and indigo, and purple by a mixture of crimson lake and Prussian blue. Slates should be coloured according to the kind used, red, purple, gray, or green.

Saucers and palettes in which to mix the colours can be obtained in a great variety of shapes and sizes.

Brushes are made of sable (brown or red) and camel-hair, the latter being cheaper but far inferior. The hairs forming the brush are fitted into either a quill or an albata (white metal) ferrule, to which a wood handle is attached. If the point of a moderate-

sized sable brush is worn away, or if the brush is damaged by being trodden on or in some other way, it will pay to send it to be re-set.

SUGGESTED COLOURS

Materials.	Plan.	Elevation.	Sectional Parts.
Brickwork	Indian Red (pale)	Indian Red (pale)	Indian Red (dark).
Stonework	Indigo (pale)	Yellow Ochre	Sepia.
Concrete	Pale Green	Pale Green	Dark Green.
Iron and Steel	Prussian Blue (pale)	Prussian Blue (pale)	Prussian Blue (dark).
Tiles (floor, wall, and roof)	Crimson or Scarlet Lake (pale)	Crimson or Scarlet Lake (pale)	Crimson or Scarlet Lake (dark).
Wood (deal, &c.)	Yellow Ochre	Burnt Sienna (pale)	Burnt Sienna (dark).
Wood (hardwood)	Burnt Sienna	Burnt Sienna (medium)	Burnt Sienna (dark).
Old Work	Neutral Tint (pale)	Neutral Tint (pale)	Neutral Tint (dark).
Glass	Green	Green	Green.
Plaster		Purple (pale)	Purple (dark).
Brass	Gamboge	Gamboge	Gamboge (dark).

CHAPTER IV

HINTS ON DRAWING

The paper should be selected according to the nature of the drawing to be made. For a drawing which will be in use for a long time, the best hand-made drawing-paper should be used, and if this is mounted on union or brown holland so much the better. For ordinary detail-drawings cartridge-paper is good enough, while for full-size details, such as sections of moulds, an inferior kind of cartridge-paper may be used. Then again, the surface of the paper must be considered. For a drawing containing much fine work in line the smooth "hot-pressed" surface is the most suitable, but for coloured drawings the "natural" and "rough" surfaces are better, as the ink lines are not so apt to "run" as on the smooth paper, and the colour works more freely.

The paper may be fixed to the board by gluing or pasting around the edges, or by pins. The former method gives a tighter and therefore better surface for working on; but as the paper is very tightly stretched in consequence of the preliminary damping, there is a possibility of shrinkage after the drawing is cut off. This shrinkage renders scaled measurements somewhat inexact, but little or no inconvenience will result if the dimensions of all the parts are carefully figured on the drawing. It is a disadvantage of the paste and glue methods of fixing that they require so many drawing-boards, as each drawing should remain attached until it is quite finished. When pins are used, it is an easy matter to remove one drawing when the pencilling is complete, and fix another in its place. For small drawings, and for ordinary detail-drawings, pins are almost invariably used.

The stock of the T-square should work only along the left-hand edge of the board. All vertical lines, except perhaps border-lines, should be drawn by means of set-squares. Pupils usually commence by attempting to use

Fig. 242.—Drawing-board, T-square, and Set-square

the right-hand side of the set-square, and this method is preferred by many draughtsmen, although it is not by any means as convenient for vertical lines as the left-hand edge, unless the light happens to be to the right of the draughtsman. Fig. 242 shows the T-square and set-square in their correct position for drawing vertical lines; the left fore-arm rests on

the T-square and keeps it firmly in its place, while the fingers of the left hand press on the set-square and move it to and fro as required; the right hand holds the pencil or drawing-pen.

In pencilling a drawing, care should be taken not to "dig" into the paper, and on the other hand not to make the lines so faint that they will be obliterated. The pencil must be of that degree of hardness which is most suited to the individual draughtsman's "touch". H H and H H H pencils are the most generally used, but the degrees of hardness of pencils having the same designation vary with different makers; some H H pencils are as hard as other makers' pencils marked H H H. The H H "Koh-i-noor" pencil is among the best. It is very desirable that the pencils in compasses should not be too hard, as pressure in drawing a circle inevitably entails pressure on the centre and consequent risk of making a larger hole than would otherwise be the case. Horn centres can of course be obtained for preventing the disfigurement of the drawing by centre-holes, but it is not every draughtsman who will take the trouble to use them. The greatest possible care should be observed in fixing the centres of circles and circular arcs: one wrong centre may throw the whole of a piece of tracery wrong.

In preparing a drawing many temporary lines must be drawn in pencil for the mere purpose of guidance in drawing other lines, as, for example, the line at the springing of a series of arches to receive the centres from which the arches are struck; or pencil lines must be drawn of greater length than the ink lines of the finished drawing; or continuous pencil lines must be drawn to include a number of separate features which are in the same straight line, as, for example, a range of window sills or heads. Such temporary lines are known as "construction-lines" or "service-lines", and should be faintly drawn so that they can be thoroughly removed with india-rubber. Other most important service-lines are the centre-lines of symmetrical buildings or features, such as of towers and spires, columns, arches, doorways, roofs.

In his early drawings the young draughtsman will find it best to draw in pencil every line which has to appear in ink in the finished drawing, but after some practice he will be able to rule many of the lines in ink without previous pencilling; thus—to give an easy example—the horizontal service-lines for the heads and sills of a series of plain windows must be drawn in pencil, but the position of the vertical lines may be marked from the scale with simple ticks, and ruled directly in ink. This method, of course, requires practice and care, and usually necessitates a little scratching out, for which a *very* sharp knife is essential. The surface of paper damaged by scratching out can be restored to some extent by means of French chalk and alum. With a little practice ink lines can be removed by means of a little india-rubber after the lines have been damped with a moistened brush.

It is a great mistake to commence "inking-in" one drawing of a set before the others are well advanced. A plan, for example, may appear quite satisfactory, but it will almost invariably be found that alterations are necessary when the elevations and sections have been drawn. Similarly a large-scale drawing of details should not be inked until the full-size moulds have been designed. If one drawing has been inked, the draughtsman may be tempted to make the others tally with it rather than take the trouble to alter it, even though alteration would be an improvement. This is often a strong temptation, but it is a temptation which should always be resisted by remembering that it is easier to make alterations and improvements in a drawing than in a building. No trouble in the preparation of drawings should be considered too great if it results in the building or feature or piece of furniture being more beautiful or better adapted to its purpose.

Incorrect pencil lines are usually removed by india-rubber. This should be soft, free from all trace of grit, and quite colourless. Service-lines may be faintly scribbled through, so that they may not be inked-in by mistake.

Incorrect pencil lines may often be conveniently treated in the same way, as too frequent application of the india-rubber spoils the surface of the paper.

Circles and circular arcs should generally be inked-in before straight lines, as the latter can be more readily drawn to join the former, than the former to join the latter. When a number of circles are to be described from one centre, the smaller should be inked first, while the centre is in better condition. All straight lines, except the very shortest (say, those less than a sixteenth of an inch), should be ruled with the drawing-pen and not drawn by hand. Care should be taken that the lines stop exactly at the proper place, and do not run beyond or fall short.

Working-drawings should above everything be clear and accurate. An artistic feeling may be given to them, but this should always be a secondary consideration. What is required is an artistic structure, not necessarily an artistic drawing, and that working-drawing is the best which best enables the builder or cabinet-maker to carry out the designer's intentions. Such a drawing or set of drawings will be clear, accurate, and complete: unnecessary lines will be avoided; all important dimensions will be clearly figured in feet and inches; no difficulty will be shirked, nothing left to chance. The labour involved in preparing such drawings is well spent; it saves the builder's time, and also the architect's time during the progress of the building, and prevents many mistakes which would otherwise be made in the execution of the work.

The lettering of drawings requires much practice. Nearly every draughtsman has certain mannerisms of his own, but it is a great mistake to allow these mannerisms to run riot in such a way that the lettering becomes almost illegible. Quaintness and obscurity are not necessarily marks of cleverness. One of the chief points to be attended to is the absolute verticality of all letters intended to be vertical. Large letters may be ruled with the drawing-pen, and small set-squares can be bought for the purpose, containing the different slopes required for the inclined strokes of the letters A, K, M, N, V, W, X, Y, and Z.

Soft india-rubber may be used for cleaning drawings. Bread, two or three days old, is very useful for cleaning dirty drawings, but is not equal to india-rubber for removing pencil marks.

Washes of colour should be laid on freely with a somewhat large brush, commencing at the top left-hand corner and working down to the bottom right-hand corner; superfluous colour can be removed with a squeezed-out brush. The remarks already made about inking-in a drawing apply in great measure to the colouring. If the colouring tends to confusion, it is better omitted. In a working-drawing, colour should merely differentiate the parts; it should not aim at the production of a pretty picture. Washes are much more easily and evenly made if the paper has first been washed over with water. In colouring tracings, it is necessary to mix a little ox-gall with the colour; as already stated, soap may be used as an inferior substitute if there is no ox-gall at hand.

CHAPTER V

TAKING MEASUREMENTS AND PLOTTING THEM

It would be out of place to consider in this work the subject of surveying, but some hints on measuring buildings will be useful. Speaking broadly, plan-measurements (as distinguished from elevation-measurements) should always be taken in triangles; thus, in measuring a four-sided room the dimensions of the four sides and of at least one diagonal should be taken, otherwise the measurements cannot be exactly "plotted", *i.e.* laid down to scale on the drawing. If only the dimensions of the sides are taken, the accuracy of the

plan cannot be assured. Fig. 243 shows three trapeziums, all having the corresponding sides of the same dimensions, but the trapeziums are all different. Indeed an infinite number of trapeziums can be drawn with the same lengths of sides. If, however, the length

Fig. 243.—Different Trapeziums with the corresponding Sides of the same length

of one diagonal is measured, dividing the trapezium into two triangles, only one trapezium can be drawn which will agree with all the measurements. This is shown in fig. 244.

The importance of the diagonal measurement will be better understood by an object lesson. Make a four-sided figure by means of four narrow strips of paper, cardboard, or wood, secured together by ordinary pins passing vertically through the strips where they meet at the corners of the figure. It will be found that the pins act as pivots, and that the

Fig. 244.—The use of the Diagonal in plotting Measurements

shape of the figure can be altered in innumerable ways without removing any of the pins. Then take another strip, and pin it to opposite corners of the figure so as to form a diagonal. This will at once render the figure rigid, although the pins are still as loose as before.

Although one diagonal is really sufficient, it is always safer to measure both diagonals, as the second diagonal acts as a check on the whole of the measurements. Errors are sometimes made either by careless reading of the tape, or by a mistake in counting the number of 2-foot lengths (if the measurement is taken by rule), or by mishearing the measurement called out by an assistant, and such an error cannot always be detected unless "check" measurements have been taken. Suppose the measurements of an irregular four-sided room have been taken as follows: A B, 12 feet; B C, 10 feet 8 inches; C D, 14 feet; D A, 10 feet; diagonal B D, 15 feet 10 inches. These measurements can be plotted as shown in fig. 244, without any appearance of error. But suppose that the other diagonal, A C, measures 18

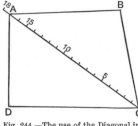

Fig. 245.—One Diagonal and two Check-lines

feet, and is laid down on the drawing as shown by the dotted line, it will be found that it does not "fit", and—if the plotting is correct—the only possible conclusion is, that an error has been made in taking one or more of the measurements.

But the employment of two diagonal measurements can only disclose the fact that an error has been made; it does not locate the error. To do this, it is necessary to proceed somewhat differently. One way is to mark a certain distance on the line of one diagonal, as at E in fig. 245, and from this point to measure check-lines to the remaining angles A and C.

To plot the measurements, an indefinite line is first drawn, and on it the length of the diagonal D B is marked to the required scale. Take, in the compasses, the length of the side D C (to the same scale), and with the centre D describe an arc of a circle; in the same manner, from the centre B, with the length B C, describe another arc cutting the former in C; and from E describe a third arc with the length E C. If this third arc crosses the other two exactly in the same point C, this part of the trapezium is correct. Then proceed with the other part in the same way. If the three arcs do not meet in the same point A, there must be an error in one of the three lines A B, A D, or A E, and it will be necessary to have the dimensions of at least two of these (say A B and A D) taken again.

Another method, which locates the error still more nearly, consists in measuring the two diagonals, and recording the distance of their intersection from the ends of each diagonal, as shown in fig. 246. The additional check afforded by this method lies in the fact that the two check-lines, A E and E C, are in the same straight line, and it will be found that by this method the erroneous dimension can be discovered and the drawing correctly made without having to take the measurement again.

Fig. 246.—Two Diagonals with the Point of Intersection fixed

It may be thought that such carefulness of measurement is unnecessary, particularly in the case of rooms which are apparently rectangular. Experience shows, however, that the regularity is often more apparent than real. In old buildings especially the irregularity of apparently regular rooms is so common a feature that it ought always to be assumed notwithstanding the evidence of the eyes. And in the case of polygonal rooms careful measurement is still more necessary. Even in details, such as octagonal capitals, the sides are seldom alike.

To measure a polygonal room requires only an extension of the principles already laid down. Each side should be carefully measured, and a convenient point near the centre of the room may then be marked on the floor, and measurements taken from it to each angle. To plot these measurements it is best to proceed by laying down the longest line first, as A B in fig. 247; then, from A with the length of A G, describe an arc, and from B with the length of B G, describe another arc cutting the former in G. This gives the central point marked on the floor of the room. From G with the length of G C, describe an arc, and from B with the length of B C, describe another arc cutting the former in C; join B C, and this gives the second side of the polygon. Proceed in a similar way for the sides C D, A F, and F E. Then join E D, and if the length of this tallies with the measurement, the plan is correct. This method, although

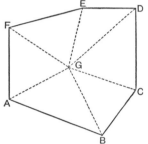

Fig. 247.—To measure an irregular Polygon—*First Method*

perhaps the most obvious, is not by any means the best, as the slightest error in laying down the first triangle A G B is increased in the remaining triangles.

A better method is to take a measurement between any two opposite corners, as A D in fig. 248, and from some recorded point, G, in this line to take measurements to the remaining angles, and proceed as before. In plotting the measurements taken in this way, the diagonal A D must first be laid down, and the point G marked on it to scale.

A third method is shown in fig. 249. The distance between any two opposite angles, as A E, is measured, and with this as a base other measurements are taken to divide the polygon into a number of triangles, as A B E, A C E, and A D E on the one side, and A G E and A F E on the other. The length of each side must also be taken. The diagonal A E is first drawn. Then from A

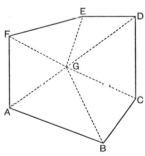

Fig. 248.—To measure an irregular Polygon—*Second Method*

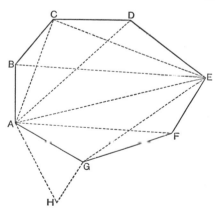

Fig. 249.—To measure an irregular Polygon—*Third Method*

with the length of A B, describe an arc, and from E with the length of E B, describe another arc cutting the former in B; join A B. Find E D in a similar way. Then find the point C, and if the distances B C and C D on the drawing tally with the measured lengths of these sides, this part of the polygon is evidently correct. The other part must be laid down in a similar way, the side F G acting as a check, just as B C and C D served as checks in the first part.

Rooms with one or more re-entrant angles, such as G H A B C D E F in fig. 249, can usually be measured from one base or diagonal. In this figure the diagonal G D might be taken as the base, and measurements taken from both extremities to each angle. Another method would be to measure the triangle A G H separately, and to treat the remainder of the room as shown.

Curved figures are more difficult to measure, but the principles already laid down can be applied to them. Thus in fig. 250 measure any convenient axis A B, and carefully mark the points A and B on the floor or walls. Then mark on the floor or walls any suitable number of points along the curve as C, D, E, F, and G, taking care to introduce a sufficient number in the quicker parts of the curve. Measure A C and C B, A D and D B,

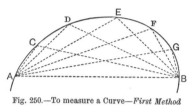

Fig. 250.—To measure a Curve—*First Method*

&c. When these measurements have been plotted, a series of points will have been laid down —namely, A, C, D, E, &c.—through which the curve passes, and the curve can then be drawn through these points by compasses or by

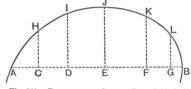

Fig. 251.—To measure a Curve—*Second Method*

hand. If the distances between the points, as A to C, C to D, &c., are also taken in straight lines (not along the curve), they will serve as checks on the other measurements and on the plotting.

Another method is shown in fig. 251. Any convenient axis A B is taken, and perpendiculars, known as "offsets", are measured from recorded points in it to the curve, as C H, D I, E J, &c. This method is the one adopted by surveyors, and the practised eye can lay the tape at right angles to the chain with sufficient accuracy for ordinary work, but where an absolutely accurate drawing to a large scale is required, the method cannot be recommended, as it necessitates the use of a square for setting-up the perpendiculars. Either of the methods shown in figs. 250 and 251 can be employed for ascertaining the curves of arches and vaults. If the second is adopted, a string or rod will be fixed horizontally at the springing or top of the capitals, and a plumb-line let down from different points in the curve. The vertical and horizontal measurements in each case will be recorded, as A C and H C, A D and I D, A E and J E, &c.

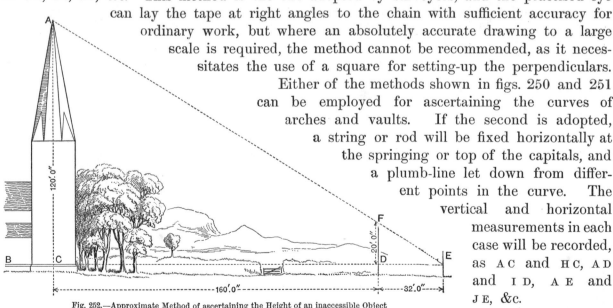

Fig. 252.—Approximate Method of ascertaining the Height of an inaccessible Object

The measurement of elevations often presents difficulties of a different character. These are usually difficulties of access, but ladders and long rods will generally overcome them. Inaccessible objects, such as lofty spires, can be measured by the theodolite, and in other ways. One method, which, however, can only be regarded as approximate, is illustrated in fig. 252. A ranging-pole or stake is fixed at any point E; the farther it is from the spire the better. On this pole or stake a pin must be fixed horizontally at the level of some horizontal member of the tower, say the top of the base. For a rough measurement, this can be done by "sighting" along the base, but for more accurate work the height at E should be obtained by levelling. At any convenient point between E and the spire—but the farther from E the better—another rod must be fixed absolutely vertical,

and on it a mark must be made or a pin inserted at D level with the base of the tower and with the pin at E. The chief then stands at E, with his eye near the pin, and looks towards A; an assistant raises a boning-rod (a sort of T-square), or any other rod, by the side of D F (taking care to keep it exactly vertical), until the top of it exactly coincides with the line of sight from E to A. If this rod extends below the point D, it must be marked exactly opposite that point, and the distance from this mark to the top of the rod gives the height D F. If the rod is too short to reach to D, a mark must be made on D F exactly opposite the end of the rod; and the measurement from this mark to D, added to the length of the rod, gives the required height D F. The distances from E to D, and from D to the *centre* of the spire or tower, must then be measured.

To plot these measurements the base-line B E must first be drawn, and the points C, D, and E marked on it. A perpendicular of the recorded length is set up at D, *i.e.* D F, and another perpendicular at C; then join E F, and produce the line till it cuts C A at A. C A is the height of the apex A above the base B C, and the measurement may either be read from the drawing by scale, or may be found by a simple rule-of-three sum, thus: D E : D F :: C E : C A.

The theodolite is necessary if an accurate measurement is desired. It would lead us too far afield to describe this instrument. Suffice it to say that it should be set up at any convenient point as E, and a horizontal sight taken to any point on the tower. From this point a measurement must be taken up or down, as the case may be, to the base or ground-line. The telescope is then partly revolved vertically, till a sight taken through it exactly coincides with the point A. A dial like a protractor forms part of the instrument, and allows the operator to read the number of degrees in the angle E A C. The distance from C to E must of course be measured. In plotting, the horizontal line C E must first be drawn of the proper length, and at the point E the recorded angle must be laid down by means of a protractor. Produce the hypotenuse thus obtained until it meets the perpendicular from C in the point A. The height can be read from the drawing by means of a scale, or can be calculated by trigonometry.

CHAPTER VI

THE CARPENTER AND JOINER'S DRAWING-INSTRUMENTS

The drawing-instruments required in the workshop are stronger and larger than those used in the drawing-office. The drawings are usually done "full-size", and a piece of planed board often serves instead of paper. Trammel points attached to a rule or lath are often used instead of compasses. Fig. 253 shows a set of Stanley's trammel points for attaching to an ordinary rule; the set consists of two brass trammel heads with movable steel points, and one head with a socket for pencil. The trammel heads shown in fig. 254 are attached to one side of any straight lath, and are easily adjusted.

Fig. 253.—Stanley's Trammel Points

The pencil-socket A is arranged to receive a round or oval pencil, which is kept in position by the set-screw.

The "rule" takes the place of the architect's scale, and is used not only for taking dimensions but also for "scaling" measurements from drawings. The ordinary pocket-rule is 2 feet long, and is made either "twofold" or "fourfold". A fourfold 2-foot rule is shown in fig. 255. On one side the outer edge of the rule is divided into inches and

sixteenths; on the other side the outer edge is divided into inches and eighths, and one-half of the inner edge into inches and twelfths and the other half into inches and tenths. Some joiners prefer the fourfold 3-foot rule, as this allows long measurements to be taken more quickly and accurately. "Bench" rules are generally from 3 feet to 6 feet in length, and are not jointed.

Rules are usually made of boxwood, with brass joints and ends, but ivory, brass, iron, and steel are sometimes used instead of wood. Metal rules are more durable, but have the great disadvantage of being somewhat difficult to read.

The carpenter's slide-rule is in general appearance similar to the ordinary twofold rule, but has in addition a brass slide let into one half, and is marked with numerous lines and figures, by which calculations can be made, including multiplication, division, proportion, superficial and cubic measurements, &c.

Fig. 255.—Fourfold 2-foot Rule

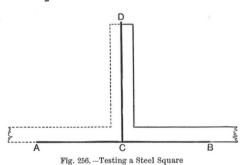

Fig. 254.—Special Trammel Points

Full information is given in a small pamphlet published by John Rabone & Sons, the well-known rule-makers.

The "steel square" is a most important drawing-instrument. It combines the advantages of a T-square or set-square and of a rule, and has a very wide practical application. The blade should be 24 inches long and 2 inches wide, and the tongue 14 or 18 inches long and 1½ inch wide. The blade and tongue should be *exactly* at right angles with each other, along both the inner and outer edges. This can easily be tested by using the blade of the square as a straight-edge and ruling (on a piece of planed board) a straight line A B, say 24 inches long; then, from a point about midway along this line draw a line C D perpendicular to it by means of the square, placed as shown by the dotted lines in fig. 256. Reverse the square as shown by the full lines, and if the tongue coincides exactly with C D while the blade coincides with A B, the outer angle of the square is correct. Lay the inner edges of the tongue and blade on A C and C D, or on B C and C D, and if they coincide, the inner edges also are perfectly true. Then try the inner edge of the blade and the outer edge of the tongue in a similar manner.

Fig. 256.—Testing a Steel Square

The face side of a steel square is shown in fig. 257, about one-fourth the actual size. The inner edge is divided into inches and quarters (or, better, eighths), and the outer into inches and sixteenths. Many geometrical problems can be solved by means of these divisions of the square; the most important will be found described in Section V, "Practical Geometry", Problems XVII, XVIII, LIII, LVII, LXII, LXIII, LXIV, and LXXXVII.

These do not by any means exhaust the uses of the square. By the help of the patent stair-gauge, the square can be utilized for setting out, on the string-boards, the treads and risers of stairs, as shown in fig. 258. The gauge is a steel angle ⅞ inch by ⅝ inch by ⅛ inch thick, and 18 or 28 inches long, and is grooved along one face to allow the set-screws to slide to and fro. In using the gauge it is set on the tongue of the square to the height of the riser, and on the blade to the width of the tread. If the side of the gauge is then laid along the edge of the string-board, lines ruled along the edges of

the square will give a tread and riser; run the gauge along the string-board until the angular point formed by the blade and gauge coincides with the top of the riser-line already

Fig. 257.—Face of the Steel Square

drawn, and rule lines as before; these give the second tread and riser. Repeat the operation for each step in succession.

Instead of the patent gauge, a piece of close-grained hardwood may be used about 2 inches wide and $1\frac{5}{8}$ inch thick, with a saw-cut $\frac{1}{8}$ inch wide (i.e. equal to the thickness of the square) cut from each end exactly along the central line, and leaving about 10 inches of solid wood in the middle, as shown in fig. 259. The groove at one end of the gauge is fitted to the blade of the square, and that at the other end to the tongue, in the required positions, and the gauge is secured by means of $1\frac{1}{2}$-inch screws or by small bolts and nuts.

The gauge can also be used for marking out the sinkings in rafters to receive collars or braces. Suppose that the roof is two-thirds pitch, that is to say, that the height of the roof is one-third of the span or two-thirds of the half-span or horizontal projection of the rafter. Set the gauge to (say) 15 on the blade, and 10 (i.e. $\frac{2}{3}$ of 15) on the tongue; run the gauge along the top of the rafter (fig. 260) to the required point, and a line drawn along the blade of the square will give the horizontal line required for the collar. In the same way the horizontal line at the foot of the rafter can be found. If the gauge is run to the upper end of the rafter, a line drawn along the tongue will give the vertical line at the ridge.

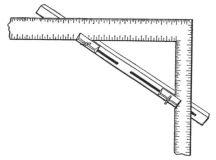

A similar procedure can be adopted for finding, in principal rafters, the cuts required for vertical ribs or purlins, and for horizontal tie-beams and collar-beams. With a little thought, the workman will be able to apply the square and gauge to the solution of many other problems. Some of the more difficult of these will, however, be considered in subsequent sections.

Fig. 258.—Patent Stair-gauge and Steel Square

The back of a steel square may be divided similarly to the face, but other lines are sometimes added to facilitate the solution of other problems which confront the carpenter and joiner. Fig. 261 shows the back of what is known as the "No. 100" steel square. The edges are divided in the same manner as those on the face. A diagonal scale is introduced on the tongue close to its junction with the blade, but as the use of this has already been explained (page 210), nothing need be said here. Along the centre of the

Fig. 259.—Wood Gauge or Fence

tongue the lengths of "braces" are given for different lengths of "run"; the two figures immediately over each other represent the run, and the figures to the right give the length of brace for the run. The figures on this square apply only to right-angled triangles, in which the sides enclosing the right angle are equal to each other. Thus, if the sides enclosing a right angle are each 24 inches long, the hypotenuse or third side will

measure 33·94 inches. Similarly the diagonal of a square whose sides measure 24 inches will be 33·94 inches, and that of one whose sides measure 33 inches will be 46·67 inches. On the blade lines and figures are marked by which superficial measurements can be calculated. Thus if we have a board 13 feet long and 9 inches wide, to find the superficial measurement

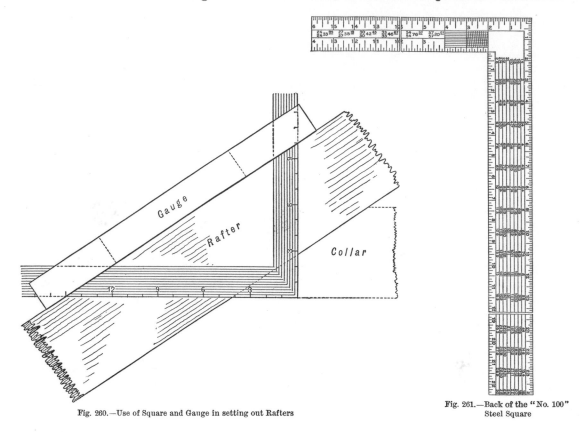

Fig. 260.—Use of Square and Gauge in setting out Rafters

Fig. 261.—Back of the "No. 100" Steel Square

it is simply necessary to find 13 in the column under 12 (the number of inches in a foot) and follow the space in which this figure 13 occurs, horizontally, to the column under 9 inches (the width of the board); the superficial measurement is there found to be 9 feet 9 inches. If the board is 2 inches thick, this measurement must be multiplied by 2 to obtain the "board measure".

Other appliances which partake of the nature of drawing-instruments are bevels and marking gauges, but the uses of these are too well-known to need description.

SECTION V
PRACTICAL GEOMETRY

BY

THE EDITOR

PLATE XX

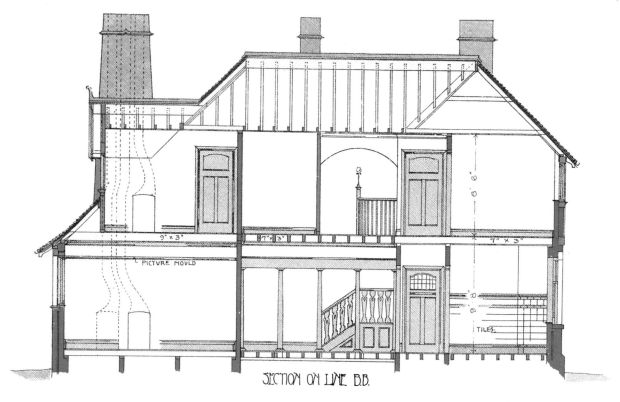

SECTION ON LINE B.B.

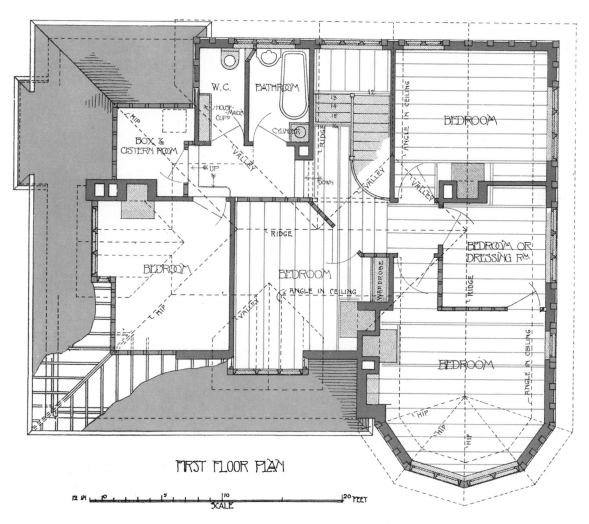

FIRST FLOOR PLAN

FIRST-FLOOR PLAN AND SECTION OF SMALL COUNTRY HOUSE

PLATE XX

The lower illustration is the first-floor plan of the house, of which the ground-plan was given in Plate XIX. The floors of the bath-room, W.C., and adjacent passage are two steps below the remainder of the floor in order to obtain sufficient height for the W.C. (see North-west Elevation, Plate XXIII). The wood partitions (or studding) are shaded brown. The floor-joists are shown by single brown lines, and the trimmers and trimming-joists by double lines. The main lines of the roof are shown by dotted black lines.

The upper illustration is a section on the line B B, marked on the ground-plan, Plate XIX. The section is made through the drawing-room, hall, and cloak-room on the ground floor, and through two bed-rooms, landing, and dressing-room on the first floor. The general construction of the roof and dormers will be understood from this section and that given in Plate XIX.

Section V
PRACTICAL GEOMETRY

CHAPTER I

INTRODUCTORY

Geometry is that branch of mathematical science which treats of the properties and relations of extended things; that is, of lines, surfaces, and solids.

Plane Geometry deals only with plane figures, *i.e.* surfaces having only length and breadth.

Solid Geometry deals with solids, *i.e.* bodies having length, breadth, and thickness.

Practical Geometry, as the term implies, is the application of geometry to practical purposes.

The problems in *Practical Geometry* can be theoretically demonstrated, but this implies such a knowledge of theoretical geometry as the ordinary practical man can scarcely be expected to possess. What the practical man requires is the ability to draw accurately certain figures which meet him in his business; the theoretical demonstration of the accuracy of his draughtsmanship may be interesting, but it is not absolutely necessary. Moreover, the theoretical part of the work is much more difficult than the practical, and tends to confuse the young student rather than assist him. For this and other reasons, theoretical demonstrations of the problems in practical geometry will not be given in this treatise.

In practical geometry certain appliances are assumed, namely, a ruler or straight-edge, by the help of which straight lines can be drawn, and a pair of compasses for drawing circles. But there is absolutely no valid reason why the possession of other common drawing-implements should not also be assumed—for example, squares, by means of which lines can be drawn perpendicular to a given line, or parallel to each other, and scales or rulers, by which distances can be measured. A knowledge of elementary arithmetic, by which distances measured by the scale or ruler can be halved or doubled, or diminished or increased in other simpler ratios, may also be assumed. If we grant these assumptions, many of the problems of practical geometry need not be considered, and the student's time will be to that extent economized. I propose, therefore, to omit much that is usually found in works on practical geometry. A

few simple problems will, however, be given, in order to pave the way for the more difficult parts of the subject. In the earlier examples, for the sake of clearness, the given lines are drawn full, the service-lines are dotted, and the required lines are shown full and thick.

Before proceeding farther it is necessary to consider the most important terms employed in geometry.

1. A *Point* has position but not magnitude. Practically it is represented by the smallest visible mark or dot, but, geometrically understood, it occupies no space. The extremities or ends of lines are points; and when two or more lines cross one another the places that mark their intersections are also points.

2. A *Line* has length, without breadth or thickness, and, consequently, a true geometrical line cannot be exhibited; for however finely a line may be drawn, it will always occupy a certain extent of space.

3. A *Superficies* or *Surface* has length and breadth, but no thickness. For instance, a shadow gives a very good representation of a superficies; its length and breadth can be measured, but it has no depth or substance. The quantity of space contained in any plane surface is called its *area*.

4. A *Plane Superficies* is a flat surface which will coincide with a straight line in every direction.

5. A *Curved Superficies* is an uneven surface, or such as will not coincide with a straight line in any direction.

Note.—By the term "surface" is generally understood the outside of any body or object, the boundaries of which are pictorially represented by lines, either straight or curved, according to the form of the object.

6. A *Solid* is anything which has length, breadth, and thickness.

7. *Lines* may be drawn in any direction, and are termed straight, curved, mixed, concave, or convex lines, according as they correspond to the following definitions:—

A *Straight Line* is one that lies in the same

direction between its extremities, and is, of course, the shortest distance between two points.

A *Curved Line* is such that it does not lie in a straight direction between its extremities, but is continually changing by inflection. It may be either regular, as A, or irregular, as B (fig. 262).

A *Mixed* or *Compound Line* is composed of straight and curved lines, connected in any form, as A (fig. 263).

Fig. 262 Fig. 263

A *Concave* or *Convex Line* (fig. 264) is such that it cannot be cut by a straight line in more than two points; the concave or hollow side in the figure is turned towards the straight line, while the convex or swelling side looks away from it. For instance,

Fig. 264 Fig. 265 Fig. 266

the inside of a basin is concave, the outside of a ball is convex.

8. *Parallel Straight Lines* are everywhere at an equal distance from each other; consequently they can never meet, though produced or continued to infinity in either or both directions. Parallel lines may be either straight or curved (fig. 265), provided they are equally distant from each other throughout their extension.

9. *Oblique* or *Converging Lines* (fig. 266) are straight lines, which, if continued, being in the same plane, change their distance so as to meet or intersect each other.

10. A *Plane Figure, Scheme, or Diagram*, is the lineal representation of any object on a plane surface. If it is bounded by straight lines, it is called a rectilineal figure; and if by curved lines, a curvilineal figure.

11. An *Angle* is formed by the inclination of two lines meeting in a point: the lines thus forming the angle are called the sides; and the point where the lines meet is called the *vertex* or *angular point*.

Note.—When an angle is expressed by three letters, as A B C, fig. 267, the middle letter B should always denote the angular point; where there is only one angle it may be expressed more concisely by a letter placed at the angular point only, as the angle at B. The quantity of an angle is estimated by the arc of any circle contained between the two sides or lines forming the angle; the junction of the two lines, or vertex of the angle, being the centre from which the arc is described.

Fig. 267

The circumference of every circle is divided by mathematicians into 360 equal parts, called degrees (°); each degree being again subdivided into 60 equal parts, called minutes ('), and each minute into 60 equal parts, called seconds ("). Hence it follows that

the arc of a quarter circle or quadrant includes 90 degrees, that is, one-fourth part of 360 degrees. By dividing a quarter circle, that is, the portion of the circumference of any circle contained between two radii forming a right angle, into 90 equal parts, or, as shown in fig. 268, into 9 equal parts of 10 degrees each, then drawing straight lines from the centre through each point of division in the arc, the right angle will be divided into 9 equal angles, each containing 10 degrees. Thus, suppose B C the horizontal line, and A B the perpendicular ascending from it, any line drawn from B—the centre from

Fig. 268

which the arc is described—to any point in its circumference, determines the degree of inclination or angle formed between it and the horizontal line B C. Thus, a line from the centre B to the tenth degree, separates an angle of 10 degrees, and so on.

12. A *Right Angle* is produced either by one straight line standing upon another, so as to make the adjacent angles equal (fig. 269), or by the inter-

Fig. 269

Fig. 270

section of two straight lines, so as to make all the four angles equal to one another, fig. 270.

13. An *Acute Angle* is less than a right angle, or less than 90 degrees, as the angle A B C (fig. 271).

Fig. 271

Fig. 272

14. An *Obtuse Angle* is greater than a right angle, or more than 90 degrees, as C B E, fig. 271.

Note.—The number of degrees by which an acute angle is less than 90 degrees is called the complement of the angle. The difference between an obtuse angle and a straight line, or 180 degrees, is called the supplement of that angle. Thus, C B D is the complement of the acute angle A B C in fig. 271; and A B C is the supplement of the obtuse angle C B E.

15. *Plane Rectilineal Figures* are bounded by straight lines, and are named according to the number of sides or angles which they contain. Thus, the space included within three straight lines, and

forming three angles, is called a trilateral figure or triangle. *Similar* rectilinear figures are those which have the corresponding angles equal to one another; the sides of similar figures are proportional to one another, thus, in two similar triangles A and B (fig. 272), A 1 : B 1 :: A 2 : B 2 :: A 3 : B 3.

16. A *Right-Angled Triangle* has one right angle: the sides forming the right angle are called the base and perpendicular; and the side opposite the right angle is named the hypotenuse. Thus, in the right-angled triangle A B C (fig. 273), B C is the base, A B the perpendicular, and A C the hypotenuse. The hypotenuse, or longest side of a right-angled triangle, may also form the base or underline. In that case, the other two sides are called the legs of the triangle.

Fig. 273

Note.—In all right-angled triangles the square of the hypotenuse is equal to the sum of the squares of the other two sides; thus, $A c^2 = A B^2 + C B^2$. A triangle having the sides in the ratio of 3, 4, and 5 is a right-angled triangle, as $5^2 = 4^2 + 3^2$; with these dimensions a right angle can easily be constructed.

17. An *Equilateral Triangle* is one whose three sides are equal, as in fig. 274; the three angles are also equal, and as the angles of every triangle are

Fig. 274

Fig. 275

Fig. 276

together equal to two right angles (*i.e.* to 180°), the angles in an equilateral triangle are 60° each.

18. An *Isosceles Triangle* has only two sides equal, as fig. 275; the angles at the base are also equal.

19. A *Scalene Triangle* is one whose three sides are all unequal, as fig. 276; the angles also are all unequal.

20. An *Acute-Angled Triangle* has all its angles acute, as those in figs. 274 and 275.

21. An *Obtuse-Angled Triangle* has one of its angles obtuse, as in fig. 276. It is obvious from fig. 276 that a triangle cannot contain more than one obtuse angle.

22. *Quadrilateral Figures* are literally "four-sided" figures. They are also called quadrangles, because

Fig. 277

Fig. 278

they have four angles. The four angles are together equal to four right angles, *i.e.* to 360°.

23. A *Parallelogram* is a quadrilateral figure whose opposite sides are parallel, as A B C D, fig. 277.

24. A *Rectangle* is a parallelogram having four right angles, as A B C D, fig. 277.

25. A *Square* is an equilateral rectangle, *i.e.* a rectangle with equal sides, as fig. 278.

26. An *Oblong* is a rectangle whose adjacent sides are unequal, as the parallelogram A B C D, fig. 277.

27. A *Rhombus* is an oblique-angled parallelogram, having four equal sides, whose opposite angles only are equal, as fig. 279.

28. A *Rhomboid* is an oblique-angled parallelogram, of which the adjoining sides are unequal, as fig. 280.

Fig. 279

29. A *Trapezium* is an irregular quadrilateral figure, having no two sides parallel, as fig. 281.

30. A *Trapezion* or *Kite* is a quadrilateral figure, which is divided by one of its diagonals into two

Fig. 280

Fig 281

unequal isosceles triangles, as A B C D, fig. 282, which is divided by the diagonal B C into the two unequal isosceles triangles A B C and D B C.

31. A *Trapezoid* is a quadrilateral figure, which has two of its opposite sides parallel, and the remaining two neither parallel nor equal to one another, as fig. 283.

32. A *Diagonal* is a straight line drawn between two opposite angular points of a quadrilateral figure.

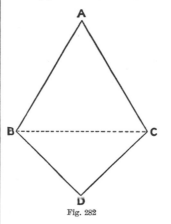
Fig. 282

Fig. 283

Fig. 284

Note.—If the figure is a parallelogram, the diagonal will divide it into two equal triangles, the opposite sides and angles of which will be equal to one another. Let A B C D (fig. 284) be a parallelogram; join A C, then A C is a diagonal, and the triangles A D C, A B C, into which it divides the parallelogram, are equal, and the angle D A C is equal to the angle A C B, and D C A to C A B.

33. A plane figure, bounded by more than four straight lines, is called a *Polygon*. A *regular polygon* has all its sides equal, and consequently its angles are also equal, as figs. 286–289. An *irregular*

polygon has its sides and angles unequal, as fig. 285. Polygons are named according to the number of their sides, or angles, as follows:—

A *Pentagon* is a polygon of five sides, as figs. 285 and 286.

A *Hexagon* is a polygon with six sides, as fig. 287.

Fig. 285 Fig. 286 Fig. 287

A *Heptagon* has seven sides, as fig. 288.

An *Octagon* has eight sides, as fig. 289.

An *Enneagon* or *Nonagon* has nine, a *Decagon* ten, an *Undecagon* eleven, and a *Dodecagon* twelve sides.

Fig. 288 Fig. 289

Fig. 290

Figures having more than twelve sides are generally designated *Polygons*, or many-angled figures.

Note.—The angles formed by the sides of regular polygons are together equal to twice as many right angles as the figure has sides, *minus* four; thus, the angles of a regular pentagon, taken together, equal $(2 \times 5) - 4 = 6$ right angles; each angle contains, therefore

$$\left(\frac{90^\circ \times 6}{5} = \right)108^\circ.$$

34. A *Circle* is a plane figure, bounded by one uniformly curved line, *b c d* (fig. 290), called the circumference, every part of which is equally distant from a point within it, called the centre, as *a*. The circumference of a circle is always 3·14159 (or roughly, $3\frac{1}{7}$) times its diameter, the diameter being twice the radius.

Note.—The terms circle and circumference are frequently misapplied. Thus we say, describe a circle from a given point, &c., instead of saying, describe the circumference of a circle—the circumference being the curved line thus described, everywhere equally distant from a point within it, called the centre; whereas the circle is properly the superficial space included within that circumference.

35. The *Radius* of a circle is a straight line drawn from the centre to the circumference: hence all the radii of the same circle are equal, as *b a*, *c a*, *e a*, *f a*, in fig. 290.

36. The *Diameter* of a circle is a straight line drawn through the centre, and terminated on each side by the circumference, as *b a e* (fig. 290); consequently the diameter is exactly twice the length of the radius; and hence the radius is sometimes called the semi-diameter.

37. An *Arc*, or *Arch*, is any portion of the circumference of a circle, as *c d e*, fig. 291.

38. The *Chord* or *Subtens of an arc* is a straight line joining the extremities of the arc; thus, in fig. 291, *c e* is the chord of the arc *c d e*. If the chord divides the circle into two equal parts, the chord is also the diameter, and the space included between each arc and the diameter is called a semicircle, as *a f d* in fig. 291. If the parts cut off by the chord are unequal, each of them is called a *segment* of the circle. The same chord is therefore common to two arcs and two segments; but, unless stated otherwise, it is always understood that the lesser arc or segment is spoken of, as, in fig. 291, the chord *c e* would be taken to mean the chord of the arc *c d e*.

Fig. 291

Note.—If a straight line be drawn from the centre of a circle to meet the chord of an arc perpendicularly, as F D in fig. 291, it will divide the chord into two equal parts, and if the straight line be produced to meet the arc, it will also divide the arc into two equal parts, as *c d*, *d e*.

39. Each half of the chord is called the *Sine* of the half-arc to which it is opposite; and the line drawn from the centre to meet the chord perpendicularly is called the *co-sine* of the half-arc. Consequently the sine and co-sine of an arc form a right angle.

40. Any line which cuts the circumference in two points, or a chord lengthened out so as to extend beyond the boundaries of the circle, such as *g h* in fig. 291, is sometimes called a *Secant*. But in trigonometry, the secant is a line drawn from the centre through one extremity of the arc, so as to meet the tangent which is drawn from the other extremity at right angles to the radius. Thus, F *c b* is the secant of the arc *c e*, or of the angle *c* F *e*, in fig. 291.

41. A *Tangent* is any straight line which touches the circumference of a circle in one point, which is called the point of contact, as in the tangent line *e b*, fig. 291.

42. A *Sector* is the space included between any two radii, and that portion of the circumference comprised between them: *c d e* F is a sector of the circle *a f c e*, fig. 291.

43. A *Quadrant*, or quarter of a circle, is a sector bounded by two radii, forming a right angle at the centre, and having one-fourth part of the circumference for its arc, as F *f d*, fig. 291.

44. *Concentric Circles* are circles within circles, described from the same centre; consequently, their circumferences are parallel to one another, as fig. 292.

45. *Eccentric Circles* are those which are not described from the same centre. Any point which is not the centre of a circle is also eccentric in reference to the circumference of that circle. Eccentric circles may also be tangent circles, that is, such as come in contact in one point only, as fig. 293.

46. *Altitude.* The height of a triangle, or any other figure, is called its *altitude*. To measure the altitude, let fall a straight line from the vertex, or

highest point in the figure, perpendicular to the base or opposite side; or to the base produced or continued, as at B D, fig. 294, should the form of the figure require

Fig. 292 Fig. 293

Fig. 294

its extension. Thus, C D is the altitude of the triangle A B C.

47. It is impossible to give short definitions of the *ellipse, parabola,* and *hyperbola* which shall be comprehensible to the young student. The definition of an ellipse as "the locus of a fixed point on a line of constant length moving so that its extremities are always on two fixed straight lines perpendicular to each other" is strictly accurate, but probably conveys less meaning to the uninitiated than the term "ellipse" itself. The definition, however, will be understood if it is considered in connection with fig. 214, page 203, where *l* is the "fixed point" on the "line of constant length" *h k*, *h* and *k* the two "extremities" of this line, and E G, D F, the "two fixed straight lines perpendicular to each other". If the "line of constant length" *h k* is first laid by the side of E D, the "fixed point" *l* will coincide with A; if then, the "extremity" *k* is moved up D F, the other extremity *h* being at the same time moved along from E towards D, the "fixed point" *l* will follow the curve A *l*, until, when *h k* lies alongside D F, *l* reaches the point B. The figure A B D is a quarter of an ellipse.

It will be best to reserve complete descriptions of these and other complicated figures to a later chapter.

CHAPTER II

PLANE GEOMETRY

1. STRAIGHT LINES

PROBLEM I.—*To bisect a given straight line—that is, to divide it into two equal parts.*

Let A B (fig. 295) be the given straight line. From A as centre, with radius greater than half A B, describe an arc as shown. From B as centre, with the same radius, describe another arc, cutting the former in *a* and *b*. Join *a b* by a line cutting A B in C. A B is bisected in the point C.

Fig. 295

Note.—The lines *a* c, *b* c are perpendicular to A B, and this method may be adopted for drawing a line at right angles to any given line. The same construction may be adopted for bisecting an arc of a circle.

PROBLEM II.—*From a given point to draw a perpendicular to a given straight line.*

Case 1.—*When the given point is in the given straight line.*

Let A B (fig. 296) be the given straight line, and C the given point. Take any point D, nearer C than A,

Fig. 296

and from D as centre, with radius D C, describe the arc E C F. Join E D and produce it till it cuts the arc in F. Join F C. F C is the perpendicular required.

Case 2.—*When the given point is without the given line.*

Let A B (fig. 296) be the given line, and F the given point without it. Take any convenient point E in A B, join F E and bisect F E in D. With D as centre and radius D F or D E describe the arc F C E, cutting A B in C. Join F C. F C is the perpendicular required.

Fig. 297

Note.—A perpendicular can also be drawn by means of any scale of equal parts, or standard measure of inches, feet, yards, &c., by setting off distances in proportion to the numbers 3, 4, and 5; or any common multiple thereof, as 15, 20, and 25; or 30, 40, and 50. The two smallest numbers in each case will form the base and perpendicular, and the largest number the hypotenuse of a right-angled triangle. Let A B (fig. 297) be the given line, and B the given point. From any scale of equal parts set off from B, on the line A B, the distance B A equal to three of these parts; then from A, with a radius equal to 5 of the same parts, describe the arc 5 c; also from B as a centre, with a radius equal to 4 parts, describe another arc intersecting the former in c; join B C; the line B C will be perpendicular to A B. This mode of drawing right angles

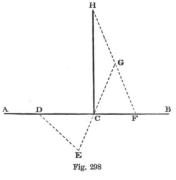

Fig. 298

is often useful in setting out large right angles, as in staking out buildings, &c. Perpendiculars can also be erected upon straight lines, without having recourse to the arcs of circles. Let A B (fig. 298) be a given straight line, and c a given point in it; it is required to draw a line from the point c at right angles to A B. Between c and A take any point D; draw D E at any angle to D B, and equal to D C; join E C, and produce it to G, making C G = C D. On C B set off C F equal to C E; join F G, and produce it till G H is equal to G F or G C; draw C H; it will be perpendicular to A B.

PROBLEM III.—*To draw a straight line parallel to a given straight line, at a given distance from it.*

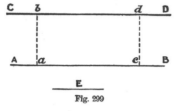

Fig. 299

Let A B (fig. 299) be the given straight line and E the given distance. From any convenient point a draw a b perpendicular to A B and equal to E. From any other convenient point c draw c d perpendicular to A B and equal to E. The line C D drawn through b d is the parallel line required.

PROBLEM IV.—*Through a given point to draw a straight line parallel to a given straight line.*

Let A B (fig. 300) be the given straight line, and C the given point. From any convenient point a in A B, with radius a c, draw an arc cutting A B at b. From C, with the same radius, draw another arc cutting A B at a. From a, with radius equal to b c, draw an arc, cutting the arc a D at D. The line drawn through c and D will be the parallel line required.

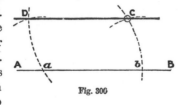

Fig. 300

PROBLEM V.—*To divide a given straight line into any given number of equal parts.*

Let A B (fig. 301) be the given line, and let it be required to divide it into five equal parts. From A draw any line A a obliquely to A B, and along it set off five convenient equal parts as numbered. Join 5 B, and through 4, 3, 2, and 1 draw lines parallel to 5 B, cutting A B in IV, III, II, and I. The line A B is divided into five equal parts as required.

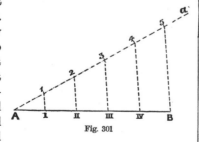

Fig. 301

Note.—The problem may be solved in another way. Let A B (fig. 302) be the given straight line, which we shall suppose, in this instance, is to be divided into four equal parts. Draw the straight line C D of any convenient length, and from c set off four equal parts. Then from c, with a radius equal to the distance c 4, describe an arc; and from the point marked 4, with the same radius, describe another arc cutting the former in G. From the point of intersection G, draw G C, G 1, G 2, G 3, and G 4. Again, from G, with a radius equal to the given line A B, describe an arc cutting G C and G 4 in the points E and F; join these

points: the line E F will be equal to the given line A B, and it will also be divided into four equal parts by the lines G 1, G 2, and G 3.

PROBLEM VI.—*To divide a given straight line similarly to a given divided straight line; that is, into parts proportional to the parts of the given divided line.*

Let A B (fig. 303) be the given divided line, divided into five parts as shown, and C D the given line to be

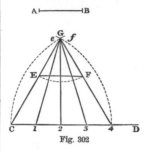

Fig. 302

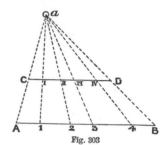

Fig. 303

similarly divided. Draw A B and C D parallel to each other at any convenient distance. Join A C and B D, and produce till they meet at the point a. Join a 1, a 2, a 3, and a 4. C D will be divided at I, II, III, and IV similarly to A B at 1, 2, 3, and 4.

Note.—If the line to be divided is greater than the given divided line, no new principle is involved. Let C D be the given divided line, and A B the line to be divided. Proceed as before; then join a I, a II, &c., and produce the lines till they cut A B at 1, 2, &c.

PROBLEM VII.—*To find a mean proportional between two given lines.*

Let A and B (fig. 304) be the two given lines. Draw a straight line a b, making a c equal to A, and c b equal to B. Bisect a b in c, and from c as centre, with radius c a or c b, describe a semicircle. Erect C D perpendicular to a b, and cutting the semicircle at D. C D is the mean proportional required, *i.e.* A is to C D as C D is to B.

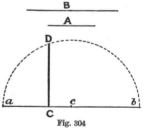

Fig. 304

Note.—This is usually expressed thus—A : C D :: C D : B. This and the next three problems are used in graphic arithmetic. If the given lines are in feet or inches, and are laid down by scale, the length of the proportional can be read (approximately) by applying the same scale. Thus, in fig. 304, if A measures 30 feet and B 60 feet, the mean proportional C D measures about 42·4 feet, *i.e.* 30 : 42·4 :: 42·4 : 60.

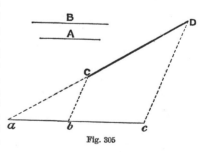

Fig. 305

PROBLEM VIII.—*To find a third proportional to two given lines:—*

1. *When the required line is to be greater than either of the given lines.*

Let A and B (fig. 305) be the two given lines. From

any point *a* draw two straight lines, as *a*D and *a c*, making any angle. Make *a b* equal to A, *b c* equal to B, and *a* c equal to B. Join *b* C, and from *c* draw *c* D parallel to *b* C, and cutting *a* D at D. CD is the third proportional required, *i.e.* A : B :: B : C D.

Note.—It will be seen at a glance that *a b* : *a c* :: *b c* : C D. But *a b* was made equal to A, and *a c* and *b c* were each made equal to B. Therefore, A : B :: B : C D.

2. *When the required line is to be less than either of the given lines.*

Let A and B (fig. 306) be the two given lines. From any point C draw two straight lines, as C *a* and C *b*, making any angle. Make C *a* equal to A, and C *b* equal to B. Set off on C *a* a part C c equal to B. (This can be done by drawing the arc *b c* from the centre C, with radius C *b*.) Join *a b*, and through *c* draw *c* D parallel to *a b*. CD is the third proportional required, *i.e.* A : B :: B : C D.

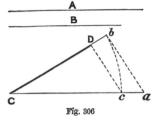

Fig. 306

PROBLEM IX.—*To find a fourth proportional to three given lines:*—

1. *When the required line is to be greater than the third given line.*

Let A, B, and C (fig. 307) be the three given lines. From any point *a* draw two straight lines, as *a* E and *a c*, making any angle. Make *a b* equal to A, *a* D equal to B, and *b c* equal to C. Join *b* D, and through *c* draw *c* E parallel to *b* D and cutting *a* E at E.

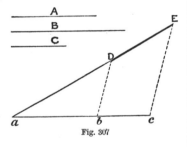

Fig. 307

D E is the fourth proportional required, *i.e.* A : B :: C : D E.

2. *When the required line is to be less than the third given line.*

Let B, A, and D E (fig. 307) be the three given lines. Proceed as before, and make *a* D equal to B, *a b* equal to A, and D E equal to D E. Join D *b*, and through E draw E *c* parallel to D *b* and cutting *a c* at *c*. *b c* is the fourth proportional required, *i.e.* B : A :: D E : *b c*.

PROBLEM X.—*To divide a straight line into mean and extreme proportion.*

Let A B (fig. 308) be the given straight line. At A erect a perpendicular A *a* equal to half the given line, and join *a* B. From *a* as centre, with radius *a* A, draw an arc *a b*, cutting *a* B at *b*. From B as centre, with radius B *b*, draw an arc *b* C, cutting

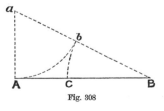

Fig. 308

A B at C. A C is the extreme and C B the mean proportional of the line A B, *i.e.* A C : C B :: C B : A B.

2. ANGLES

PROBLEM XI.—*To bisect a given angle.*

Let B A C (fig. 309) be the given angle. From A, with any convenient radius, draw an arc cutting A C at *a* and A B at *b*. From *b*, with any convenient radius, draw an arc as shown, and from *a*, with the same radius, draw another arc cutting the former at D. Join D A, and the angle is bisected as required.

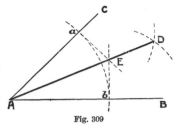

Fig. 309

Note.—The arc *a b* is also bisected at the point where it is intersected by the line A D. The problem may be easily solved by means of the carpenter's square and rule. Set off along A B and A C equal distances as A *a* and A *b*; by means of the square draw *b* E perpendicular to A B, and *a* E perpendicular to A C, intersecting at E; join A E, and the angle is bisected.

PROBLEM XII.—*To trisect a right angle, that is, to divide it into three equal angles.*

Let B A C (fig. 310) be the given right angle. From A as centre, with any convenient radius, draw an arc cutting A B at *a* and A C at *b*. From *a* as centre, with the same radius, draw an arc cutting the large arc at *c*, and from *b*, with the same radius, draw another arc cutting the large arc at *d*. Join A *c* and A *d*, and the angle is trisected as required.

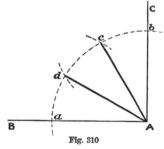

Fig. 310

Note.—This construction shows also how to trisect the quadrant of a circle; the quadrant *a b* is trisected at the points *c* and *d*. For an approximate method of trisecting any angle or any arc, see Problem LII. As a right angle measures 90°, it follows that, by trisecting it, we obtain three angles of 30°, and two of these taken together give us an angle of 60°. These angles can be easily found by means of the carpenter's square; draw a line

Fig. 311

A B (fig. 311) of any convenient length, say 24 inches; place the figure on the tongue of the square representing half this length (*i.e.*, in this case, 12 inches) at one end of the line, and at the same time let the blade of the square touch the other end of the line; the angle formed by the blade and the line will measure 30°, and that formed by the tongue and the line 60°.

PROBLEM XIII.—*To bisect the inclination of two oblique straight lines, the point of intersection of which is inaccessible.*

Let A B and C D (fig. 312) be the given oblique

straight lines. Take any convenient point *a* in A B, and from it erect a perpendicular *a b*, and from any convenient point *c* in C D erect a perpendicular *c d* and make it equal to *a b*. Through *b* draw *b* E parallel to A B, and through *d* draw *d* E parallel to C D. Bisect the angle at E by the line E F. E F is the required bisecting line.

Fig. 312

PROBLEM XIV.—*Through a given point to draw a straight line which, if produced, would pass through the point of intersection of two oblique lines, the point of intersection being inaccessible.*

Let A B and C D (fig. 313) be the given oblique lines, and E the given point. Through E draw any convenient line *a b* cutting A B and C D, and draw any other convenient line *c d* parallel to *a b* and also cutting A B and C D. Join *b c*; through E draw E *e* parallel to A B, and from *e* draw *e* F parallel to C D. The line drawn through E and F is the line required.

Fig. 313

PROBLEM XV.—*From a given point in a given straight line to draw an angle equal to a given angle.*

Let A B (fig. 314) be the given straight line, C the given point, and *a* D *b* the given angle. From D, with any convenient radius, draw an arc cutting the sides of the given angle in *a* and *b*, and from C, with the same radius, draw another arc *c d*. From *d*, with radius equal to *b a*, draw a third arc cutting the second in *c*. Draw C E through the point *c*. The angle B C E is equal to the given angle *a* D *b*.

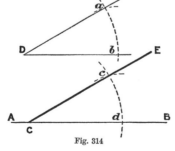

Fig. 314

PROBLEM XVI.—*From a given point without a given straight line to draw a straight line which shall make with the given straight line an angle equal to a given angle.*

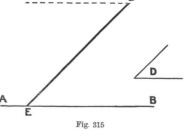

Fig. 315

Let A B (fig. 315) be the given straight line, C the

given point, and D the given angle. From C draw a line parallel to A B. Construct at C an angle equal to the given angle D, and produce the side till it cuts A B at E. The straight line C E makes with A B an angle C E B equal to the given angle D.

3. TRIANGLES

PROBLEM XVII.—*On a given straight line to construct an equilateral triangle.*

Let A B (fig. 316) be the given straight line. From A, with radius A B, draw an arc C B, and from B, with the same radius, draw another arc intersecting the former at C. Join A C and B C. The triangle A B C is the equilateral triangle required.

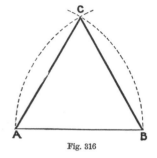

Fig. 316

Note.—The draughtsman usually solves the problem by means of a set-square of 60°, *i.e.* by setting up an angle of 60° at each end of the given line. The carpenter and joiner often solve it by means of the carpenter's square. Suppose the given line A B (fig. 311) is 24 inches long. Place the 12-inch mark on the tongue of the square (*i.e.* one half the length of the given line) at one end of the given line, and let the blade of the square touch the other end of the line. Draw a line along the tongue of the square, and produce it till it equals A B, *i.e.* to the point D, and join A D. A D B is the equilateral triangle required.

PROBLEM XVIII.—*To construct an equilateral triangle, the altitude or vertical height being given.*

Let A B (fig. 317) be the given altitude. Through A draw *a b* perpendicular to A B, and through B draw C D

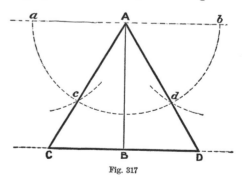

Fig. 317

also perpendicular to A B, *i.e.* parallel to *a b*. From A, with any convenient radius, describe a semicircle cutting *a b* in *a* and *b*. From *a*, with the same radius, draw an arc cutting the semicircle at *c*, and from *b*, with the same radius, draw another arc cutting the semicircle at *d*. From A through *c* and *d* draw the lines A C and A D, cutting C D at *c* and D. The triangle A C D is the equilateral triangle required.

Note.—This problem can also be solved by means of the carpenter's square, by first drawing from B a perpendicular on each side of A B, as B C and B D, and then setting off on each side of A B at the point A an angle of 30° (see note on Problem XII), and producing the lines forming these angles till they meet C D at the points C and D.

PROBLEM XIX.—*Upon a given base to construct an isosceles triangle which shall have its vertical angle equal to a given angle.*

Let A B (fig. 318) be the given base, and C the given angle. Produce A B to *a*, and make the angle *a* B *b*

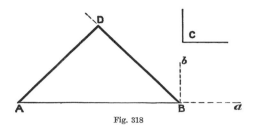

Fig. 318

equal to the given angle C. Bisect the angle A B *b* by the straight line B D. At A construct an angle equal to the angle A B D, and produce the side till it cuts B D at D. The triangle A D B is the isosceles triangle required, the vertical angle A D B being equal to the angle C, and the side D A equal to the side D B.

Note.—The construction of an isosceles triangle on a given base, and with a given angle at the base, is an easy matter. At each extremity of the base, as at A and B in fig. 318, set up the given angle and produce the sides till they meet at D.

PROBLEM XX.—*To construct a triangle with two sides respectively equal to two given straight lines, and an angle equal to a given angle:*—

1. *The given angle to be between the two given lines.*

Let A and B (fig. 319) be the two given straight lines, and C the given angle. Draw a line D E equal to A. At the point D construct an angle equal to the given angle C, and make D F equal to B. Join F E. D F E is the triangle required.

2. *The given angle to be opposite one of the given sides.*

Let B be the side opposite which the angle is to be formed equal to the given angle. The given angle is now assumed to be equal to the angle at E in the preceding figure. Draw a line D E equal to A. At E construct an angle equal to the given angle. From D, with radius equal to B, draw an arc cutting F E at F, and join D F. D F E is the required triangle.

Note.—In practice the given angles in problems of this class are usually stated in degrees (as 30°, 45°, and 60°), and, except in the case of right angles and other angles which can be drawn by means of set-squares, the simplest and most accurate way of procedure is to set off the angle by means of a protractor. A great many different angles can, however, be found geometrically. Thus, an angle of 45° can be found by bisecting a right angle; one of 22½° by bisecting an angle of 45°; and so on. Angles of 30° and 60° can be found by trisecting a right angle (Problem XII), and the bisection of an angle of 30° will give the angle of 15°. We shall show hereafter how to construct regular polygons, and in this way numerous other angles can be found geometrically. Thus, each angle of a regular pentagon measures

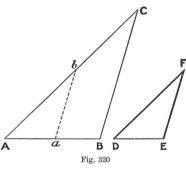

Fig. 319

108°; by subtracting a right angle from this, an angle of 18° remains. By adding or subtracting different angles found in this way, the student will be able to construct geometrically all angles commonly required; but however good this may be as an exercise, it is too laborious for practical use.

PROBLEM XXI.—*To construct a triangle with sides equal to three given straight lines.*

Let A, B, and F E (fig. 319) be the three given straight lines, A being the longest. Draw D E equal to A. From D as centre, with radius equal to B, draw an arc, and from E as centre, with radius equal to F E, draw another arc cutting the former at F. The triangle formed by joining F D and F E will be the required triangle.

Note.—This problem is of great importance, as already explained in Chapter V, Section IV. By its aid quadrilateral figures of all kinds can be described when the sides and one diagonal are known, and irregular polygons can be drawn when the proper dimensions are known.

PROBLEM XXII.—*On a given straight line to construct a triangle similar to a given triangle.*

Let A B C (fig. 320) be the given triangle, and D E the given base of the triangle to be constructed. At D set up an angle equal to the angle at A, and at E set up an

Fig. 320

angle equal to the angle at B, and produce the sides till they meet at F. D E F is a triangle similar to A B C, *i.e.* A B : D E : : A C : D F : : C B : F E.

Note.—This problem can be most expeditiously solved by setting off along A B a length A *a* equal to the given base D E, and through *a* drawing *a b* parallel to B C till it cuts A C at *b*; A *a b* is the triangle required. If the given base is longer than A B, produce A B and A C as required.

4. QUADRILATERAL FIGURES

PROBLEM XXIII.—*To describe a square:*—

1. *One side being given.*

Let A B (fig. 321) be the given side. Draw C D equal to A B. From C as centre, with radius C D, describe an arc as shown, and from D as centre, with the same radius, describe another arc cutting the former at *g*. Bisect the arc C *g* at *h*, and from *g* as centre, with radius *g h*, describe an arc cutting the other arcs at F and E. Join C F, F E, and E D. C F E D is the square required.

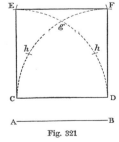

Fig. 321

Note.—A quicker method is to draw C E and D F perpendicular to C D, make one of them (say C E) equal to C D, and draw F E parallel to C D. The vertical sides can be made equal to the base, either by setting off the distance with a scale, or by means of arcs drawn from the extremities of the base with the base as

radius, or by bisecting the angles at the base by means of a 45° set-square (thus drawing the diagonals of the square).

2. *The diagonal being given.*

Let A B (fig. 322) be the given diagonal. Bisect A B at *a*, and through *a* draw C D at right angles to A B, and make C *a* and *a* D equal to A *a* or *a* B. Join A C, C B, B D, and D A. A C B D is the square required.

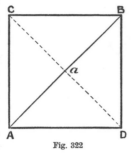

Note.—The construction of other quadrilateral figures offers no difficulties which the student cannot overcome by the help of the various problems which have already been given. The construction of parallelograms within given quadrilateral figures is more novel, and will therefore be considered.

Fig. 322

PROBLEM XXIV.—*To inscribe a parallelogram in a given quadrilateral figure.*

Let A B C D (fig. 323) be the given quadrilateral figure. Bisect each of the sides, at F, G, H, and E respectively, and join F G, G H, H E, and E F. E F G H is the parallelogram required.

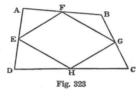

Fig. 323

PROBLEM XXV. — *To inscribe a rhombus in a given parallelogram.*

Let A B C D (fig. 324) be the given parallelogram. Join A C and B D, intersecting at E. Through E draw

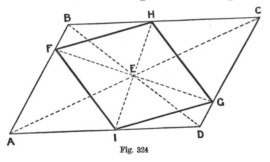

Fig. 324

any line F G, and also the line H I perpendicular to F G. Join F H, H G, G I, and I F. F H G I is the rhombus required.

5. CIRCLES

PROBLEM XXVI.—*To find the centre of a given circle.*

Let A B C D (fig. 325) be the given circle. Draw any chord as *a b*, bisect it at *c*, and through *c* draw E *d* perpendicular to *a b*. Bisect E *d* at F. F is the centre of the given circle, and F E is a radius, and *d* E a diameter.

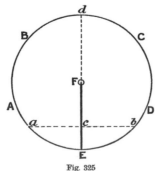

Fig. 325

PROBLEM XXVII.—*To describe a circle or arc of a circle which shall pass through two given points, with a given radius.*

Let A and B (fig. 326) be the two given points, and C the given radius. From A as centre, with radius equal to C, describe an arc as shown, and from B as centre, with the same radius, describe another arc cutting the former at *a*. From *a* as centre, with the same radius, describe the arc A B. A B is the required circle or arc of a circle.

Fig. 326

PROBLEM XXVIII.—*To describe a circle whose circumference shall pass through three given points not in a straight line.*

Let A, B, and C (fig. 327) be the three given points. Join A B and B C. Bisect A B at *a*, and draw *a c* perpendicular to A B. Bisect B C at *b*, and draw *b c* perpendicular to B C, and cutting *a c* at *c*. With *c* as centre, and radius *c* A, *c* B, or *c* C, describe a circle. It will pass through the three given points.

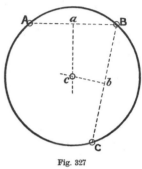

Fig. 327

Note.—For two methods of solving this problem without finding the centre, see Problem XLVI.

PROBLEM XXIX.—*To draw a tangent to a given circle, passing through a given point in the circumference:—*

1. *By using the centre of the circle.*

Let A (fig. 328) be the given point in the circumference of the given circle. Find the centre *a* of the given circle, and join A *a*. Through A draw B C perpendicular to A *a*. B C is the tangent required.

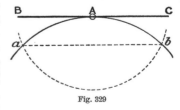

Fig. 328

Note.—To draw a tangent to a circle, which shall be parallel to a given straight line, let fall a perpendicular from the centre of the circle to the given straight line (produced if required), and through the point where this perpendicular cuts the circumference draw a line parallel to the given line.

2. *Without using the centre of the circle.*

Let A (fig. 329) be the given point in the circumference of the given circle. From A as centre, with any convenient radius, describe an arc cutting the circumference of the circle at *a* and *b*. Join *a b*, and through A draw B C parallel to *a b*. B C is the tangent required.

Fig. 329

Note.—If the given point is at or near one extremity of the given arc, another method must be adopted. Let A (fig. 330) be the given point in the given arc. Take any other convenient point *a* in the given arc, join *a* A, and bisect *a* A at *b*. From *b* draw *b c* perpendicular to *a* A, cutting the given arc at *c*. Join *c* A, and from A as centre, with radius A *c*, describe the arc *d c* B. Make *c* B equal to

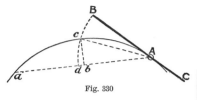
Fig. 330

c d, and through B and A draw the line B C. Or make the angle B A *c* equal to the angle *c* A *d*, and produce the side B A to C. B C is the tangent required.

PROBLEM XXX.—*To draw a tangent to a given circle from a given point without the circumference:*—

1. *By using the centre of the given circle.*

Let A (fig. 331) be the given point, and B the centre of the given circle. Join A B, and bisect A B at *a*. From *a*

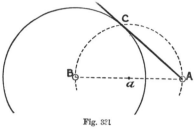
Fig. 331

as centre, with radius *a* A or *a* B, describe a semicircle cutting the given circle at C. Draw A C through the points A and C. A C is the tangent required.

2. *Without using the centre of the given circle.*

Let A (fig. 332) be the given point, and B C D an arc of the given circle. Take any convenient point *a* in the part of the given arc which is concave towards A, join *a* A, cutting the arc at *b*, and produce it to *c*, making A *c* equal to A *b*. Bisect *a c* at *d*, and from *d* as centre, with the radius *d a* or *d c*, describe a semicircle. From A draw *a e* perpendicular to *a c*, and

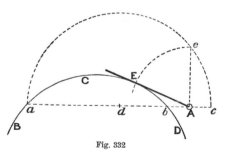
Fig. 332

cutting the semicircle at *e*. From A as centre, with the radius A *e*, describe an arc cutting the given arc at E. Draw A E through the points A and E. A E is the tangent required.

PROBLEM XXXI.—*To draw tangents to two given circles.*

Let A B C and D E F (fig. 333) be the two given circles. Find the centres, *a* and *b*, of the two circles, and join them by the line cutting the circumferences of the two circles in A and E respectively. From the centre *a*, with a radius equal to *b* E, describe the circle *c d e*, and from *b* draw tangents to this circle, namely, *b d*

and *b e*. From *a* draw *a* B perpendicular to *b d*, and *a* C perpendicular to *b e*, and from *b* draw the perpen-

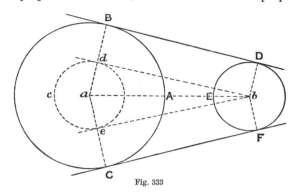
Fig. 333

diculars *b* D and *b* F. Join B D and C F. B D and C F are the two tangents required.

Note.—In practical work the tangents to the two circles would be drawn by simply applying a straight-edge or ruler to the outermost parts of the circumferences, and ruling a line from one to the other. Other problems relating to tangents may be left to the student's ingenuity.

PROBLEM XXXII.—*Given the span or chord line, and height or versed sine of the segment of a circle, to describe the segment or circle.*

Let A B (fig. 334) be the given span or chord line. Bisect A B at D by the perpendicular line C E, and make D C equal to the given height or versed sine. Join A C, and also bisect it by a line drawn perpendicular to it, and meeting D E in F. Join F A, then from F as centre, with the radius F A or F C, describe the arc A C B, which will be the segment required.

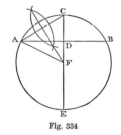
Fig. 334

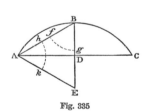
Fig. 335

Another Method.—Let A C (fig. 335) be the given chord. Bisect it (as before) in D by the line B E, drawn at right angles to it. Make D B equal to the given height or versed sine. Join A B, and from the point B, with any radius less than A B, describe the arc *f g*, and from A, with the same radius, draw the arc *h k*, making it equal to *f g*. Through the point *k* draw the line A E, which will meet B E in E. From E, with the radius E A or E B, describe the arc A B C, which will be the segment required.

Note.—The radius of an arc or arch, of which the span, or chord, and height are given, may be obtained by calculation thus: Divide the square of half the chord by the height of the arc, to the quotient add the height of the arc, and the sum will be the diameter of the circle, or double the radius sought. For example, suppose the chord A B (fig. 334) to be 22 feet, and the versed sine C D 7 feet; half of 22 is 11, and 11 squared is 121, which, divided by 7, gives $17\frac{2}{7}$ for the quotient; then 7 added to $17\frac{2}{7}$ is $24\frac{2}{7}$, the diameter of the circle C E, one half of which,

12¼ feet, is the length of the radius F A or F C. For methods of describing segments of circles without having recourse to the centres, see Problems XLVI to XLIX.

PROBLEM XXXIII.—*The chord of an arc, and also the radius of the circle, being given; to find the height or versed sine of that arc.*

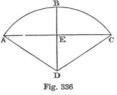

Fig. 336

Let A C (fig. 336) be the given chord. From the extremities A and C, with the given radius, describe arcs intersecting each other in D. Join D A and D C. Bisect A C in E. Join also D E, and extend it till D B is equal to D A or D C. B E will be the height of the arc required.

Note.—Another method is as follows:—Find D as above; from this centre D, with the given radius, describe the arc A B C; and having bisected A C in E, join D E, and produce it to meet the circumference in B; B E is the versed sine, or height of the arc as before.

The problem may also be solved by calculation:—Subtract the square root of the difference between the square of the radius and that of half the chord, from the radius, and the remainder is the height of the arc. As an example, suppose the half chord E A or E C to be 16 feet, and the radius 20 feet; then the square of 20 is 400, and the square of 16 is 256, which subtracted from 400 gives 144 of a remainder, the square root of which is 12. This subtracted from 20 leaves a remainder of 8, the height or versed sine E B.

PROBLEM XXXIV.—*To describe a circle that shall touch two straight lines given in position, and one of them at a given point.*

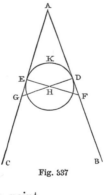

Fig. 537

Let A B and A C (fig. 337) be the given lines, and D the given point in A B. If the given lines are not parallel, they will meet if produced; let them meet in the point A. Make A E equal to A D: draw D G at right angles to A B, and meeting C A in G. Cut off A F equal to A G, and join E F, intersecting D G in H. From H, with the radius H E or H D, describe the circle E K D; it will touch the given lines, and A B in D the given point.

PROBLEM XXXV.—*To inscribe a circle in a given triangle.*

Let A B C (fig. 338) be the given triangle. Bisect any two of its angles, as those at A and C, by the straight lines A D and C D.

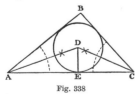

Fig. 338

From the point D, where the bisecting lines meet, let fall the perpendicular D E upon the line A C; then from D as a centre, with the radius D E, describe a circle. This circle will be inscribed in the triangle A B C, as required.

PROBLEM XXXVI.—*To describe a circle to touch three given straight lines making angles with each other.*

Let A B, B C, and C D (fig. 339) be the three given lines. Bisect the angles A B C and B C D by the lines intersecting at E. From E let fall a perpendicular upon one of the given lines, as E F, and from E, with radius E F, describe the circle F G H J. It will touch the given lines at F, G, and J.

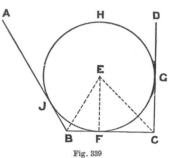

Fig. 339

Note.—This problem is useful in describing contiguous circles about a given circle. Let it be required to describe six equal circles about the given circle A D E (fig. 340), each to touch two others and also the circumference of the given circle. Draw two diameters as A D and C E at right angles to each other; trisect

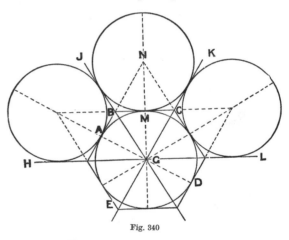

Fig. 340

the angles thus formed, and produce the lines as shown. Draw a tangent at M, meeting G J and G K in B and C; bisect the angle J B C or K C B by a line meeting G M produced in N. With N as centre and radius N M, describe a circle. It will be one of the circles required. The others can be found without difficulty.

PROBLEM XXXVII.—*To describe a series of contiguous circles touching two given converging lines, one circle to touch one of the lines at a given point.*

Let A B and C D (fig. 341) be the given converging

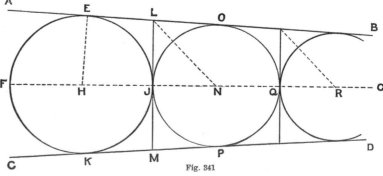

Fig. 341

lines, and E the given point. Bisect the inclination of the two given lines by the line F G, and from E, the

given point, erect a perpendicular to A B meeting F G in H. From H as centre, with radius H E, describe the circle E J K F, which will touch A B at E and C D at K, and will cut F G at J. Through J draw the tangent M L, and bisect the angle B L M by the line L N meeting F G at N. From N as centre, with radius N J, describe the circle O Q P J, which will touch the first circle at J, A B at O, and C D at P. In the same manner find the centre R and describe the third circle.

PROBLEM XXXVIII.—*To inscribe a circle within three given oblique lines, which, if produced, would form a triangle, but whose angular points are supposed to be inaccessible.*

Let A B, D C, and E F be the three given lines. From any point *g* in the line C D (fig. 342), let fall *g h* perpendicular to A B; and from the same point *g* erect

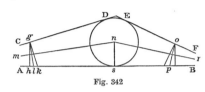

Fig. 342

a perpendicular to C D, meeting A B in *k*. Bisect the angle *k g h* by the line *g l*; bisect also the line *g l* by the perpendicular line *m n*. In like manner, find the line *o p*; bisect it also, and through the point of bisection draw the perpendicular line *r n*, meeting *m n* in the point *n*. Lastly, from *n*, the point of intersection, let fall upon A B the perpendicular *n s*: *n s* will be the radius of the required circle.

PROBLEM XXXIX.—*Two circles touching each other being given, to find the point of contact.*

Fig. 343

First, let the circles touch each other internally, as in fig. 343 (No. 1). Find C and B, the centres of these circles. Join C B, and produce it to meet both the circumferences in A. This will be the point of contact between the two circles. Second, let the circles touch each other externally, as in No. 2. Join A and C, the centres of the two circles; then the point D, where the line A C intersects the common boundary of the two circles, is the point of contact.

Note.—From a study of this problem the method of describing a circle to touch another at a given point will be easily mastered.

PROBLEM XL.—*To describe with given radii two contiguous circles, which shall also touch a given line.*

Let A B (fig. 344) be the given line, and C D and E F the given radii. From any point *g* in A B, erect a perpendicular *g h* equal to C D, the greater radius, and set off *g k* equal to E F, the lesser. Through *k* draw *k m*

parallel to A B; and from *h*, the extremity of the perpendicular *g h*, with a distance equal to the sum of C D and E F, describe an arc intersecting the parallel *k m* in the point *m*. Let fall the line *m l* perpendicular to A B, and it will be equal to E F, one of the given radii. From *m*, with the radius *m l*, describe a circle. Again, from *h*, with the radius *h g*, describe a circle, and it will touch the former in *n*, while *g* and *l* are the respective points of contact with the given line A B.

Fig. 344

PROBLEM XLI.—*In a given circle to inscribe three equal circles, which shall touch each other and the*

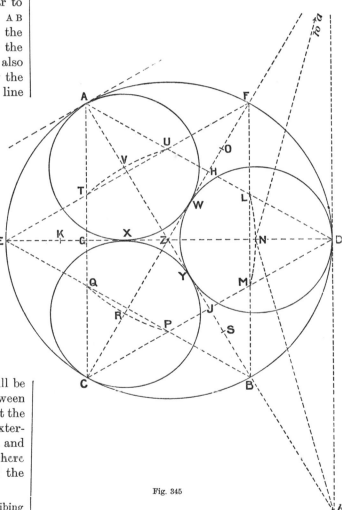

Fig. 345

given circle, and one of which shall touch the given circle in a given point.

Let A E C B F (fig. 345) be the given circle, and A the given point. Find the centre Z of the given circle, and draw the diameter A B. At A on each side of A B set off an angle of 30°; this can be done by drawing a tangent through A, and trisecting each of the right angles thus formed. Produce the sides of these angles

till they meet the circumference at C and D; join C D. From D draw the diameter D E, and from E proceed as before to find the triangle E B F. Join F C. Trisect H F in O, J B in S, and G E in K. From O, with radius O Q or O P, describe an arc cutting Z C in R; from S, with the same radius, describe an arc cutting Z A in V; and from K, with the same radius, describe an arc cutting Z D in N. From R, V, and N as centres, with radius equal to R C, V A, or N D, describe circles; they will touch each other at W, X, and Y, and will touch the given circle at A, D, and C.

Note.—The foregoing construction has been given because it is all contained within the given circle, and this is often an advantage in actual work; but the following is a simpler and better method. It is evident that the three inscribed circles touch the three diameters at the points W, X, and Y, and that, if tangents are drawn through the points A, D, and C, and the diameters are produced to meet them, three equal triangles are obtained in which circles can be inscribed by Problem XXXV. These circles will touch each other and also the given circle. Thus, through D draw the tangent *a b*, and produce Z F and Z B to meet it in *a* and *b*; bisect the angles *z a* D and *z b* D by the lines *a* N and *b* N, intersecting at N. N is the centre of the circle D W Y. In practice it is only necessary to produce one diameter, as Z *a*, to meet the tangent; bisect the angle *z a* D by a line cutting Z D (which bisects the angle *a z* B) in N. To find the other centres, describe a circle from the centre Z, with radius Z N, cutting Z A in V and Z C in R. This method of procedure shows how to inscribe a circle in a given sector, such as Z B D F, and can be adopted for inscribing any number of equal contiguous circles in a given circle, if the central angles of a polygon, having the same number of sides as there are circles to be drawn, are first found. Let it be required to inscribe five contiguous circles within and touching a given circle, one of them to touch the circle at a given point A. Construct a pentagon about the given circle (Problem LXVII), and draw lines from the centre to the angles of the pentagon as shown in fig. 382; then in each of the five triangles formed by the radial lines and tangents, as *f o g*, *g o h*, &c., describe a circle. The five circles thus described will touch each other and the given circle, and one of them will touch the given circle at the given point A. Problems of this kind frequently occur in the tracery of windows, &c.

PROBLEM XLII.—*In a given sector to inscribe a semicircle.*

Let A B D C (fig. 346) be the given sector. Bisect the angle B A C by the line A D, meeting the arc in D, and from D draw D E perpendicular to A D. Bisect the angle A D E by the line D F meeting the radius A C in F, and draw F G parallel to D E and cutting A D in H. From H as centre, with radius H G or H F,

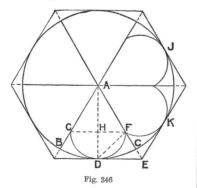

Fig. 346

describe the semicircle G D F; it will be the required semicircle.

Note.—This problem is useful for inscribing a series of contiguous semicircles in a given circle. The diagram shows how six semicircles can be inscribed in a circle. The central angles of a polygon containing as many sides as there are semicircles to be inscribed must first be drawn (see Problems LXVIII and LXX),

and these angles must then be bisected; on the bisecting lines the centres of the required semicircles will lie. Obtain one centre, as H, and the remainder can be found by describing a circle from the centre A, with radius A H; the points at which this circle cuts the bisecting lines will be the centres of the required semicircles. The inscribing of semicircles in polygons is effected in a similar manner, provided that the semicircles are required to touch the sides of the polygons at their middle points, as J and K. If each semicircle must touch two adjacent sides of the polygon, the following problem must be employed.

PROBLEM XLIII.—*In a given trapezion or kite to inscribe a semicircle.*

Let A B C D (fig. 347) be the given trapezion. Draw the diagonals A C and B D, and on B D describe a semicircle as shown. From E, the centre of the semicircle, draw E F perpendicular to B C, join F A by the line cutting B C in G, and from G draw G H parallel to F E and meeting A C in H. From H as centre, with radius H G, describe a semicircle; it will be the semicircle required.

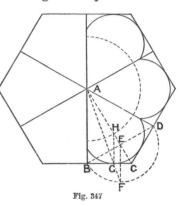

Fig. 347

Note.—The diagram shows the application of this problem to the drawing of a number of contiguous semicircles in polygons.

PROBLEM XLIV.—*From a given circle to cut off a segment, that shall contain an angle equal to a given angle.*

Let A B D (fig. 348) represent the given circle. From any point B in the circumference, draw a tangent B C; also from the point of contact B draw a chord line B A, so as to form an angle equal to the given angle; the chord A B will divide the circle into two segments. In that segment having its portion of the circumference concave towards the tangent B C, take any point D, and

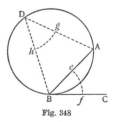

Fig. 348

join A D and D B. The angle A D B in this alternate segment is equal to A B C, which was made equal to the given angle; therefore A D B is the segment required.

Note.—If a tangent and chord be drawn from any point in the circumference of a circle, the angle formed by these lines will be equal to the vertical angle of any triangle having the chord for its base, and its vertex in any part of the circumference which bounds the alternate segment of the circle.

PROBLEM XLV.—*An arc of a circle being given, to raise perpendiculars from any given points in that arc without finding the centre.*

Let A B (fig. 349) be the given arc, and A, *c*, *d*, and *e* the given points from which the perpendiculars are to be erected. In the arc *e* B take any point *f*, so as to make *e f* equal to *e d*. From *d* and *f* as centres, with any

equal radii greater than half the distance between them, describe arcs intersecting each other in g. Join e g, and it will be one of the perpendiculars required. d h and c k are found in the same manner. In order to raise a perpendicular from A, the extremity of the arc, suppose the perpendicular c k to be erected.

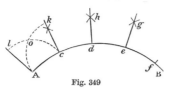

Fig. 349

From c, with the distance c A, describe the arc A k; and from A, with the same radius, describe c l, intersecting A k in o. Make o l equal to o k, and join A l, which will be the perpendicular sought.

Note.—The perpendicular to any curve at a given point is a line perpendicular to the tangent drawn through that point.

PROBLEM XLVI.—*To describe an arc of a circle through three given points (not in a straight line) without finding the centre.*

Let A, B, and C (fig. 350) be the three given points. Join A, B, and C to form the triangle A B C, and let A C

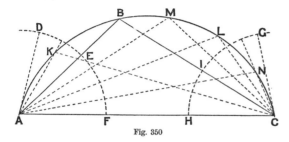

Fig. 350

be the chord of the required arc. From A, with any convenient radius, describe the arc D F, intersecting A B in E, and from C, with the same radius, describe the arc G H, intersecting C B in I; make the arc D E equal to the arc H I, and the arc G I equal to the arc F E, and join D A and G C. Bisect the angles D A E and I C H, and produce the bisecting lines till they meet at K. Bisect the angles F A E and G C I, and produce the bisecting lines till they meet at L. A, K, B, L, and C are five points, through which the required arc can be traced. If more points are desired between B and C, bisect the angles B A L and B C L, and produce the bisecting lines till they meet at M; also bisect the angles L A C and L C G, and produce the bisecting lines till they meet at N. M and N are two additional points in the required arc. A curve traced through A, K, B, M, L, N, and C will give the arc required.

Another Method.— Let A, B, and C (fig. 351) be the given points, through which the arc is to be drawn. Join these points, so as to form the triangle

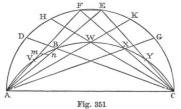

Fig. 351

A B C. Upon A C describe a semicircle, and extend the lines A B and C B to meet the semi-circumference in E and D. In the semicircle A D E C insert the chords C F

and A G, equal to the chords A E and C D; then the point X, where C F and A G intersect, is a point in the proposed arc. Bisect each of the arcs D F and E G in the points H and K, and join A K and C H by lines intersecting in W, which is also a point in the curve. Join A F and C E, and draw the chord E F. From A F cut off F m, equal to B E, and through m draw m n parallel to F E, and cutting A E in n. Again, from A F cut off F V, equal to E n; also from C E cut off C Y, equal to A V; then a curve traced through A, V, B, W, X, Y, and C will describe the arc required.

Note.—The most expeditious, as also the most accurate, method of tracing curves of this description on a large scale is the following. Having obtained a sufficient number of true points in the proposed curve, and having placed small nails in the several points, bend a thin slip of wood, or some other elastic substance, round these nails; then by drawing the pencil along this slip on the side of the nails, the required curve line will be described.

PROBLEM XLVII.—*Three points, neither equidistant nor in the same straight line, being given, through which the arc of a circle is to be described, to find the altitude of the proposed arc.*

Let A, B, and C (fig. 352) be the given points. Connect them by the straight lines A B, B C, and A C, forming a triangle, the base of which, viz. A C, will be the chord of the arc whose height is to be determined. Bisect the vertical angle A B C by the line B D, meeting the base in D. Bisect also the base A C in E, and from E draw the line E g perpendicular to A C.

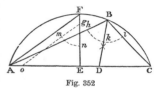

Fig. 352

From the vertex B, with any radius, describe the arc h k, cutting the sides of the triangle A B D, in the points h and k; and from any point g in the perpendicular, with the same radius, describe the arc m n, making it equal to the arc h k. Join g m, producing it to meet the base A C in o, or A C produced if necessary; then draw A F parallel to o g, and meeting E g produced in F. E F is the extreme height or altitude of the arc proposed.

Another Method.—Let A, B, and C (fig. 353) be the given points. Join them so as to form the triangle A B C. Upon A C, as a diameter, describe a semicircle, and produce A B and C B to meet the semi-circumference in the points D and E. From A set off on the semicircle the arc A F, equal to the arc C D; join C F, and from A, with a radius equal to C B, cut the line C F in G.

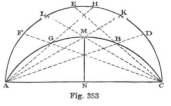

Fig. 353

Join A G, and produce it to meet the semicircle in H. Bisect the arcs D H and E F in the points K and L. Join A K and C L, intersecting each other in M. From M, the point of intersection, let fall upon A C the perpendicular M N, and it will be the altitude of the arc proposed.

PROBLEM XLVIII.—*A segment of a circle being given, to produce the corresponding segment, or to complete the circle without finding the centre.*

Let A B C (fig. 354) be the given segment; and let B be situated anywhere between A and C. Join A B and B C. Bisect the vertical angle at B by the straight line B D, meeting A C in the point D. From the extremities A and C, according to the method previously shown, describe angles on the contrary side of the chord A C, equal to the angle A B D or C B D, and produce the lines forming these angles from A and C to meet in the point E; then the vertex

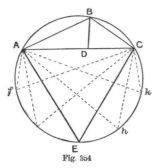

Fig. 354

E of the triangle A C E is a point in the arc which is to form the opposite segment. Find by Problem XLVI any other number of points in the proposed arc, as *f, g, h,* and *k,* and join the extremities of the chord A C by a curved line passing through these points, and it will complete the circle as proposed.

Another Method.—Let A B C (fig. 355) be the given segment. From B draw the line B D, cutting A C at any angle, and produce it until D E is a fourth proportional to B D, D A, and D C. Take any other point F, and join F D, producing it to G, so as to make D G a fourth proportional to F D, D A, and D C. Find the points K, N, R, &c., in the same manner, and a curved line traced through these points will complete the circle.

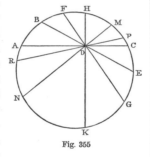

Fig. 355

PROBLEM XLIX.—*The chord and versed sine of an arc being given, to find the curve, without having recourse to the centre.*

Let A B (fig. 356) be the chord, and D C the versed sine. From C draw the tangent C *g* parallel to A B; join C B, and bisect it in *f.* Make C *g* equal to C *f,* and from *f* and *g* raise perpendiculars to the lines C *f,* C *g,* intersecting in *e,* and *e* will be a point in the curve.

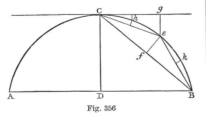

Fig. 356

Or, which is the same thing, bisect the angle *f* C *g* by the straight line C *e,* and to this draw the perpendicular from *f* or *g,* meeting it in *e,* which is the point required.

In the same way the point *h* is found by bisecting the angle *e* C *g,* then bisecting the line *e* C by a perpendicular cutting the bisecting line of the angle in *h.*

As the segments C *e, e* B are equal, another point may be found by joining *e* B, bisecting it by a perpendicular in *k,* and making the perpendicular or versed sine equal to that of the segment already found. Proceed thus until sufficient points are obtained.

PROBLEM L.—*To describe an arc of a circle, each point in which shall be equidistant from a given straight line and from a given arc.*

Let A B (fig. 357) be the given straight line, and C F D the given arc. Complete the circle C F D, and find the centre E. From E let fall a perpendicular upon A B, intersecting the arc C F D at F, and meeting A B at G. Through F draw H L parallel to A B, and from E, with radius E G, describe an arc intersecting H L in I and K. Bisect F G in M,

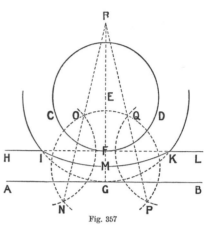

Fig. 357

and from M, with any convenient radius greater than half the distance from M to I, describe an arc as shown, and from I and K, with the same radius, describe other arcs intersecting the former at N and O, and P and Q, respectively. Join N O and P Q, and produce them till they meet G E produced in R. From R, with radius R M, describe the arc I M K. I M K is the arc required.

Note.—This problem and the next are indispensable for finding curved mitres, and are therefore particularly interesting to the carpenter and joiner.

PROBLEM LI.—*To describe an arc of a circle, each point in which shall be equidistant from two other arcs of different radius and described from different centres.*

Let A B C (fig. 358) be one given arc, and D E F the

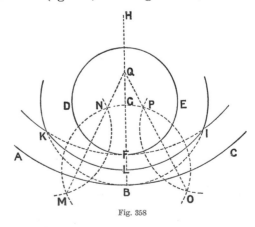

Fig. 358

other given arc. Find the centres H and G of the two given arcs. Join H G and produce the line till it cuts the two arcs in F and B. From H, with radius H F,

PLATE XXI

SOUTH-EAST ELEVATION OF SMALL COUNTRY HOUSE

SCALE

12 IN

0 5 10 20 30 FEET

PLATE XXI

This is the south-east or front elevation of the house, of which plans and sections were given in Plates XIX and XX. The front of the two-storied part is in plan a semi-decagon, and was so designed in order to command the extensive prospects which the site afforded. For the same reason, ordinary sash-windows were provided in the dining-room, although the external effect is much less satisfactory than would have been obtained by the use of smaller casement windows. The half-timber work (see First-Floor Plan, Plate XX, and Detail Drawing, Plate XXIV) is constructed of timbers chiefly 6 inches thick, embedded to the depth of $4\frac{1}{2}$ inches in the 9-inch brickwork which forms the walls of the upper story. The brick panels are finished with cement. Details of the porch and drawing-room bay will be found in Plate XXIV.

describe the arc K F I, and from G, with radius G B, describe the arc K B I cutting the former in K and I. Bisect F B in L; from L as centre, with any convenient radius, describe an arc as shown, and from K and I, with the same radius, describe two arcs intersecting the former in M and N, and O and P, respectively. Join M N and O P, and produce the lines till they meet G H in Q. From Q, with radius Q L, describe the arc K L I. K L I is the arc required.

The five following problems are not mathematically correct, but as they are sufficiently accurate for most practical purposes, and as they have their uses, they are here included.

PROBLEM LII.—*To trisect a given arc.*

Let B C (fig. 359) be the given arc. Complete the circle and find the centre A. Join B A and A C. Bisect the angle B A C by the line A *a*, and join B *a* and *a* C. Trisect B *a* in *b* and *c*, or *a* C in *d* and *e*, and from *a*, with radius *a c* or *a d*, describe an arc as shown. From A draw tangents to this arc, cutting the given arc in D and E. The given arc B C is approximately trisected in the points D and E.

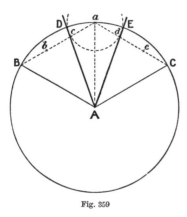
Fig. 359

Note.—The angle B A C is also approximately trisected. For the sake of clearness a large arc is shown, the radii from the extremities forming an obtuse angle at the centre. In cases of this sort it is best either to bisect the arc and angle, and then trisect each half, or, better, to divide the angle into a right angle and an acute angle, trisect the arc of the former in the correct way (Problem XII), and then trisect the arc of the acute angle; one-third of the right-angled arc *plus* one-third of the acute-angled arc will give very nearly the exact third of the whole arc.

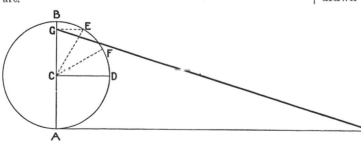
Fig. 360

PROBLEM LIII.—*To draw a straight line equal to the circumference of a given circle.*

Let A B (fig. 360) be a diameter of the given circle and C the centre. From C draw C D perpendicular to A B, and trisect the angle B C D by the radii C E and

C F. From E draw E G perpendicular to A B, and meeting A B in G. From A draw A H perpendicular to A B, and make it equal to three times A B. Join G H. G H is a very close approximation to the circumference of the given circle.

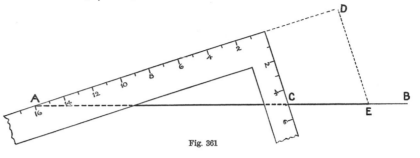
Fig. 361

Note.—Another method consists in dividing the diameter A B into seven equal parts, and then drawing a straight line equal to three diameters and one-seventh. This is sufficiently accurate for most practical purposes. The diameter of a circle is to its circumference as 1 is to 3·1415926, &c. As the decimals may be continued indefinitely, the exact proportion cannot be obtained, but the ratio of 7 to 22, or of 1 to $3\frac{1}{7}$, is fairly correct.

The problem can also be approximately solved by means of the carpenter's square. Draw any convenient line A B (fig. 361). Place the 16-inch mark on the blade of the square at one extremity of the line, and let the 5-inch mark on the tongue of the square touch the line as shown at c; draw a line along the blade of the square and produce it if required, making A D equal to three times the diameter of the given circle; then by means of the square draw D E perpendicular to A D. A E will be, approximately, the length of the circumference of the given circle. Instead of 16 inches and 5 inches, 8 inches and $2\frac{1}{2}$ inches may be taken to give the angle D A B, or, more correctly, 24 inches and $7\frac{15}{32}$.

PROBLEM LIV.—*To draw a straight line equal to any given arc of a circle.*

Let A B (fig. 362) be the given arc. Find C the centre of the arc, and complete the circle A D B. Draw the diameter B D, and produce it to E, until D E is equal to C D. Join A E, and extend it so as to meet a tangent drawn from B, in the point F; then B F will be nearly equal to the arc A B.

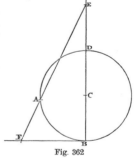
Fig. 362

Another Method.—Let A B (fig. 363) be the given arc. Find the centre C, and join A B, B C, and C A. Bisect the arc A B in D, and join also C D;

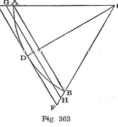
Fig. 363

then through the point D draw the straight line E D F, at right angles to C D, and meeting C A and C B produced in E and F. Again, bisect the lines A E and B F in the points G and H. A straight line G H, joining these points, will be a very near approach to the length of the arc A B.

Note.—Seeing that in very small arcs the ratio of the chord to the tangent, or, which is the same thing, that of a side of the inscribed to a side of the circumscribing polygon, approaches equality, an arc may be taken so small that its length shall differ from either of these sides by less than any assignable quantity; therefore, the arithmetical mean between the two must differ from the length of the arc itself, by a quantity less than any that can be assigned. Consequently, the smaller the given arc, the more nearly will the line found by the last method approximate to the exact length of the arc. If the given arc is above 60°, or two-thirds of a quadrant, it ought to be bisected, and the length of the semi-arc thus found being doubled, will give the length of the whole arc.

Since the two preceding problems cannot be exactly solved by any rule founded upon geometrical principles, the two following methods may also be used, which will give the length of a circular arc, or indeed of any curved line whatever, as accurately perhaps as it can possibly be obtained. The first is to bend a thin slip of wood, or any other flexible substance, around the curve; this slip, extended out at length, will be a very near approach to the length required. The second is to take a small distance between the compasses, and suppose the curve to con-tain this distance any number of times with a remainder. Upon a straight line repeat this distance, or chord, the same number of times, and transfer also the remainder from the curve to the straight line: the straight line thus extended will be very nearly equal to the given curve. It is obvious that if a given curve be divided into any number of equal parts or arcs, and if the chords of these arcs be transferred to a straight line, the line thus formed must be somewhat less than the curved line, as the chord of an arc, however small, can never be exactly equal to the arc itself. It is also evident, however, that the smaller the distance between the points, and the more numerous the parts taken on the curve, the more nearly will the straight line to which these parts, or rather their chords, are transferred, approximate to the length of the curved line itself.

PROBLEM LV.—*Having the chord and versed sine of the segment of a circle of large radius given, to find any number of points in the curve by means of intersecting lines.*

Let A C (fig. 364) be the chord and D B the versed sine. Through B draw E F indefinitely and parallel

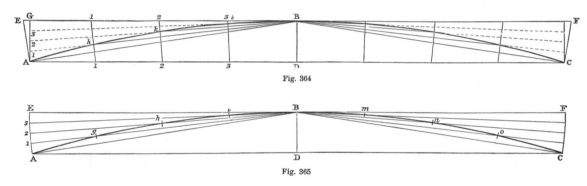

Fig. 364

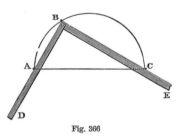

Fig. 365

to A C. Join A B, and draw A E at right angles to A B. Draw also A G at right angles to A C, and divide A D and E B into the same number of equal parts, and number the divisions from A and E respectively, and join the corresponding numbers by the lines 1 1, 2 2, 3 3. Divide also A G into the same number of equal parts as A D or E B, numbering the divisions from A upwards 1, 2, and 3; and from the points 1, 2, and 3 draw lines to B; the points of intersection of these, with the other lines at *h, k, l*, will be points in the curve required. Proceed in the same manner from B to C.

Another Method.—Let A C (fig. 365) be the chord and D B the versed sine. Join A B, B C, and through B draw E F parallel to A C. From the centre B, with the radius B A or B C, describe the arcs A E, C F, and divide them into any number of equal parts, as 1, 2, 3. From the divisions 1, 2, 3 draw radii to the centre B, and divide each radius into the same number of equal parts as the arcs A E and C F; and the points *g, h, l, m, n, o*, thus obtained, are points in the required curve.

Note.—These methods, though not absolutely correct, are sufficiently accurate when the segment is less than the quadrant of a circle.

The three following problems will prove useful to the carpenter and joiner. They are strictly accurate.

PROBLEM LVI.—*To describe a semicircle by means* of a carpenter's square, or a right angle, without having recourse to its centre.

At the extremities of the diameter A C (fig. 366) fix two pins, then by sliding the sides of the square, or other right-angled instru-ment, D B, B E, in con-tact with the pins, a pencil held in contact with the point B will describe the semicircle A B C.

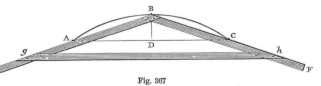

Fig. 366

PROBLEM LVII.—*To describe the segment of a circle by means of two rods or straight laths, the chord and versed sine being given.*

Take two rods, E B, B F (fig. 367), each of which must be at least equal in length to the chord of the

Fig. 367

proposed segment A C. Join them together at B, and expand them, so that their edges shall pass through the extremities of the chord, and the angle where they join shall be on the extremity B of the versed

sine D B, or height of the segment. Fix the rods in that position by the cross piece *g h*, then by guiding the edges against pins in the extremities of the chord line A C, the curve A B C will be described by the point B.

PROBLEM LVIII.—*To describe a segment at twice by rods or laths, forming a triangle like the last, or by a triangular mould; the chord and versed sine being given.*

Let A C (fig. 368) be the chord of the segment, and D B its height or versed sine. Join C B, and draw B E parallel to A C, and make it equal to B C. Fix a pin in C and another in B, and with the point of the angle

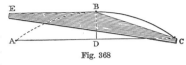
Fig. 368

E B C describe the arc C B. Then remove the pin C to A, and by guiding the sides of the triangle against A and B, describe the other half of the curve A B.

6. POLYGONS

PROBLEM LIX.—*Upon a given straight line to describe a regular pentagon.*

Let A B (fig. 369) be the given straight line. From its extremity B erect B *c* perpendicular to A B, and equal to its half. Join A *c*, and produce it till *c d* is equal to B *c*, or half the given line A B. From A and B as centres, with a radius equal to B *d*, describe arcs intersecting each other in *e*, which will be the centre of the circumscribing circle A B F G H. The side A B applied successively to this circumference, will give the angular points of the pentagon; and these being connected by straight lines will complete the figure.

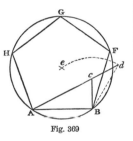
Fig. 369

Another Method.—Let A B (fig. 370) be the given line. Erect B *d* perpendicular and equal to A B. Bisect A B in *c*, and join *cd*. Produce A B, making *c e* equal to *c d*. Then from A and B as centres, with the radius A *e*, describe the arcs G H and G F, intersecting each other in G. Again, from the same points A and B, with the radius A B, describe arcs intersecting the former in H and F. Join B F, F G, G H, and H A, and the rectilineal figure A B F G H will be a regular pentagon, having A B as one of its sides, as required.

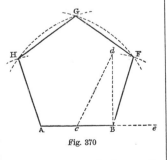
Fig. 370

PROBLEM LX.—*Upon a given straight line to describe a regular hexagon.*

Let A B (fig. 371) be the given straight line. From the extremities A and B as centres, with the radius

VOL. I,

A B, describe arcs cutting each other in *g*. Again from *g*, the point of intersection, with the same radius, describe the circle A B C, which will contain the given side A B six times when applied to its circumference, and the hexagon required will be completed by joining the points thus found.

Another Method.—Upon the given line A B (fig. 372) describe the equilateral triangle A B C. Extend the sides

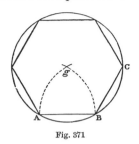
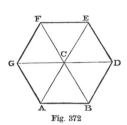
Fig. 371 Fig. 372

A C and B C to E and F, making C E and C F each equal to a side of the triangle. Bisect the angles A C F and B C E by the straight line G C D, drawn through the common vertex C, and make C D and C G each equal to C E or C F. Join B D, D E, E F, F G, and G A; then A B D E F G is a regular hexagon, described upon A B as required.

PROBLEM LXI.—*To describe a regular octagon upon a given straight line.*

Let A B (fig. 373) be the given line. From the extremities A and B erect the perpendiculars A E and B F. Extend the given line both ways to *k* and *l*, forming external right angles with the lines A E and B F. Bisect these external right angles, making each of the bisecting lines A H and B C equal to the given line A B. Draw H G and C D parallel to A E or B F, and each equal in length to A B. From G draw G E parallel to B C, and intersecting A E in E, and from D draw D F parallel to A H, intersecting B F in F. Join E F, and A B C D F E G H is the octagon required. Or from D and G as centres, with the given line A B as radius, describe arcs cutting the perpendiculars A E and B F in E and F, and join G E, E F, F D, to complete the octagon.

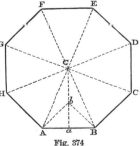
Fig. 373

Another Method.—Let A B (fig. 374) be the given line. Bisect A B in *a*, and draw the perpendicular *a b* equal to A *a* or B *a*. Join A *b*, and produce *a b* to *c*, making *b c* equal to A *b*. Join also A *c* and B *c*, extending them so as to make *c* E and *c* F each equal to A *c* or B *c*. Through *c* draw C *c* G at right angles to A E. Again, through the same point *c*, draw D H at right angles to B F, making each of the lines *c* C, *c* D, *c* G, and *c* H equal to

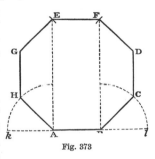
Fig. 374

A c or c B, and consequently equal to one another. Lastly, join B C, C D, D E, E F, F G, G H, H A. A B C D E F G H will be a regular octagon, described upon A B as required.

Note.—To draw an octagon on a given straight line by means of the carpenter's square, place the square over the line in such a manner that, when the blade and tongue touch the extremities of the line, the points of contact are at equal distances from the

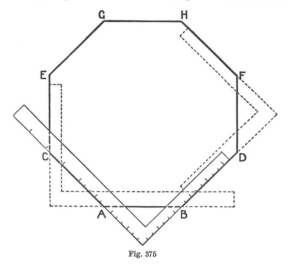

Fig. 375

angle of the square (fig. 375); rule lines along the blade and tongue, namely A C and B D, making them equal to A B; then lay the blade of the square along A B in such a manner that the tongue touches the point c, and rule the line C E along the tongue, making it equal to A B; proceed in a similar manner to find D F; then lay the blade of the square along B D in such a manner that the tongue touches the point F, and rule the line F H along the tongue, making it equal to A B; find E G in a similar manner, and finally join G H.

PROBLEM LXII.—*Upon a given straight line to describe any regular polygon.*

Let A B (fig. 376) be the given straight line, and let it be required to construct thereon a regular heptagon. Produce A B to C, making B C equal to A B, and from B as centre, with radius B A or B C, describe the semi-circle A D C. Divide the semi-circumference A D C into seven equal parts—the number of sides in a *heptagon*. Draw B D to the second division of the semicircle from C. Bisect also A B in e, and B D in f, and draw e G and f G respectively perpendicular to A B and B D. G is the centre of a circle, whose circumference passes through the points A, B, and D. Complete the circle A B D H, and it will contain the given side A B seven times, which is the number of sides required. The points of the heptagon may be found by setting off the distances with the compasses, or by producing the dotted radii from B.

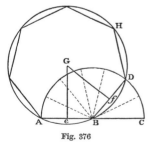

Fig. 376

Note.—A protractor is required to divide the semicircle A D C *accurately* into seven parts, and it might just as well be used directly to set off the angle A B D = 128$\frac{4}{7}$°; then make B D equal to A B, and find the centre G, and proceed as above.

Regular polygons can also be constructed on given straight lines by calculating the length of their apothems or of their radii. The apothem of a polygon is the length of the perpendicular let fall from the centre of the circle circumscribing the polygon to one of the sides; thus, in fig. 376, G e or G f is the apothem of the heptagon, while G A and G B are radii. The following table gives the lengths of the apothem and radius when the side of the polygon equals 1, and also the length of the side when the radius equals 1. For convenience the interior and central angles of polygons are given in the same table.

Name of Polygon.	No. of Sides.	Apothem when Side=1.	Radius when Side=1.	Side when Radius =1.	Interior Angle.	Central Angle.
Pentagon......	5	0·6882	0·851	1·175	108°	72°
Hexagon......	6	0·866	1	1	120°	60°
Heptagon....	7	1·0383	1·152	·8677	128° 34$\frac{2}{7}$'	51° 25$\frac{5}{7}$'
Octagon.......	8	1·2071	1·3071	·7653	135°	45°
Nonagon.....	9	1·3737	1·4863	·684	140°	40°
Decagon.......	10	1·5388	1·6181	·618	144°	36°
Undecagon...	11	1·7028	1·7754	·5634	147° 16$\frac{4}{11}$'	32° 43$\frac{7}{11}$'
Dodecagon...	12	1·866	1·9323	·5176	150°	30°

Example.—Let A B (fig. 376) be the given line on which it is required to construct a heptagon. Bisect A B in e, and from e erect a perpendicular and make it equal to A B × 1·0383 (this being the apothem of a heptagon as given in the table). Suppose A B to be 20 inches long. Then the perpendicular e G must be 20 × 1·0383 = 20·766 inches, or about 20$\frac{3}{4}$ inches. Having made e G of the required length, from the centre G, with radius G A or G B, describe a circle, and set off around the circumference the length A B to obtain the points D, H, &c. Join these points, and the required heptagon is described on the given line. Or the *radius* may be found by calculation; assuming A B to measure 20 inches as before, the radius of the circumscribing circle will measure 20 × 1·152 = 23·04, or 23$\frac{1}{25}$ inches; then from A and B as centres, with radius equal to 23$\frac{1}{25}$ inches, describe arcs intersecting at G, and from G, with the same radius, describe the circle and proceed as before.

If it is required to describe a polygon in a given circle, the figures given in the column headed "Side when radius = 1" must be used. Suppose the radius measures 12 inches, then the side of an inscribed heptagon will measure 12 × ·8677 = 10·4124 inches, or about 10$\frac{13}{32}$ inches. This distance set off around the circle will give the points of the heptagon.

PROBLEM LXIII.—*In a given square to inscribe a regular octagon.*

Let A B C D (fig. 377) be the given square. Draw the diagonals A C and B D, intersecting each other in e; then from the

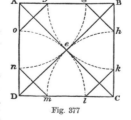

Fig. 377

angular points A B C and D as centres, with a radius equal to half the diagonal, viz. A e or C e, describe arcs cutting the sides of the square in the points f, g, h, k, l, m, n, o, and the straight lines o f, g h, k l, and m n,

joining these points, will complete the octagon, and be inscribed in the square A B C D as required.

Note.—This problem can be easily solved by means of the carpenter's square and rule. Draw the diagonals, and from the point of intersection *e* set off along each diagonal a distance equal to half the side of the square. From the points thus found draw, by means of the square, perpendiculars on both sides of the diagonals, and these will give the lines *o f*, *g h*, *k l*, and *m n*. The octagon can be drawn by the half of the rule only; set off the length of half the diagonal, *i.e.* B *e*, along each side of the given square, as A *g*, B *f*, B *k*, C *h*, &c., and join the points thus found.

PROBLEM LXIV.—*In a given circle to inscribe any regular polygon.*

Let A B D (fig. 378) be the given circle, in which it is required to inscribe a regular *pentagon.* Draw the diameter A B of the given circle, and divide it into the same number of equal parts as there are sides in the required polygon, viz. five. Bisect A B in *e*, and erect *e* C perpendicular to A B, cutting the circumference in F; and make F C, the part without the circle, equal to three-fourths of the radius F *e*. From C, the extremity of the extended radius, draw the straight line C D through the second division from A of the diameter A B, producing it to meet the opposite circumference at D. Join D A; then the line or distance between the point D thus found, and the adjacent extremity A of the diameter A B, will be a side of the required polygon; and if successively applied to the circumference A B D will form the pentagon as proposed.

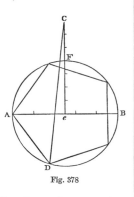

Fig. 378

Note.—The point C may be found by describing arcs from A and B with radius A B; they will intersect almost exactly at the point C.

PROBLEM LXV.—*In a given circle to inscribe any regular polygon.*

This can be done by finding the central angle of the polygon.

Divide 360° (*i.e.* the whole circumference of the circle) by the number of sides in the given polygon, and the quotient will be the number of degrees contained in the angle at the centre. Suppose, for example, that the polygon to be inscribed in the given circle A (fig. 379) is a regular hexagon. By a scale of chords, or any other instrument for measuring angles, make an angle at B, the centre of the circle, equal to 60°, the legs of which when produced meet the circumference at C and D. Draw the chord C D; this line, applied six times successively to the circumference of the given circle, will constitute the required hexagon. To find the angle of any polygon, we have

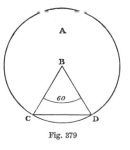

Fig. 379

only to subtract the angle at its centre from 180°. For instance, the angle at the centre of a hexagon being 60°, subtract 60 from 180, and the remainder is 120, the interior angle of the hexagon, *i.e.* the angle formed by any two of its adjacent sides. Suppose the required polygon to be an octagon, the angle at the centre of this figure is found, as directed above, to be 45°, which being subtracted from 180°, gives for the remainder 135°, the angle formed by the adjoining sides of the octagon.

Or, more simply, for the hexagon draw any radius B C (fig. 379), and upon B C describe the equilateral triangle B C D, which, being repeated round the circle, will complete the hexagon.

Note.—To find the angle at the base of the elementary triangle of any regular polygon, find first the interior angle of the polygon, by the rules already given, and one-half of that angle will be the angle at the base of its elementary triangle. Thus, the interior angle of a hexagon is 120°, one half of which is 60°; this is the angle at the base of the elementary triangle, upon which the hexagon is constructed. The interior angle of an octagon is 135°, one-half of which is 67½, or 67° 30'—the angle at the base of its elementary triangle.

PROBLEM LXVI.—*In a given circle to inscribe an equilateral triangle, a hexagon, or a dodecagon.*

Let A D G E, &c. (fig. 380), be the given circle, of which B is the centre. From any point A in the circumference of the circle, with the radius A B, equal to that of the given circle, describe the arc C B D, and join C D. From C as a centre, with the radius C D, cut the circumference at E, also join D E and E C, then C D E will be the equilateral triangle required. For the hexagon, apply the radius A B six times round the circumference of the given circle, and the figure A C F E G D

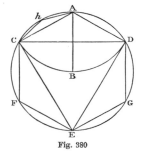

Fig. 380

will be the hexagon sought; or the same result may be obtained by bisecting each of the three arcs between the points of the triangle, namely, C A D, D G E, and E F C. To draw the dodecagon, bisect the arc A C in *h*, and join A *h*, *h* C; then either of these lines, applied twelve times successively to the circumference, will form the dodecagon, and be contained in the circle.

Another method of inscribing an equilateral triangle.—Let A B E (fig. 381) be the given circle, and C its centre. Draw the diameter A B, upon which describe the equilateral triangle A D B. Join C D, cutting the circumference in E. Then through E draw E F parallel to D A, and E G parallel to D B, and meeting the opposite circumference in F and G. Join F G. The triangle E F G is equilateral, and inscribed in the circle A B E.

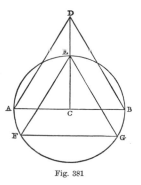

Fig. 381

PROBLEM LXVII.—*In a given circle to inscribe a square or an octagon.*

Let A B C (fig. 382) be the given circle. Draw the diameters A C and B D at right angles to each other. Join A B, B C, C D, and D A. These lines will form the square A B C D. Bisect the arcs A B, B C, C D, and D A in the points *e, f, g,* and *h.* Join A *e,* *e* B, B *f,* &c., and the octagon will be completed and inscribed, as required.

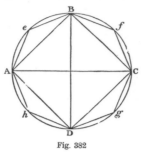

Fig. 382

PROBLEM LXVIII.—*To inscribe a regular pentagon or a regular decagon in a given circle.*

Let A B C D (fig. 383) be the given circle, of which *o* is the centre. Draw the diameters A C, B D at right angles to each other. Bisect the radius A *o* in E, and from E, with the distance E B, describe the arc B F, cutting A C in F. Also from B as a centre, with the distance B F, describe the arc F G, cutting the circumference in G. Join G B, and four such chords applied from G round the circumference will terminate in B, and form the pentagon.

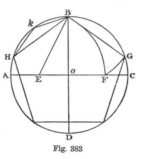

Fig. 383

Bisect the arc B H in *k.* Join B *k* and H *k.* If the same process be repeated with each of the arcs, or if either of the chords B *k* or *k* H be carried round the circumference, a decagon will be inscribed in the circle, as required.

Note.—The solution of the problem may be obtained somewhat differently. Let B be one of the angular points of the required pentagon. From B draw the diameter B D; then divide any radius, as *o* C, into mean and extreme proportion (Prob. X) at F; from D, with radius equal to *o* F (the mean proportion), describe arcs cutting the circumference of the circle to the right and left, and join the points of intersection; this gives one side of the required pentagon, and the figure can be completed by setting off chords of the same length around the circle.

PROBLEM LXIX.—*To describe a square, and an octagon, about a given circle.*

Let A D B C (fig. 384) be the given circle. Draw the diameters A B and C D, intersecting each other at right angles. Through the extremities of these diameters draw the lines E C F, G D H, F B G and H A E, parallel to A B and C D, and intersecting at the angular points E, F, G, and H. The figure E F G H is the circumscribing square. Join E G and F H, cutting the circle in the points *a, b, c,* and *d*; also through these points draw the lines *k l, m n, e f,* and *g h,* at right angles to their respective radii, and they will complete the octagon, which is also described about the circle A D B C.

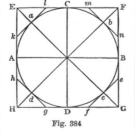

Fig. 384

PROBLEM LXX.—*About a given circle to describe a regular polygon.*

Let it be required to describe a regular pentagon about a given circle A C D (fig. 385), whose centre is *o.* Divide the circumference into five equal parts— the number of sides contained in the given polygon—and from the points A B C D and E, thus found, draw to the centre *o* the radii A *o,* B *o,* C *o,* D *o,* and E *o*; also through these same points draw the lines *f* A *g,* *g* B *h,* *h* C *k, k* D *l,* and *l* E *f* perpendicular to

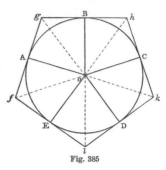

Fig. 385

their respective radii, and intersecting one another in the angular points *f, g, h, k,* and *l.* A regular pentagon will be formed, and be described about the circle.

Note.—Another method is to inscribe a regular polygon in the circle, and then draw tangents parallel to the sides of the inscribed polygon.

PROBLEM LXXI.—*Any regular polygon being given, to construct another having the same perimeter, but containing any different number of sides.*

Let it be required to construct a regular octagon, having its perimeter equal to that of a given hexagon. Divide A B, a side of the given hexagon (fig. 386 No. 1),

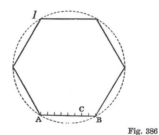
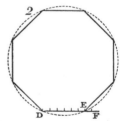

Fig. 386

into eight equal parts, the number of sides in the required figure. Let A C be six of these equal parts. Draw D E (No. 2) equal to A C, or to six-eighths of the given line A B; and upon D E, by Problem LXI or LXII, describe a regular octagon; its perimeter will be equal to that of the given hexagon.

Note.—In the preceding example the figure required has a greater number of sides than that which is given; but to reverse the process, let D E (No. 2) be the side of a given octagon, and let a hexagon be the polygon required. Divide the line D E into six equal parts, and extend it to F, so as to make E F equal to two of these parts, or the whole line D F equal to eight of these same parts, and consequently equal to A B.

7. THE ELLIPSE, PARABOLA, AND HYPERBOLA

THE ELLIPSE.—The technical definition of an ellipse has already been given (page 235), and need not be repeated here, but a little further description is necessary. The longest diameter of an ellipse, A B in fig. 387, is known as the *major axis,* and the shortest diameter, C D, at right angles to A B and passing

through its central point E, is known as the *minor axis*; E is the "centre", and A and B are the two "vertices" of the curve. The two points F and G are the two *foci* of the ellipse, and are found by turning an arc from C or D as centre, with the radius A E or B E;

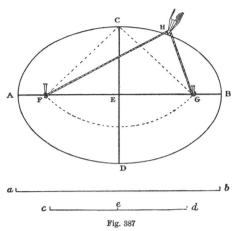

Fig. 387

the points where the arc intersects the major axis are the two foci. The sum of the two lines drawn from the foci of an ellipse to any point in the circumference is equal to the sum of the two lines drawn from the foci to any other point in the circumference, and also equal to the major axis; thus, in fig. 387,

$$F C + C G = F H + H G = F B + B G = A B.$$

This property of an ellipse is applied in drawing an ellipse by means of a cord, as shown in fig. 387. Two methods of drawing ellipses by means of the trammel and square have been illustrated and described on page 203, and need not be further considered.

PROBLEM LXXII.—*To draw an ellipse by means of a string, the major and minor axes being given.*

Let *a b* (fig. 387) be the major axis, and *c d* the minor axis. Draw A B equal to *a b*, and bisect it in E; bisect *c d* in *e*, and through E draw C E at right angles to A B, making C E equal to *c e* and E D equal to *e d*. From C, with radius equal to A E or E B, describe an arc cutting A B in F and G. F and G are the two foci. Insert pins vertically at F and G, and tie to them the two ends of a string of such a length that, when extended in an angular form as shown by the dotted lines, the point of the angle will coincide with the point C. Insert the point of a pencil in the angular loop at C, and the circumference of the ellipse can be traced by carrying the pencil around as at H.

Note.—The length of the string can be more easily adjusted if a third pin is inserted temporarily at C, and if the string is fixed at F and G by being transfixed by the pins at those points instead of being knotted. First transfix the string at F, then pass the string around the temporary pin at C, and transfix it again at G; remove the pin at C, and the curve A C B can be traced. To trace the other half, it will be necessary to lift the string over the pins, and then proceed as before. The whole operation can be completed at once, if in the first instance the string is made in the form of a triangle, of which the sides are F C, C G, and G F, the two ends being knotted together; if this is done, the string is merely looped around the three pins and not

fixed; on removing the pin at C the curve can be traced. The string should be flexible but non-elastic.

PROBLEM LXXIII.—*To draw an ellipse by means of a slip of paper, the major and minor axes being given.*

Let A B (fig. 388) be the major axis, and C D the minor axis. Take any straight-edged slip of paper, and set off along it *a e* equal to A E, and *e c* equal to E C, and produce A B and C D indefinitely. Lay the slip of paper thus marked in any position as shown by the dotted lines, with the point *a* on the line E D or E D produced, and the point *c* on the line E B or E B produced; the point *e* will give one point in the circumference of the ellipse. Any number of points between D and B can be found in the same way, as shown by the dotted lines. To find points between C and B, *a* must be laid on E C or E C produced, and *c* on E B

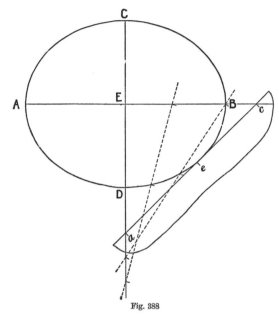

Fig. 388

or E B produced. Proceed in a similar manner for the other half of the ellipse. A line traced through the points thus found will give the circumference of the required ellipse.

PROBLEM LXXIV.—*To draw an ellipse by finding a number of points in the curve, the major and minor axes being given.*

Let A C (fig. 389) be the major axis, and D B the

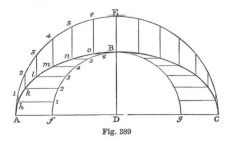

Fig. 389

semi-axis minor. On A C describe the semicircle A E C, and from the same centre D, and with the length of the semi-axis minor as radius, describe the semicircle

f B *g*. Divide both semicircles into the same number of parts, 1, 2, 3, 4, &c., by drawing radii from D to 1–1, 2–2, 3–3, 4–4, &c.; through the points of division of the greater semicircle draw lines perpendicular to A C, and through the corresponding points of division of the smaller semicircle draw lines parallel to A C, and the intersections of the two sets of lines *hklmno*, &c., will be points in the curve required.

Note.—The curve may be traced by hand, or may be drawn with compasses in the following manner. In fig. 390 the points 1′, 2′, 3′, and 4′ have been obtained as explained above. Then,

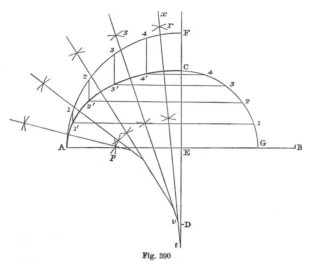

Fig. 390

through the centre of the side 4′ c, draw a perpendicular *r t* cutting the minor axis produced in *t*, and *t* is the centre of the arc 4′ c. Through the centre of 3′ 4′ draw a perpendicular *s v* cutting *r t* in *v*, and *v* is the centre of the arc 3′ 4′; and so on until the last arc A 1′, the centre for which is obtained at the intersection of the perpendicular with the major axis at *p*. As the ellipse is a symmetrical figure divided into four equal and similar parts by its axes, the remaining three quarters can readily be drawn, by producing the horizontal lines 4′ 4, 3′ 3, 2′ 2, and 1′ 1 to the right, and making the parts on the right of the minor axis equal to the corresponding parts on the left; for the lower half of the ellipse draw vertical lines from 1′, 2′, 3′, 4′, and set off on these lines below the major axis the same distances that the points are above the major axis.

PROBLEM LXXV.—*The axes of an ellipse being given, to draw the curve by intersections.*

Let A C (fig. 391) be the major and D B the semi-axis minor. On the major axis construct the parallelo-

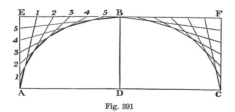

Fig. 391

gram A E F C, and make its height equal to the semi-axis minor. Divide A E and E B each into the same number of equal parts, and number the divisions from A and E respectively; then join A 1, 1 2, 2 3, &c., and their intersections will give points through which the curve may be drawn.

Another Method.—Let A C (fig. 392) be the major and E B the minor axis. Draw A F and C G each perpendicular to A C, and equal to the semi-axis minor. Divide A D, the semi-axis major, and the lines A F and

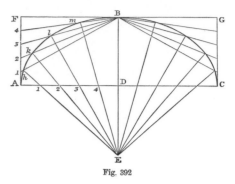

Fig. 392

C G each into the same number of equal parts, in 1, 2, 3, and 4; then from B, to the divisions 1, 2, 3, and 4 on the line A F, draw the lines B 1, 2, 3, and 4; and from E, through the divisions 1, 2, 3, and 4, on the semi-axis

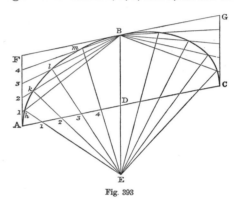

Fig. 393

major A D, draw the lines E *h*, E *k*, E *l*, and E *m*, and the intersection of these with the lines B 1, 2, 3, and 4, in the points *h k l m*, will be points in the curve. In the same manner are drawn the rampant ellipse, fig. 393,

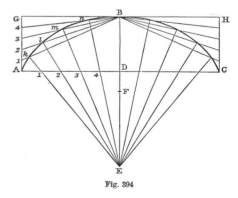

Fig. 394

the segment of the ellipse, fig. 394, and the rampant segment, fig. 395, the point F in the two latter figures being the intersection of the major and minor axes, *i.e.* the "centre" of the ellipse.

Note.—The lines A C and B E (fig. 393) are two diameters of the ellipse, as they pass through the centre D. They are also "conjugate" diameters, because the tangents at the extremities of each diameter are parallel to the other diameter; thus, F G is parallel to A C, and F A and G C are parallel to B E.

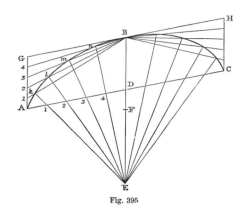

Fig. 395

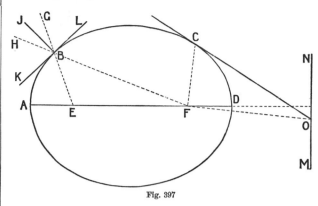

Fig. 397

PROBLEM LXXVI.—*To find the centre, axes, foci, and directrix of a given ellipse.*

Let A B C D (fig. 396) be the given ellipse. Draw any two parallel straight lines across the ellipse, as A B and C D, and bisect them in E and F. Join E F and produce both ways to meet the circumference in G and H. Bisect G H in J; J is the centre of the ellipse. With centre J and any suitable radius describe an arc to cut the circumference of the ellipse

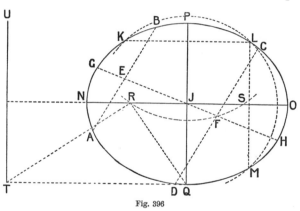

Fig. 396

in three points, as K, L, M, and join K L and L M; through J draw N J O parallel to K L, and P J Q parallel to L M. N O and P Q are the axes of the ellipse. From P or Q with radius equal to J N or J O, describe an arc cutting N O in R and S. R and S are the two foci of the ellipse. Join Q R, and from R draw R T perpendicular to Q R; from Q draw Q T parallel to N O and meeting R T in T; and through T draw T U parallel to Q P. T U is the directrix of the ellipse.

PROBLEM LXXVII.—*To draw a perpendicular and tangent at any given point in the circumference of an ellipse.*

Let A B C D (fig. 397) be the given ellipse, and B the given point. Find the foci E and F, and join E B and F B and produce to G and H. Bisect the angle G B H by the line B J. B J is the perpendicular required. Through B draw L K perpendicular to B J, or bisect the angle G B F by the line L K. L K is the tangent required.

Note.—Tangents can also be drawn by the help of the directrix. Let it be required to draw a tangent at the point c (fig. 397). Find the directrix M N. Join C F, and from F draw F O perpendi-

cular to C F, and meeting the directrix M N in O. Join O C. O C is the tangent required.

PROBLEM LXXVIII.—*To describe with a compass a figure resembling an ellipse, the major axis being given.*

Let A B (fig. 398) be the given axis. Divide A B into three equal parts at the points *f* and *g*. From these

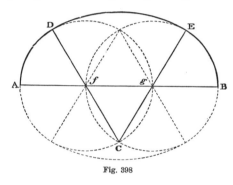

Fig. 398

points as centres with the radius *f* A, describe circles which intersect each other, and from the points of intersection through *f* and *g*, draw the diameters C *g* E, C *f* D. From C as a centre, with the radius C D, describe the arc D E, which completes the semi-ellipse. The other half of the ellipse may be completed in the same manner, as shown by the dotted lines.

Note.—The proportions of the ellipse may be varied by altering the number of the divisions of the given axis, as thus :— Divide the major axis of the ellipse A B (fig. 399) into four equal

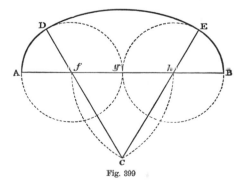

Fig. 399

parts, in the points *f*, *g*, and *h*. On *f h* construct an equilateral triangle *f c h*, and produce the sides of the triangle C *f*, C *h* indefinitely, as to D and E. Then from the centres *f* and *h*, with the radius A *f*, describe the circles A D *g*, B E *g*; and from the centre C, with the radius C D, describe the arc D E to complete the

semi-ellipse. The other half may be completed in the same manner. By this method of construction the minor axis is to the major axis as 14 to 22.

PROBLEM LXXIX.—*To describe with a compass a figure resembling an ellipse, the major and minor axes being given.*

Let A C (fig. 400) be the major axis, and D B the semi-axis minor. Divide D B into three equal parts in

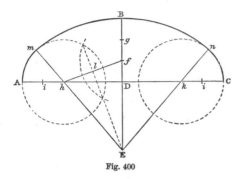

Fig. 400

f and *g*, and make A *h*, C *k* each equal to two of these parts. Join *h f*. From *h* and *k*, with the radius A *h*, describe the circles A *m*, C *n*. Bisect the line *h f* by the perpendicular *l*, meeting the axis B D produced in E. From E, through *h*, draw the line E *h m*, meeting the circle A *m*, and from E, with the radius E *m*, describe the arc *m* B *n*, completing the semi-ellipse.

Another Method.—Let A C and B E (fig. 401) be the axes of the ellipse. Draw A F parallel and equal to D B:

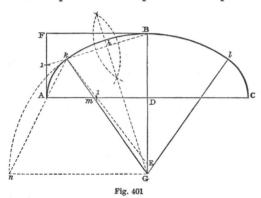

Fig. 401

bisect it in 1, and join 1 B. Divide A D also into two equal parts in 1, and from E, through 1, draw the line E 1 *k*, meeting 1 B in *k*. Bisect *k* B by the perpendicular *h*, meeting the axis B E produced in G. Join G *k*, cutting the major axis in *m*. Then from *m*, with the radius *m* A, describe the arc A *k*, and from G, with the radius G *k*, describe the arc *k* B. A *k* B is one quarter of the figure required.

PROBLEM LXXX.—*To describe with a compass a figure still more closely approximating to the ellipse, the major and minor axes being given.*

Let A C and B E (fig. 402) be the two given axes. Draw A F parallel and equal to D B, divide it into three equal parts, and draw 1 B, 2 B. Then divide A D also into three equal parts, and from E, through the points 1 and 2, draw the lines E *m*, E *k*, cutting the lines 1 B

and 2 B in *m* and *k*. Bisect *k* B by a perpendicular *h*, meeting E B produced in G, and join *k* G. Bisect *m k* by a perpendicular *l*, meeting *k* G in *n*, and join *m n*. Then G is the centre for the arc B *k*, *n* is the centre for the arc *k m*, and *o* is the centre for the arc *m* A. From the centre D measure the points of intersection

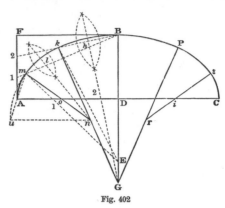

Fig. 402

of the lines G *k*, *n m*, with the axis A C, and transfer the measurements to the other side of D; and set off and make G *r* equal to G *n*. Through *r* draw *r s*, and the centres G *r i*, for the other half of the curve, will be obtained.

Note.—By dividing A F and A D into a greater number of equal parts, a still closer approximation to the ellipse can be obtained.

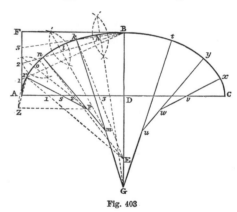

Fig. 403

This is shown in fig. 403; it is unnecessary to describe the construction, as no new principle is involved.

THE PARABOLA.—The parabola is a plane figure produced by the section of a cone parallel to its side or inclination. The curve S M E P T (fig. 404) is a parabola. The line E A bisecting the figure is called the "axis", and any line parallel to the axis is called a "diameter" of the curve; E is the "vertex". Lines drawn perpendicular to the axis from points in the curve are known as "ordinates" of those points; thus, M G is the ordinate of the point M. The "double ordinate" passing through the focus is called the "latus-rectum" or "principal parameter", and is always equal to four times the distance from the focus to the vertex of the curve; in fig. 404 S T is the "latus-rectum", and is equal to four times the length of A E. The parabola has only one focus, and this is always at a point on the axis; the distance from the focus to any point in

the parabolic curve is invariably equal to the distance from that point to the nearest point in a certain line outside the parabola and perpendicular to its axis, this line being known as the "directrix". The following problem illustrates this property of the parabola.

PROBLEM LXXXI.—*To draw a parabola, the focus and directrix being given.*

Let A (fig. 404) be the given focus, and B C the given directrix. From A draw A D perpendicular to B C, and bisect A D at E; E will be one point in the required curve. From A as centre, with radii greater than A E, as A F, A H, A K, and A D, describe arcs as shown. From E set off along E A the parts E G, E J, and E L equal to E F, E H, and E K— E A is by construction equal to E D—and through the points G, J, L, and A draw lines perpendicular to D A, and intersecting the arcs in M and N, O and P, Q and R, and S and T respectively. The points of intersection are points in the required curve, and the parabola T E S can be traced through them

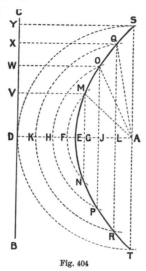

Fig. 404

as shown. The line drawn from the focus A to any point in the curve is equal to the line drawn from that point to the nearest point in the directrix; thus, A M is equal to M V, A O to O W, A Q to Q X, and A S to S Y.

PROBLEM LXXXII.—*To draw a tangent at any point in a given parabola, the axis being given.*

Let A (fig. 405) be the given point, and B C the given axis. From A draw A D perpendicular to B C, and produce B C to E, making B E equal to B D. The line drawn from E through A is the tangent required.

Note.—Perpendiculars to the curve at any points can be drawn by first drawing tangents to those points, and then from the points drawing perpendiculars to the tangents.

PROBLEM LXXXIII. —*To find the focus and directrix of a given parabola, the axis being given.*

Let B A (fig. 405) be part of the given parabola and B C the given axis. Draw the tangent E A (Prob. LXXXII); from A draw A F parallel to B C, and make the angle E A G equal to the angle E A F. The point G is the focus required. Or, from A draw the "normal" A C (*i.e.* perpendicular to the tangent E A) till it meets the axis in C; bisect D C in H, and set off B G equal to

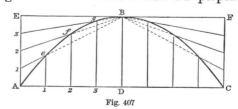

Fig. 405

D H or H C. Or, bisect any ordinate A D in K. Join B K, and from K draw K H perpendicular to B K and cutting the axis in H. From B set off B G equal to D H. To find the directrix, make B J equal to B G, and through J draw F J L perpendicular to J C. F L is the directrix.

PROBLEM LXXXIV.—*To draw a parabola, the vertex and a pair of ordinates being given.*

Let A B (fig. 406) be the given ordinates, and D the given vertex. Bisect A B in C, and join D C. Divide

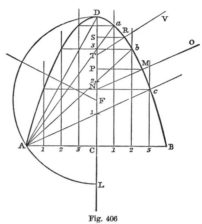

Fig. 406

A C, C B, and D C into the same number of equal parts —say four. From the points 1, 2, and 3 in C B, draw lines parallel to the axis C D, and from A, through the points 1, 2, and 3 in C D, draw lines intersecting the former at *c*, *b*, and *a*. Proceed in the same manner for the other half of the figure, and the required curve can then be traced through the points B, *c*, *b*, *a*, D, &c. to A.

Note.—Perpendiculars to the curve may be drawn by means of the parameter, which is a third proportional to C D and C A. For this, draw A D and bisect it by a perpendicular, which produce until it cuts the axis in F, from which as a centre, and with F D as a radius, describe the semicircle D A L, which meets the axis produced in L; C L is the parameter. Having found the parameter, to draw a perpendicular to any point M in the curve, proceed thus:—Draw through M a line M P, parallel to A B, and set off half the parameter C L from P to N, then draw N M O, which is the perpendicular sought. In like manner, from the point R draw R S parallel to A B; make S T equal to half the parameter, and through R draw T V, which is a perpendicular to the curve at R.

PROBLEM LXXXV.—*To draw a parabola by intersections, the vertex and a double ordinate being given.*

Let A C (fig. 407) be the given double ordinate, and B the given vertex. From B draw B D perpendicular

Fig. 407

to A C. On A C construct the rectangular parallelogram A E F C, its height being equal to D B. Divide

the side A E into any number of equal parts, and
the half of the base, A D, into the same number of
equal parts. From these divisions raise the perpen-
diculars 1 *e*, 2 *f*, 3 *g*, &c., and intersect them by the
lines 1 B, 2 B, 3 B, drawn from the divisions in A E to
the vertex B. The points of intersection, *e*, *f*, *g*, are
points in the line of the curve.

Another Method.—Let A C (fig. 408) be the double
ordinate, and B the vertex. Produce the axis to E,

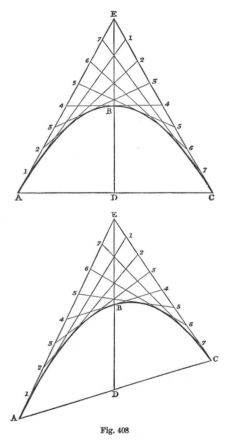

Fig. 408

and make B E equal to D B. Join E C and E A, and
divide them each into the same number of equal parts,
and number the divisions as shown. Join the corre-
sponding divisions by the lines 1 1, 2 2, &c.; these lines
will form a polygon, the sides being tangential to the
required curve.

PROBLEM LXXXVI.—*To describe a parabola by
means of a straight rule and a square, its double
ordinate and abscissa being given.*

Let A C (fig. 409) be the double ordinate, and D B
the height or abscissa. Bisect D C in F. Join B F, and
draw F E perpendicular to B F, cutting the axis B D
produced in E. From B set off B G equal to D E, and G
will be the focus of the parabola. Make B L equal to
B G, and lay the rule or straight-edge H K on L, and
parallel to A C. H K is therefore the directrix of the
parabola. Take a string M *r* G, equal in length to L E;
attach one of its ends to a pin at G, and its other end
to the end M of the square M N O. If now the square
be slid along the straight-edge, and the string be

pressed by means of a pencil against the edge M N,
as shown in one position at *r*, the pencil will describe
the curve required.

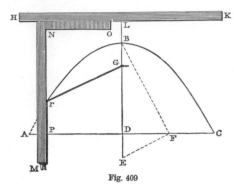

Fig. 409

THE HYPERBOLA.—The hyperbola is a plane figure
produced by the section of a cone parallel to its axis
If four right cones, as
E C B, B C H, H C G, and
G C E (figs. 410 and 411), are
placed together with their
sides touching and their
apices meeting at the point
C, and their axes in the
same plane, and a section
is then made through
them parallel to the plane
of the axes, four hyper-
bolas will be formed as
shown in the figures. If
the vertical angles of the cones are right angles, as
in fig. 410, the four cones will form a square, and a
circle can be drawn from the centre C to touch the

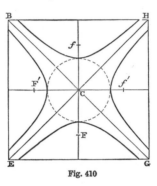

Fig. 410

vertices of the four hyperbolas. If, however, the
vertical angles of two equal opposite cones are each so
many degrees less than a right angle, and those of the
other two equal cones are each the same number of
degrees more than a right angle, the four cones will
form a rectangle, as in fig. 411, and the vertices of
the four hyperbolas will be touched by an ellipse

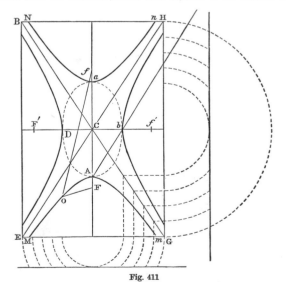

Fig. 411

D *a b* A, as shown by the dotted line. Hyperbolas of this kind are sometimes known as "elliptic" hyperbolas, the term "circular" or "equilateral" being applied to those of the kind shown in fig. 410. The diagonals B G and E H, forming the sides of the cones, are called the "asymptotes"; C is the "centre"; F, F′, *f*, and *f*′ are the foci, which are all equidistant from the centre; A *a* (fig. 411) is the "transverse" axis, and D *b* the "conjugate" axis.

The foci are thus found:—Take A *b* (fig. 411) and set it from C to F, F′, *f*, and *f*′; then F, F′, *f*, and *f*′ are the foci, which, whether the hyperbolas are circular or elliptic, are always equidistant from the centre C.

The property of the foci is, that if a line is drawn from any point of a hyperbola to its focus, and another line from the same point to the focus of the opposite hyperbola on the same axis, then the difference of these two lines will be always equal to the axis, on the production of which the foci are. Thus if a line O F (fig. 411) is drawn from a point in the hyperbola to its focus F, and another line from the same point to the focus of the opposite hyperbola *f*, then O *f* − O F = the axis A *a*. This property furnishes a ready mode of describing the hyperbola graphically, as shown in the following problem.

PROBLEM LXXXVII.—*To draw a hyperbola, the transverse axis and two foci being given.*

Let A *a* (fig. 412) be the given transverse axis, and F *f* the given foci. On the indefinite line E G make the length E H equal to A *a*; from the foci, with a radius greater than A *f* or F *a*, describe the indefinite arcs *e e*. Then set off this radius on the line E G, from E to 1, and take the difference H 1, and with that as a radius from the foci, describe other arcs cutting the

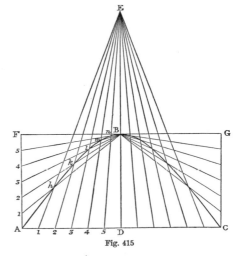

Fig. 413

Fig. 412

first arcs in 1 1, which will be points in the hyperbolas. In the same way take a radius E 2, and describe arcs from the foci as centres, and intersect them with other arcs having a radius equal to H 2, and so on for the points 3, 4. The intersections are points in the curve through which the hyperbola can be drawn.

Note.—The hyperbola can also be described by a continuous motion. Let H K (fig. 413) be a rule, one end of which moves round the focus F as a centre. To its other end let there be attached a cord a little shorter than the length of the rule, and let the other end of the cord be fastened to the focus *f* of the hyperbola to be described. When the rule is in the line of the axis F *a*, the length of the cord must be such that the bight *b* falls upon the vertex of the hyperbola *a*. Then making the rule move round F as a centre, and at the same time holding the cord close to the rule by a pencil, the pencil will describe a hyperbola.

PROBLEM LXXXVIII.—*To draw tangents and perpendiculars to given points in a hyperbola, the asymptotes being given.*

Let M and N (fig. 414) be the given points in the hyperbola, and A C, C B the asymptotes. Draw the lines H M, K N parallel to the asymptotes, and make *h* A equal to *h* C, and *k* B equal to *k* C. Then the line A M E is a tangent to the curve at the point M, and the line B N F is a tangent to the curve at the point N; and if from these points the lines M O, N P be drawn perpendicular to the tangents, these lines will be perpendiculars to the curve.

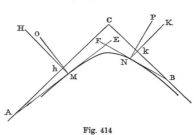

Fig. 414

PROBLEM LXXXIX.—*The axis, vertex, and ordinate of a hyperbola being given, to find points in the curve.*

Let D A (fig. 415) be the ordinate, B the vertex, and B E the axis. Produce E B to D. Produce A D to C,

Fig. 415

making D C equal to A D. Through B draw F G parallel to A C, and through A and C draw A F, C G parallel to D E; divide A D, A F into the same number of equal parts. From E draw lines to the divisions in A D, and from B draw lines to the divisions in A F, and the intersections of the lines from the corresponding points will give points in the curve.

PROBLEM XC.—*To draw a hyperbola, the asymptotes and a point on the curve being given.*

Let A B, A C (fig. 416) be the given asymptotes, and D the given point. Bisect the angles between the

asymptotes by the lines L_2 A E and G A H. Through D draw B C perpendicular to A E, meeting the asymp-

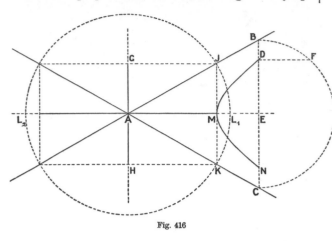

Fig. 416

totes in B and C. Take a mean proportional D F between the lines B D and D C, and set off from A, along

the line G H, A G and A H equal to D F. G H will be the conjugate axis. Through G draw G J parallel to A E and meeting A B in J, and through J draw J K parallel to G H and cutting A E in M. A M will be the semi-transverse axis. From A, with radius A J or A K, describe a circle cutting the transverse axis produced in L_1 and L_2; these points will be the foci of the pair of hyperbolas, and the hyperbola D M N can now be drawn by means of Problem LXXXVII.

8. SPIRALS

A spiral may be popularly defined as a curve described about a fixed point (known as the "pole"), and making any number of revolutions around that point but without returning into itself. In architecture the most common examples of spirals are the volutes of Ionic capitals and the scrolls of handrails.

PROBLEM XCI.—*To describe a logarithmic or equiangular spiral, the height and pole being given.*

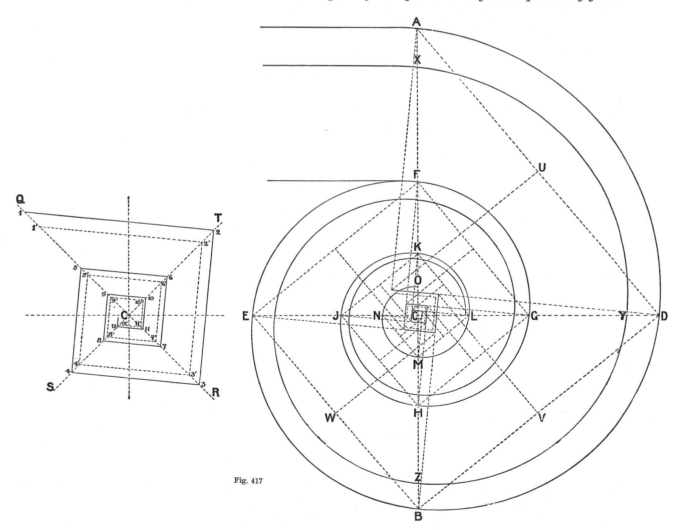

Fig. 417

Let A B (fig. 417) be the given height and c be the given pole. Through c draw E D perpendicular to A B, and make C D a mean proportional between A C and C B. Join A D and D B. Then, either make C E a third

proportional to C D and C B, and join B E, and make C F a third proportional to C B and C E, and join E F, and proceed in the same manner to find the remaining points in the curve, namely, G, H, J, K, L, M, and N; or

draw B E perpendicular to B D and cutting D C produced in E, E F perpendicular to E B and cutting A B in F, F G perpendicular to F E, and so on for the remaining points. A, D, B, E, F, G, H, J, K, L, M, and N will be points in the required spiral. [To avoid confusion in the diagram the spiral is not completed to the pole.] The curve may be drawn by means of circular arcs, the centres of which can be found as follows:—Bisect the angles at the pole C by the lines Q R and S T, shown in the enlarged diagram. Bisect A D in U, and from U

draw U 1 perpendicular to A D and meeting Q C in 1; 1 will be the centre from which the arc A D may be described. Bisect D B in V, and from V draw V 2 perpendicular to D B and meeting C T in 2; 2 will be the centre from which the arc D B may be described. The remaining centres may be found in a similar manner, or may be found by joining 1–2, and from 2 drawing a perpendicular meeting C R in 3, and from 3 drawing a perpendicular to 2–3 meeting C S in 4, and so on. If the drawing is correctly made, it will be found that

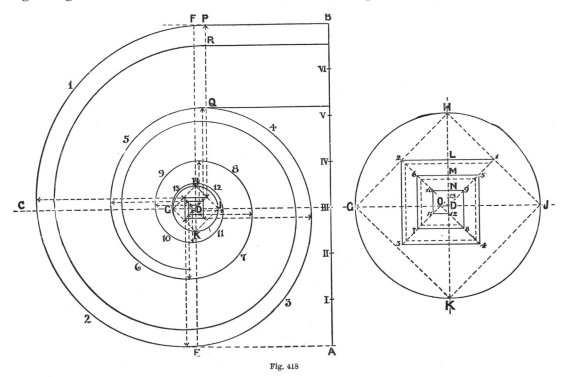

Fig. 418

the lines on which the centres lie will, if produced, meet the points already found in the spiral curve; thus, 1–2 produced meets the curve at D, 5–6 produced meets it at G, 9–10 produced meets it at L, 2–3 produced meets it at B, and so on.

Note.—This is by far the best method of drawing the Ionic volute, as it allows spirals of any degree of curvature to be described. The ordinary methods, which depend on fixed ratios between A C and C B, tend to stereotype certain forms of volute. If it is required to draw the moulds on the face of the volute, other centres must be found for them. Suppose that a fillet is required, and that it must be one-fourth the distance from A to F. Set off A X equal to one-fourth A F, and from 1 along the diagonal 1–5 set off a distance equal to one-fourth 1–5, and from the point thus found draw a line parallel to 1–2, till it meets the diagonal 2–6, and proceed in the same manner to find the remaining centres. The point 1′ on the diagonal 1–5 will be the centre of the arc X Y, the point 2′ on the diagonal 2–6 will be the centre of the arc Y Z, and so on.

PROBLEM XCII.—*To describe the Ionic volute by means of circular arcs, the height being given.*

Let A B (fig. 418) be the given height. Divide A B into seven equal parts, at I, II, III, &c., and through III draw III C perpendicular to A B. Take any convenient point D in III C, and through D draw E F parallel to A B, and from A and B erect perpendiculars to A B meeting

E F in E and F. From D as centre, with radius equal to one-half of one of the seven parts of A B, describe the circle G H J K. Join G H, H J, J K, and K G, as shown in the enlarged diagram, and bisect the angles J D H and H D G by the lines D 1 and D 2, meeting J H and H G in 1 and 2; draw the line 1 2 intersecting D H in L, and divide D L into three equal parts at M and N. From D along D G set off D O equal to half D N, and from O draw O 3 and O 4 parallel to D 1 and D 2 respectively. Through M and N draw the lines 5 M 6 and 9 N 10 parallel to J G, and from 5, 9, 10, 6, and 2 draw lines parallel to K H meeting O 4 and O 3 as shown. Join 3 and 4, 7 and 8, and 11 and 12, by lines parallel to G J. Bisect D N in the point 13. The points 1 to 13 in the enlarged diagram will be the centres of the arcs numbered 1 to 13 in the drawing of the spiral.

Note.—Another set of centres is required for drawing the inner line of the fillet of the volute. If the fillet P R is made one-fourth of P Q, the centres for the inner line will be correspondingly nearer the pole D, and may be found by setting off from L towards M a distance equal to one-fourth L M, and proceeding as shown by the dotted lines in the enlarged diagram.

Palladio's Method.—Let A B (fig. 419) be the given height. Divide A B into eight equal parts at I, II, III, &c.; bisect the part IV–V in C, and with radius C–IV or

C–V, describe a circle D–IV E–V. Through C draw F G perpendicular to A B, cutting the circle in D and E. Join D–IV, IV–E, E–V and V–D, as shown in the en-

larged diagram, and bisect the angles about C by the lines meeting E–IV in 1, IV–D in 2, D–V in 3, and V–E in 4. Divide each of the diagonals C 1, C 2, C 3, and

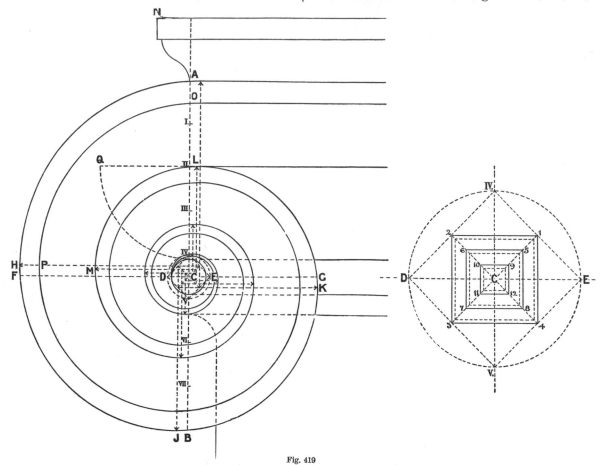

Fig. 419

C 4 into three equal parts, and join the corresponding points by lines parallel to 1–2 and 2–3. From 1 as centre, with radius 1 A, describe the arc A H; from 2,

describe the arc L M; and proceed in a similar manner for the remainder of the spiral.

Note.—If the lower diameter of the column is taken as the scale and divided into 60 parts, the dimensions of the volute, according to Palladio, should be as follows:—The height A B 28 parts; the "eye" of the volute (shown by the full-lined circle), $2\frac{2}{3}$ parts; and the abacus N A, $5\frac{1}{4}$ parts, of which $1\frac{3}{4}$ parts go to the fillet. To draw the fillet of the volute other centres are required, as shown in the enlarged diagram; if the breadth of the fillet at A is made one-fourth A L, as A O, the centre for the arc O P must be one-fourth the distance from the centre of the arc A H to the centre of the arc L M, and similarly for the remaining centres. Palladio makes A O equal to $1\frac{2}{3}$ parts, A L being equal to 7 parts. The dotted quadrant, of which the uppermost point is marked Q, represents the outline of the egg-and-dart enrichment between the volutes; below this is a torus having the same radius as the eye of the volute, then a fillet, and then the hollow forming the upper part of the necking of the capital.

PROBLEM XCIII.—*To describe the involute of a given circle (see Note below).*

Let A B (fig. 420) be a diameter of the given circle, and C the centre. Divide the circumference of the given circle into any number of equal parts. In the example

Fig. 420

with radius 2 H, describe the arc H J; from 3, with radius 3 J, describe the arc J K; from 4, with radius 4 K, describe the arc K L; from 5, with radius 5 L,

PLATE XXII

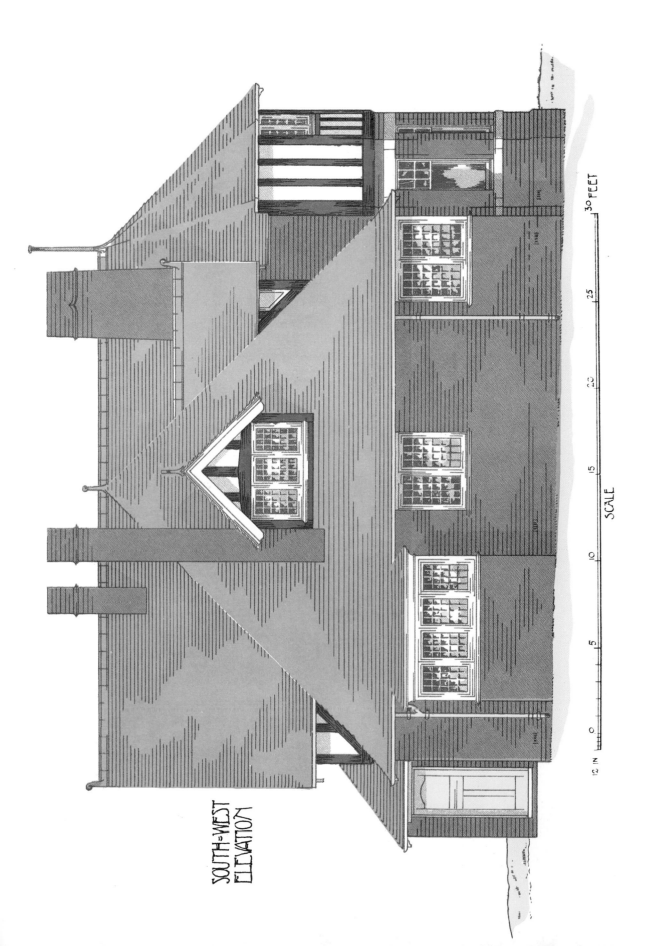

SOUTH-WEST ELEVATION

SCALE

12 IN 0 5 10 15 20 25 30 FEET

SOUTH-WEST ELEVATION OF SMALL COUNTRY HOUSE

PLATE XXII

This continues the series of drawings given in Plates XIX, XX, and XXI, and will be understood from the descriptions printed opposite those plates.

now given, it is divided into sixteen parts by drawing the diameter 4–12 perpendicular to A C, then bisecting the angles about the centre, and finally bisecting the eight angles thus formed. From B draw a tangent B D equal to the circumference of the circle (Problem LIII), and divide B D into the same number of equal parts as there are in the circumference of the circle. From the points 1, 2, 3, &c. in the semicircle, draw tangents as shown, and along the tangent from 1 set off a distance 1 a equal to B I; along the tangent from 2 set off a distance 2 b equal to B II; and so on. The points a, b, c, &c. will be points in the required curve. The curve can be drawn by compasses; produce the tangent a 1 till it cuts the tangent b 2; the point

of intersection is the centre from which the arc a b can be described. Similarly, the centre for the arc b c is the point of intersection of b 2 produced and c 3.

Note.—The involute of a circle is the path which the free end of a string would take if gradually unwound from the circle, the other end of the string being fixed to a point in the circumference of the circle. If a reel of thread is firmly held, and the thread is then unwound, the free end will describe the involute of the circular reel. This furnishes the easiest method of describing a spiral. If a string is unwound from a *cone* of proper pitch, the Ionic volute can be quickly drawn, and there can be little doubt that this is the method employed by the ancients.

Spirals suitable for the scrolls of handrails will be considered in the section on handrailing.

CHAPTER III

SOLID GEOMETRY

1. INTRODUCTORY

Solid geometry is that branch of geometry which treats of solids—*i.e.* objects of three dimensions (length, breadth, and thickness). By means of solid geometry these objects can be represented on a plane surface, such as a sheet of paper, in such a manner that the dimensions of the object can be accurately measured from the drawing by means of a rule or scale. The "geometrical" drawings supplied by the architect or engineer for the builder's use are, with few exceptions, problems in solid geometry, and therefore a certain amount of knowledge of the subject is indispensable, not only to the draughtsman who prepares the drawings, but also to the builder or workman who has to interpret them.

As the geometrical representations of objects consist entirely of lines and points, it follows that if projections of *lines* and *points* can be accurately drawn, the representation of *objects* will present no further difficulty. A study of lines and points, however, is somewhat confusing, unless the theory of projection has first been grasped, and for this reason the subject will be introduced by a simple concrete example, such as a table standing in the middle of a room. The four legs rest on the floor at A, B, C, and D (fig. 421), and perpendiculars let fall from the corners of the table-top meet the floor at E, F, G, and H. The oblong E F G H represents the horizontal projection or "plan" of the table-top; the small squares at A, B, C, and D represent the plan of the four legs, and the lines

connecting them represent the plan of the framework under the top. The large oblong J K L M is a plan of the room.

The plan or horizontal projection of an object is therefore a representation of its horizontal dimensions—in other words, it is the appearance which an object

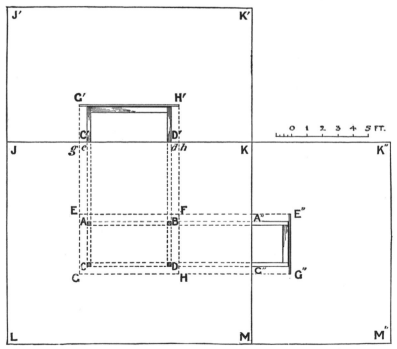

Fig. 421.—Vertical Projections (or Elevations) and Horizontal Projection (or Plan) of a Table in the Middle of an Oblong Room

presents when every point in it is viewed from a position vertically above that point.

In a similar manner an elevation or vertical projection of an object is a representation of its vertical dimensions, and also, it should be added, of some of its horizontal dimensions,—*i.e.* it is the appear-

ance which an object presents when every point in it is viewed from a position exactly level with that point, all the lines of sight being parallel both horizontally and vertically. Thus, the front elevation of the table (or the vertical projection of the side G H) will be as shown at G'H'C'D', and the vertical projection of the side J K of the room will be J'K'J K. The vertical projection of the end E G of the table will be as shown at E''G''A''C'', and of the end K M of the room will be K''M''K M; the drawing must be turned until the line K''M'' is horizontal, for these end projections to be properly seen.

By applying the scale to the *plan*, we find that the length of the table-top is 6½ feet, the breadth 4 feet, and the distance of the table from each wall 4¾ feet. From the *front elevation* we can learn the height of the table, and also its length and distance from the end walls of the room. From the *end elevation* we can ascertain the breadth of the table and its distance from the sides of the room, as well as its height.

To make the drawing clearer, let us imagine that the walls of the room are of wood and hinged at the level of the floor. On the wall J K draw the front elevation of tne table, and then turn the wall back on its hinges until it is horizontal, *i.e.* in the same plane as the floor. Proceed in a similar manner with the end K M, and we get the three projections of the room and table on one plane, as shown in the diagram. To avoid confusion the end elevation will not be further considered at present.

It will be seen that the line J K represents the angle formed by the wall and floor,—in other words, it represents the intersection of the vertical and horizontal "planes of projection"; it is known as "the line of intersection", or "the ground-line". If a line is let fall from G' perpendicular to J K, and if a line is drawn from G perpendicular[1] to J K, the two lines will meet at *g*, and they will be in the same straight line. Similarly, the perpendiculars H'*h* and *h* H are in the same straight line. Lines of this kind perpendicular to the planes of projections are known as "projectors", and are either horizontal or vertical. G'*g* and H'*h* are vertical projectors; G*g*, C *c*, D *d*, and H *h* are horizontal projectors.

Vertical projections are not always parallel to one of the sides of the object represented, or, if parallel to one side, are not parallel to other sides which must be represented; thus, a vertical projection or "elevation" of an octagonal object, if parallel to one of the sides of the octagon, must be oblique to the two adjacent sides. In fig. 422 an octagonal table is shown. The plan must first be drawn, and from the principal points of the plan projectors must be drawn perpendicular to the vertical plane of

[1] A distinction must be made between "perpendicular" and "vertical". The former means, in geometry, a line or plane at right angles to another line or plane, whether these are horizontal, vertical, or inclined; whereas a vertical line or plane is always at right angles to a horizontal line or plane. The spirit-level gives the horizontal line or plane, the plumb-rule gives the vertical,

projection, until they cut the ground-line, and from this perpendiculars must be erected to the height of the several parts of the table. The elevation can

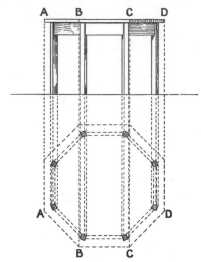

Fig. 422.—Plan and Elevation of an Octagonal Table

then be completed without difficulty. The side B C of the table is parallel to the vertical plane of projection, but the adjacent sides A B and C D are oblique.

2. POINTS, LINES, AND PLANES

I.—*To determine the position and length of a given straight line, parallel to one of the planes of the projection.*

Let G H (fig. 423) be the given straight line. To determine its position (*i.e.* in regard to horizontal and

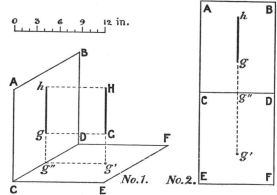

Fig. 423.—No. 1. Perspective View. No. 2. Geometrical Projections Horizontal and Vertical

vertical planes), it is only necessary to determine the position of any two points in the line. To determine its length, the position of the two extreme points must be determined.

Let A B C D be a vertical plane parallel to the given line, and C D E F a horizontal plane. The vertical projection or elevation of the line is represented by the line *h g*, and the horizontal projection or plan by the point *g'*, the various projectors being shown by dotted lines. The given line is proved to be vertical, because its horizontal projection is a point; its length, as

measured by the scale, is 6 inches; its height ($g\,g''$) above the line of intersection C D is 4 inches; and its horizontal distance ($g'\,g''$) from the same line is 8 inches.

If the illustrations are turned so that C D E F becomes a vertical plane, and A B C D the horizontal plane, then G H will be a horizontal line, because one of its vertical projections is a point. Other vertical projections of the line can be made,—as, for example, a side elevation,—in which the projection will appear as a line and not a point, but a line must be horizontal if *any* vertical projection of it is a point.

Let the given line G H (fig. 424) be parallel to the vertical plane, but inclined to the horizontal plane. Then $g\,h$ will be a vertical projection, and $g'\,h'$ its horizontal projection or plan. By producing hg till it cuts C D at c, it will be found that the given line is inclined at an angle of 60° to the horizontal plane; its length, as measured by the scale along the vertical projection $g\,h$, is 8 inches; the height of G above the horizontal plane (measured at $g\,g''$) is 3 inches; and the height of H (measured at $h\,h''$) is $9\frac{3}{4}$ inches.

Note.—Other vertical projections of the line can be made, as, for example, that at $g'''h'''$ on a plane at right angles to A B C D. In this projection the line appears vertical, but the plan shows that it is inclined, as the plan is a line and not a point; the degree of inclination can be found from $g'\,h'$ and $g'''\,h'''$ by drawing the vertical projection on a plane parallel to $g'\,h'$, that is to say, by

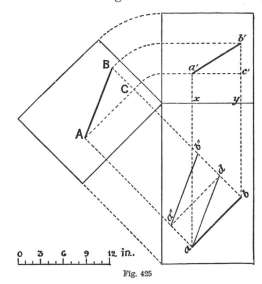

Fig. 425

usually set up from a and b as at a'' and b''; the line $a''\,b''$ is the length of the given line.

Note.—The application of this problem to hips is obvious. Suppose that $a\,b$ is the plan of a hip-rafter, and $a'\,b'$ an elevation, the length of the rafter will be equal to $a\,d$ or A B.

III.—*The projections of a right line being given, to find the points wherein the prolongation of that line would meet the planes of projection.*

Let $a\,b$ and $a'\,b'$ (fig. 426, II) be the given projections of the line A B. In the perspective representation of the problem, it is seen that A B, if prolonged, cuts the horizontal plane in c, and the vertical plane in d, and the projections of the prolongation become $c\,e$ and $f\,d$. Hence, if $a\,b$, $a'\,b'$ (fig. 426, II) be the projections of A B, the solution of the problem is obtained by producing these lines to meet the common intersection of the planes in f and e, and on these points raising the perpendiculars $f\,c$ and $e\,d$, meeting $a\,b$ produced in c and $a'\,b'$ produced in d; c and d are the points sought.

Note.—The points d and c are known respectively as the vertical and horizontal "traces" of the line A B, the trace of a straight

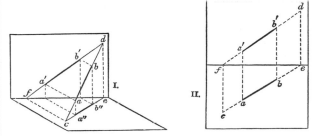

Fig. 426.—I. Perspective View. II. Vertical and Horizontal Projections

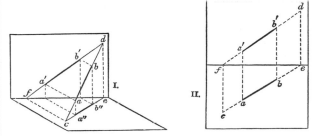

Fig. 424.—No. 1. Perspective View. No. 2. Vertical and Horizontal Projections

drawing $g\,h$. The length and inclination of the line cannot be measured from the horizontal projection $g'\,h'$ or from the vertical projection $g'''\,h'''$, but only from $g\,h$, which is the vertical projection on a plane parallel to the horizontal projection of the given line.

II.—*To determine the length of a given straight line, which is oblique to both planes of projection.*

Let $a\,b$ (fig. 425) be the horizontal projection and $a'\,b'$ the given vertical projection of the given line. Draw the projection A B on a plane parallel to $a\,b$ in the manner shown. From this projection the length of the given line will be found (by applying the scale) to be 10 inches. The height C B is of course equal to the height $c'\,b'$, and the horizontal measurement A C is equal to the horizontal projection $a\,b$, and the angle A C B is a right angle. It follows therefore that, if from b the line $b\,d$ is drawn perpendicular to $a\,b$ and equal to the height $c'\,b'$, the line joining $a\,d$ will be the

length of the given line. To avoid drawing the horizontal line $a'\,c'$ the heights of a' and b' above $x\,y$ are

line on a plane being the point in which the straight line, produced if necessary, meets or intersects the plane. A horizontal

line cannot therefore have a horizontal trace, as it cannot possibly, even if produced, meet or intersect the horizontal plane; for a similar reason, a vertical line cannot have a vertical trace.

IV.—*If two lines intersect each other in space, to find from their given projections the angles which they make with each other.*

Let ab, cd, and $a'b'$, $c'd'$ (fig. 427) be the projections of the lines. Draw the projectors $e'f'$, fe, perpendicular to the line of intersection $a'c'$, and produce it indefinitely towards E''; from e draw indefinitely, eE' perpendicular to the line $e'f$, and make eE' equal to $f'e'$, and draw fE'. From f as a centre, describe the arc E'gE'', meeting ef produced in E'', and join aE'', cE''. The angle aE''c is the angle sought. This problem is little more than a development of Problem II. If we consider ef, $e'f'$, as horizontal and vertical projections of an imaginary line lying in the same plane as ae and ce, we find the length of this line by Problem II to be fE'; in other words, fE' is the true altitude of the triangle aec, $a'e'c'$. Construct a triangle on the base ac with an altitude fE'' equal to fE', and the problem is solved.

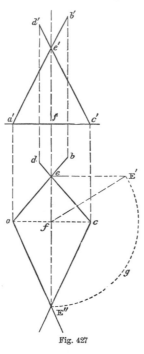

Fig. 427

The practical application of this problem will be understood if we imagine aec to be the plan and $a'e'c'$ the elevation of a hipped roof; fE' gives us the length and slope of the longest common rafter or spar, and aE''c is a true representation of the whole hip, i.e. on a plane parallel to the slope of the hip. It will be observed that the two projections (e and e') of the point of intersection of the two lines are in a right line perpendicular to the line of intersection of the planes of projection. Hence this corollary,—*The projections of the point of intersection of two lines which cut each other in space, are in the same right line perpendicular to the common intersection of the planes of projection.* This is further illustrated by the next problem.

V.—*To determine, from the projection of two lines which intersect each other in the projections, whether the lines cut each other in space or not.*

Let ab, cd, ab', cd' (fig. 428, I) be the projections of the lines. It might be supposed, as their projections intersect each other, that the lines themselves intersect each other in space, but on applying the corollary of the preceding problem, it is found that the intersections are not in the same perpendicular to the line of intersection ac of the planes of projection. This is represented in perspective in

fig. 428, II. We there see that the original lines aBcD do not cut each other, although their projections ab, cd, $a'b'$, $c'd'$, do so. From the point of intersection e raise a perpendicular to the horizontal plane, and it will cut the original line cD in E, and this point

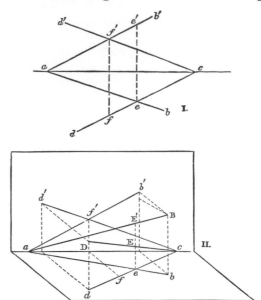

Fig. 428.—I. Vertical and Horizontal Projections. II. Perspective View

therefore belongs to the line cD, but e belongs equally to aB. As the perpendicular raised on e passes through E on the line cD, and through E' on the line aB, these points E E' cannot be the intersection of the two lines, since they do not touch; and it is also the same in regard to ff'. Hence, when two right lines do not cut each other in space, the intersections of their projections are not in the same right line perpendicular to the common intersection of the planes of projection.

VI.—*To find the angle made by a plane with the horizontal plane of projection.*

Let ab and ac (fig. 429) be the horizontal and

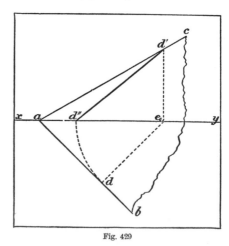

Fig. 429

vertical traces of the given plane, i.e. the lines on which the given plane would, if produced, cut the horizontal and vertical planes of projection. Take any con-

venient point d in ab, and from it draw de perpendicular to ab, and cutting the line of intersection xy in e. From e draw ed' perpendicular to xy, and cutting ac in d'. The angle made by the given plane with the horizontal plane of projection is such that, with a base de, it has a vertical height ed'. Draw such an angle on the vertical plane of projection by setting off from e the distance ed'' equal to ed, and joining $d'd''$. The angle $d'd''e$ is the angle required.

Note.—The angle made by a plane with the vertical plane of projection can be found in a similar manner. If we imagine the part above xy in fig. 429 to be the horizontal projection and the part below xy to be the vertical projection—in other words, if fig. 429 is turned upside down—ab becomes the vertical trace and ac the horizontal trace, and the angle $d'd''e$ is the angle made by the given plane with the vertical plane of projection.

VII.—*The traces of a plane and the projections of a point being given, to draw through the point a plane parallel to the given plane.*

In the perspective representation (fig. 430, II) suppose the problem solved, and let B C be the given plane, and A C, A B its vertical and horizontal traces, and E F a plane parallel to the given plane, and G F, G E its traces. Through any point D, taken at pleasure on the plane E F, draw the vertical plane H J, the horizontal trace of which, I H, is parallel to G E. The plane H J cuts the plane E F in the line kl', and its vertical trace G F in l'. The horizontal projection of kl' is H I, and its vertical projection $k'l'$; and as the point D is in kl', its horizontal and vertical projections will be d and d'. Therefore, if through d be traced a line d I, parallel to A B, that line will be the horizontal projec-

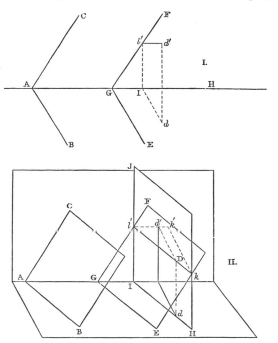

Fig. 430.—I. Vertical and Horizontal Projections. II. Perspective View

tion of a vertical plane passing through the original point D; and if on I be drawn the indefinite perpendicular I l', and through d', the vertical projection of the

given point, be drawn the horizontal line $d'l'$, cutting the perpendicular in l', then the line F G drawn through l', parallel to A C, will be the vertical trace of the plane required; and the line G E drawn parallel to A B, its horizontal trace. Hence, *all planes parallel to each other have their projections parallel, and reciprocally.* In solving the problem, let A B, A C (fig. 430, I) be the traces of the given plane, and dd' the projections of the given point. Through d draw d I parallel to A B, and from I draw I l' perpendicular to A H. Join dd', and through d' draw $d'l'$ parallel to the line of intersection A H. Then F l' G drawn parallel to A C, and G E parallel to A B, are the traces of the required plane.

VIII.—*The traces* A B, B C, *and* A D, D C, *of two planes which cut each other being given, to find the projections of their intersections.*

The planes intersect each other in the straight line A C (fig. 431, II), of which the points A and C are the

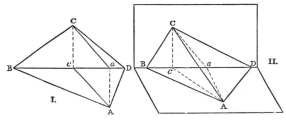

Fig. 431.—I. Vertical and Horizontal Projections. II. Perspective View

traces, since in these points this line intersects the planes of projection. To find these projections, it is only necessary to let fall on the line of intersection in fig. 431, I, the perpendiculars A a, C c, from the points A and C, and join A c, C a. A c will be the horizontal projection, and C a the vertical projection of C A, which is the line of intersection or arris of the planes.

IX.—*The traces of two intersecting planes being given, to find the angle which the planes make between them.*

The angle formed by two planes is measured by that of two lines drawn from the same point in their intersection (one along each of the planes), perpendicular to the line formed by the intersection. This will be better understood by drawing a straight line across the crease in a double sheet of note-paper at right angles to the crease; if the two leaves of the paper are then partly closed so as to form an angle, we have an angle formed by two planes, and this angle is the same as that formed by the two lines which have been drawn perpendicular to the line of intersection of the two planes. These lines in effect determine a third plane perpendicular to the arris. If, therefore, the two planes are cut by a third plane at right angles to their intersection, the solution of the problem is obtained.

On the arris A C (fig. 432, II) take at pleasure any point E, and suppose a plane passing through that point, cutting the two given planes perpendicular to the arris. There results from the section a triangle D E F, inclined to the horizontal plane, and the angle

of which, D E F, is the measure of the inclination of the two planes. The horizontal projection of that triangle is the triangle D e F, the base of which, F D,

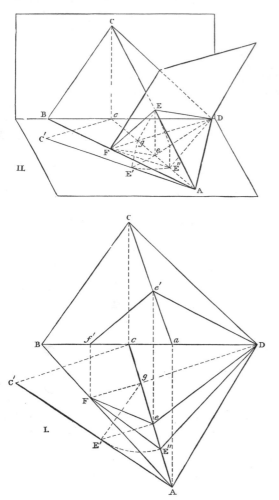

in E′; from E′ let fall a perpendicular E′ e on A c, meeting A c in e. F e D is the horizontal projection of the triangle F E D (see No. II), and from this the vertical projection f′ e′ D can be drawn as shown. We have now obtained the vertical and horizontal projections of two intersecting lines, namely, F e, e D, and f′ e′, e′ D, and by Problem IV the angle which they make with each other can be found. It will be seen that g E′ is the true altitude of the triangle f′ e′ D, as e E′ is equal to e″ e′. Set off therefore from g towards A a distance g E″ equal to g E′, and join F E″, E″ D; F E″ D is the angle made by the two intersecting planes.

Note.—If the arris A C is considered as the angle of a hipped roof, the angle F E″ D is the angle to which the hip-tiles ought to be made. In the case of hips, however, the given vertical projection or elevation is usually on a plane parallel to the horizontal trace of one of the planes forming the hip, and the diagram therefore is necessarily somewhat different. In fig. 433 A B is the vertical projection of the arris, and C D the horizontal projection, A C and C E being the horizontal traces of the two planes forming the hip. Any point g is taken in C D, and through it a line is drawn at right angles to C D meeting the traces of the two planes in A and E. On C D the vertical projection D b c is then made, and from g a line g g′ is drawn perpendicular to c b, and from g′ a perpendicular g′ f is let fall on C D. This vertical projection may be made directly on C D, or a separate diagram may be drawn as in No. III. g g′ is the vertical trace of a plane intersecting the planes of the roof, the lines of intersection forming a triangle of which the horizontal projection is A f E, but g g′ is the actual length of the line of which the horizontal projection is g f; it only remains therefore to construct on A E an isosceles triangle with an altitude equal to g g′. A F E is such a triangle,

Fig. 432.—I. Vertical and Horizontal Projections. II. Perspective View

is perpendicular to A c (the horizontal projection of the arris A C), and cuts it in the point g, and the line E g is perpendicular to D F. The line g E is necessarily perpendicular to the arris A C, as it is in the plane D E F, and its horizontal projection is g e. Now, suppose the triangle D E F turned on D F as an axis, and laid horizontally, its summit will then be at E″, and D E″ F is the angle sought. The perpendicular g E is also in the vertical triangle A C c, of which the arris is the hypotenuse, and the sides A c, C c are the projections. This description introduces the solution of the problem.

Through any point g (fig. 432, I) on the line A c, the horizontal projection of the arris or line of intersection of the two planes, draw F D perpendicular to A c; on A c (which for the moment must be considered as a "line of intersection" or "ground-line" for a second vertical projection) describe the vertical projection of the arris by drawing the perpendicular c c′ and making it equal to the height c c, and then joining A c′. A c′ gives the true length and inclination of the arris. From g draw g E′ perpendicular to A c′ and meeting it

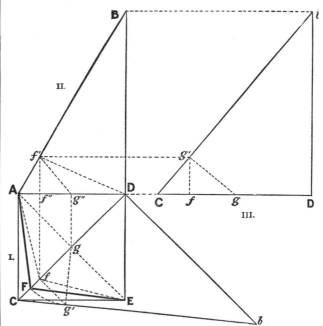

Fig. 433.—I. Horizontal Projection. II. Vertical Projection on Plane A D. III. Vertical Projection on Plane C D.

and the angle A F E is the angle for the hip-tiles or for the "backing" of the hip-rafter.

X.—*Through a given point to draw a perpendicular to a given plane.*

Let a and a′ (fig. 434, II) be the projections of the given point, and B C, C D the horizontal and vertical traces of the given plane. Suppose the problem

solved, and that A E is the perpendicular drawn through the point A to the plane B D, and that its

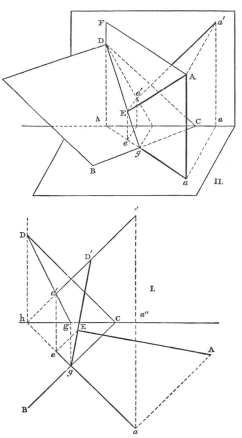

Fig. 434.—I. Vertical and Horizontal Projections. II. Perspective View

intersection with the plane is the point E. Suppose also a *vertical* plane *a* F to pass through A E, this plane would cut B D in the line *g* D, and its horizontal trace *a h* would be perpendicular to the trace B C. In the same way *a' e'*, the vertical projection of A E, would be perpendicular to C D, the vertical trace of the plane B D. Thus we find that if a line *a h* is drawn from *a*, perpendicular to B C, it will be the horizontal trace of the plane in which lies the required perpendicular A E, and *h* F will be the vertical trace of the same plane. From *a'*, draw upon C D an indefinite perpendicular, and that line will contain the vertical projection of A E, as *a h* contains its horizontal projection. To find the point of intersection of the line A E with the given plane, construct the vertical projection *g* D of the line of intersection of the two planes, and the point of intersection of that line with the right line drawn through *a'* will be the point sought. If from that point a perpendicular is let fall on *a h*, the point *e* will be the horizontal projection of the point of intersection E.

In fig. 434, I, let B C, C D be the traces of the given plane, and *a*, *a'* the projections of the given point. From the given point *a*, draw *a h* perpendicular to B C; *a h* will be the horizontal projection of a plane

passing vertically through *a*, and cutting the given plane. On *a h* as "ground-line" draw a vertical projection as follows:—From *a*, draw *a* A perpendicular to *a g*, and make it equal to *a'' a'*; from *h* draw *h* D' perpendicular to *h a*, and make *h* D' equal to *h* D; draw *g* D', which will be the section of the given plane by a vertical plane D *g*, and the angle *h g* D' will be the measure of the inclination of the given plane with the horizontal plane; there is now to be drawn, perpendicular to this line, a line A E through A, which will be the vertical projection on *a h* of the line required. From the point of intersection E let fall upon *a h* a perpendicular, which will give *e* as the horizontal projection of E. Therefore, *a e* is the horizontal projection of the required perpendicular, and *a' e'* its vertical projection on the original "ground-line" *h a''*. It follows from this problem that—

Where a right line in space is perpendicular to a plane, the projections of that line are respectively perpendicular to the traces of the plane.

Note.—The diagram will be less confusing if the projection on *a h* is drawn separately, as in fig. 435, where I is the horizontal projection or plan, II the vertical projection or elevation on a plane parallel to *h a''*, and III the vertical projection or elevation on a plane parallel to *h a*. To draw No. III draw first the ground-line *h a* equal to *h a* on No. I, and mark on it the point *g*; from *h* draw the vertical *h* D' equal to *h* D, and from *a* draw the vertical *a* A equal to *a'' a'*; join D' *g* and A *h*, and from the point of intersection E let fall a perpendicular on *h a*, cutting it in *e*. A E is the actual length and inclination of the required line, and *a e* its horizontal length. Transfer the length *a e* to No. I, and from *e* draw *e e'* perpendicular to *h a''*, and cutting *a' h* in *e'*. If the drawing has been correctly made, a line from E parallel to the ground-line *h a''* will also intersect *a' h* in *e'*.

XI.—*Through a given point to draw a plane perpendicular to a given right line.*

Let *a*, *a'* (fig. 436, I) be the projections of the given

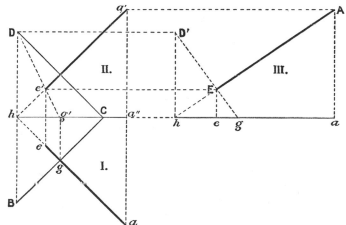

Fig. 435.—I. Horizontal Projection. II. Vertical Projection on Plane parallel to *h a''*. III. Vertical Projection on Plane parallel to *h a*

point A, and *bc*, *b'c'* the projections of the given line B C.

The foregoing problem has shown that the traces of the plane sought must be perpendicular to the projections of the line, and the solution of the problem consists in making to pass through A a vertical plane A f (fig. 436, II), the horizontal projection of which will be perpendicular to *b c*.

Through a (fig. 436, I) draw the projection a f perpendicular to $b\,c$. From f raise upon K L the indefinite perpendicular ff', which will be the vertical trace of the plane a f f' perpendicular to the horizontal plane,

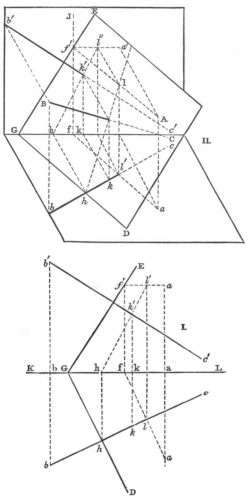

Fig. 436.—I. Horizontal and Vertical Projections. II. Perspective View

plane C E in the line fB, and the horizontal plane in the line $a\,b$. As the plane aB is in this case parallel to the vertical plane of projection, its projection on that plane will be a quadrilateral figure a b' of the same dimensions; and fB contained in the rectangle will have for its vertical projection a right line D b', which will be equal and similar to fB. Hence the two angles, $a'b'$D, ABf, being equal, will equally be the measure of the angle of inclination of the right line A B to the plane C E. Thus the angle $a'\,b'$ D (fig. 437, I) is the angle sought.

This case presents no difficulty; but when the line is in a plane which is not parallel to the plane of projection, the

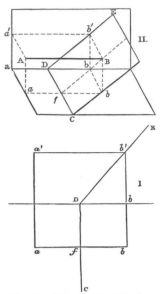

Fig. 437.—I. Horizontal and Vertical Projections. II. Perspective View

problem is more difficult; as, however, the second case is not of much practical value, it will not be considered.

3. STRAIGHT-SIDED SOLIDS

XIII.—*Given the horizontal projection of a regular tetrahedron, to find its vertical projection.*

Let A B C d (fig. 438) be the given projection of the tetrahedron, which has one of its faces coincident with the ground-line. From d draw an indefinite line d C perpendicular to $d\,c$, and make C D equal to C B, C A, or A B; d D will be the height sought, which is carried to the vertical projection from c to d'. Join A d' and B d', and the vertical projection is complete. This problem might be solved in other ways.

XIV.—*A point being given in one of the projections of a tetrahedron, to find the point on the other projection.*

Let e be the point given in the horizontal projection (fig. 438). It may first be considered as situated in the plane C B d, which is inclined to the horizontal plane, and of which the vertical projection is the triangle c B d'. According to the general method, the vertical projection of the given point is to be found somewhere in a perpendicular raised on its horizontal projection e. If through d and the point e be drawn a line produced to the base of the triangle in f, the point e will be on that line, and its vertical projection will be on the vertical projection of that line $f'\,e'\,d'$, at the intersection of it with the perpendicular raised on e. If through e be drawn a straight line $g\,h$, parallel to C B, this will be a horizontal line, whose extremity h will be on B d. The vertical projection of d B is d' B; therefore, by raising on h a perpendicular to A B, there will be obtained h', the extremity of

and passing through the original point A (in No. II). Then draw through a' in the vertical projection a horizontal line, cutting ff' in f', which point should be in the trace of the plane sought; and as that plane must be perpendicular to the vertical projection of the given right line, draw through f' a perpendicular to $b'\,c'$, and produce it to cut K L in G. This point G is in the horizontal trace of the plane sought. All that remains, therefore, is from G to draw G D perpendicular to $b\,c$. If the projections of the straight line are required, proceed as in the previous problem, and as shown by the dotted lines; the plane will cut the given line at k in the horizontal projection, and at k' in the vertical projection.

XII.—*A right line being given in projection, and also the traces of a given plane, to find the angle which the line makes with the plane.*

Let A B (fig. 437, II) be the original right line intersecting the plane C E in the point B. If a vertical plane aB pass through the right line, it will cut the

a horizontal line represented by hg in the horizontal plane. If through h' is drawn a horizontal line $h'g'$, this line will cut the vertical line raised on e in e', the point sought. If the point had been given in g on the arris cd, the projection could not be found in the first manner; but it could be found in the second manner, by drawing through g a line parallel to CB, and prolonging the horizontal line drawn through h', to the arris cd', which it would cut in g', the point sought. The point can also be found by laying down the right-angled triangle cdD (which is the development of the triangle formed by the horizontal projection

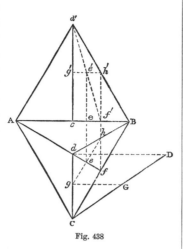

Fig. 438

of the arris cd, the height of the solid, and the length of the arris as a hypotenuse), and by drawing through g the line gG perpendicular to cd, to intersect the hypotenuse in G, and carrying the height gG from c to g' in the vertical projection. One or other of these means can be employed according to circumstances. If the point had been given in the vertical, instead of the horizontal projection, the same operations inverted would require to be used.

XV.—*Given a tetrahedron, and the trace of a plane (perpendicular to one of the planes of projection) cutting it, by which it is truncated, to find the projection of the section.*

First, when the intersecting plane is perpendicular to the horizontal plane (fig. 439), the plane cuts the base in two points ef, of which the vertical projections are e' and f'; and the arris Bd is cut in g, the vertical projection of which can readily be found in any of the ways detailed in the last problem. Having found g', join $e'g'$, $f'g'$, and the triangle $e'g'f'$ is the projection of the intersection sought.

When the intersecting plane is perpendicular to the vertical

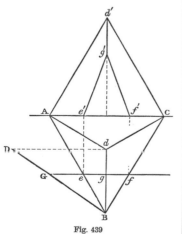

Fig. 439

plane, as $e'f'$ in fig. 440, the horizontal projections of the three points $e'g'f'$ have to be found. The point g in this case may be obtained in several ways. First by drawing G'$g'h'$ through g', then through h' drawing a perpendicular to the base, produced to the arris at h, in the horizontal projection, and then

drawing hg parallel to CB, cutting the arris Bd in g, which is the point required. Second, on dB, the horizontal projection of the arris, construct a triangle dDB, dD being the altitude of the tetrahedron, and BD the arris, and transfer this triangle to the vertical projection at dd'B'.
From g' draw the horizontal line cutting B'd' in G'; g'G' is the horizontal distance of the required point in the arris, from the vertical axis of the tetrahedron; as d is the horizontal projection of the vertical axis, and dB the horizontal projection of the arris, it follows that the length g'G', transferred to dg, will give the required point g. The points e and f are

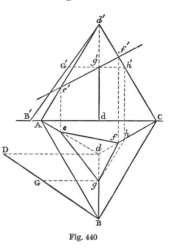

Fig. 440

found by drawing lines from e' and f' perpendicular to the ground-line, and producing them till they meet the horizontal projections of the arrises in e and f. The triangle efg is the horizontal projection of the section made by the plane $e'f'$.

XVI.—*The projections of a tetrahedron being given, to find its projections when inclined to the horizontal plane in any degree.*

Let A B C d (fig. 441) be the horizontal projection of a tetrahedron, with one of its sides coincident with the horizontal plane, and $c'd'$B its vertical projection; it is required to find its projections when turned round the arris A B as an axis. The base of the pyramid being a horizontal plane, its vertical projection is the right line c'B. If this line is raised to c'', by turning on B, the horizontal projection will be Ac^2B. When the point c', by the raising of Bc', describes the arc $c'c''$, the point d' will have moved to d'', and the perpendicular let fall from that point on the horizontal plane will give d^3, the horizontal projection of the extremity of the arris cd; for as the summit d moves in the same plane as C, parallel to the vertical plane of projection, the projection

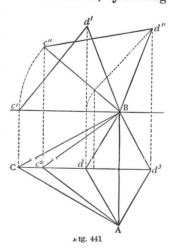

Fig. 441

of the summit will evidently be in the prolongation of the arris Cd, which is the horizontal projection or trace of that plane. The process, therefore, is very simple, and is as follows:—Construct at the point B the angle required, c'Bc'', and make the triangle $c''d$B'' equal to $c'd'$B; from d'' let fall a perpendicular cut-

ting the prolongation of the arris c d in d^3, and from c'' a perpendicular cutting the same line in c^2; join B c^2, A c^2, B d^3, A d^3.

The following is a more general solution of the problem:—Let A B C d' (fig. 442) be the horizontal projection of a pyramid resting with one of its sides on the horizontal plane, and let it be required to raise, by its angle C, the pyramid, by turning round the arris A B, until its base makes with the horizontal plane any required angle, as 50°. Conceive the right line C e turning round e, and still continuing to be perpendicular to A B, until it is raised to the required angle, as at e C'. If a perpendicular be now let fall from C', it will give the point c'' as the horizontal projection of the angle C in its new position. Conceive a vertical plane to pass through the line C e.

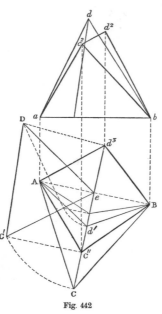

Fig. 442

This plane will necessarily contain the required angle. Suppose, now, we lay this plane down in the horizontal projection, thus:—Draw from e the line e C', making with e C an angle of 50°, and from e with the radius $e c$ describe an arc cutting it in C'. From C' let fall on C e a perpendicular on the point c'', which will then be the horizontal projection of C in its raised position. On C' e draw the profile of the tetrahedron C' D e inclined to the horizontal plane. From D let fall a perpendicular on C e produced, and it will give d'' as the horizontal projection of the summit of the pyramid in its inclined position. Join A d'', B d'', A c'', B c'' to complete the figure. The vertical projection of the tetrahedron in its original position is shown by $a\,d\,b$, and in its raised position by a, c^2, d^2, b, the points c^2 and d^2 being found by making the perpendiculars $c^3 c^2$ and $d^3 d^2$ equal to $c'' c'$ and $d'' $ D respectively.

XVII.—*To construct the vertical and horizontal projections of a cube, the axis[1] of which is perpendicular to the horizontal plane.*

If an arris of the cube is given, it is easy to find its axis, as this is the hypotenuse of a right-angled triangle, the shortest side of which is the length of an arris, and the longest the diagonal of a side. Conceive the cube cut by a vertical plane passing through its diagonals E G, A C (fig. 443), the section will be the rectangle A E G C. Divide this into two equal right-angled triangles, by the diagonal E C. If, in the upper and lower faces of the cube, we draw the diagonals F H, B D, they will cut the former diagonals in the

[1] The axis of a cube is the straight line which joins two of its opposite solid angles.

points f and b. Now, as the lines b B, b D, f F, f H, are perpendicular to the rectangular plane A E G C, $f b$ may be considered as the vertical projection of B F and D H, and from this consideration we may solve the problem.

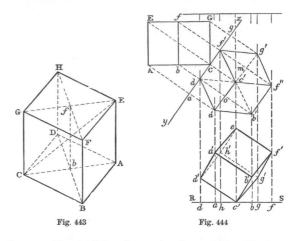

Fig. 443 Fig. 444

Let A E (fig. 444) be the arris of any cube (the letters here refer to the same parts as those of the preceding diagram, fig. 443). Through A draw an indefinite line, A C, perpendicular to A E. Set off on this line, from A to C, the diagonal of the square of A E, and join E C, which is then the axis of the cube. Draw the lines E G, C G, parallel respectively to A C and A E, and the resulting rectangle, A E G C, is the section of a cube on the line of the diagonal of one of its faces. Divide the rectangle into two equal parts by the line $b f$, which is the vertical projection of the lines B F, D H (fig. 443), and we obtain, in the figure thus completed, the vertical projection of the cube, as $a\,c\,b\,d$ (fig. 445).

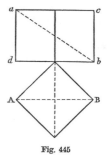

Fig. 445

Through C (fig. 444), the extremity of the diagonal E C, draw $y z$ perpendicular to it, and let this line represent the common section or ground-line of the two planes of projection. Then let us find the horizontal projection of a cube, of which A E G C is the vertical projection. In the vertical projection the axis E C is perpendicular to $y z$, and, consequently, to the horizontal plane of projection, and we have the height above this plane of each of the points which terminate the angles. Let fall from each of these points perpendiculars to the horizontal plane, the projections of the points will be found on these perpendiculars. The horizontal projection of the axis E C will be a point on its prolongation, as c'. This point might have been named e with equal correctness, as it is the horizontal projection of both the extremities of the axis, C and E. Through c' draw a line parallel to yz, and find on it the projections of the points A and G, by continuing the perpendiculars A a, G g, to a' and g'. We have now to find the projections of the points $b f$ (representing D B F H, fig. 443), which will be somewhere on the perpendiculars $b b'$, $f f''$, let fall from

PLATE XXIII

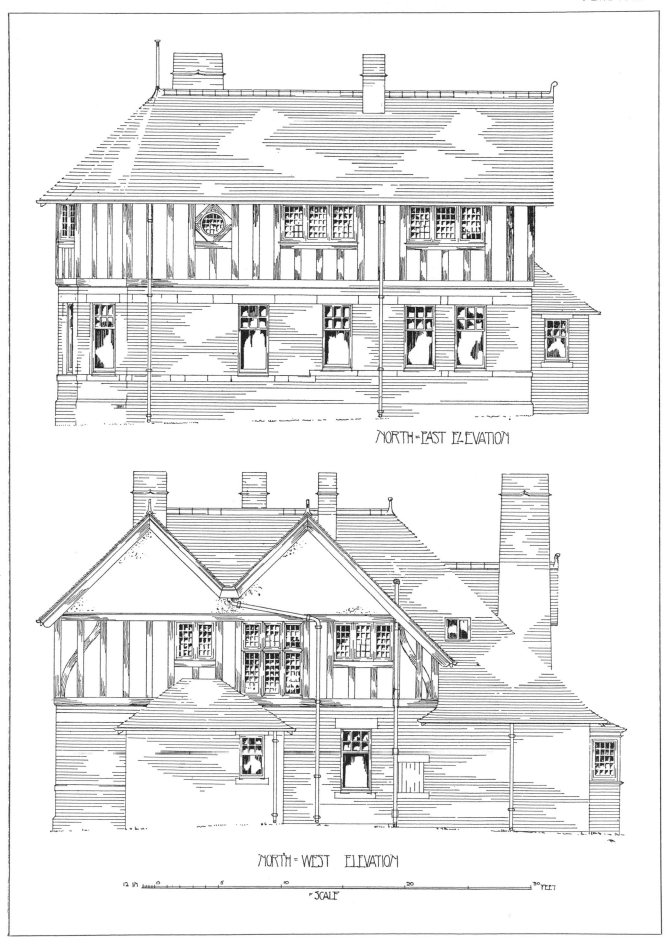

NORTH-EAST ELEVATION

NORTH-WEST ELEVATION

SCALE

NORTH-EAST AND NORTH-WEST ELEVATIONS OF SMALL COUNTRY HOUSE

PLATE XXIII

The lower illustration is the north-west or back elevation of the house, of which other drawings have been given in Plates XIX to XXII. The gables above the half-timber work are cement rough-cast on 9-inch brickwork.

The north-east elevation shows the most exposed of the four faces of the house, and was designed in two stories to afford shelter to the remainder of the building. Here, again, the sash-windows are somewhat incongruous (see description of Plate XXI).

them. We have seen in fig. 443 that B F, D H are distant from bf by an extent equal to half the diagonal of the square face of the cube. Set off, therefore, on the perpendiculars bb' and $f'f''$, from o and m, the distance A b in d, b' and f', f'', and join da', $a'b'$, $b'f''$, $f''g'$, $g'f'$, to complete the hexagon which is the horizontal projection of the cube. Join $f'c'$, $f''c'$, and $a'c'$, to give the arrises of the upper half of the cube. The dotted lines, dc', $b'c'$, $g'c'$, show the arrises of the lower side. Knowing the heights of the points in these vertical projections, it is easy to construct a vertical projection on any line whatever, as that on R S below.

XVIII.—*To construct the projections of a regular octahedron*[1], *when one of its axes is perpendicular to either plane of projection.*

Describe a circle (fig. 446), and divide it into four equal parts by the diameters, and draw the lines ad, db, bc, ca; a figure is produced which serves for either the vertical or the horizontal projection of the octahedron, when one of its axes is perpendicular to either plane.

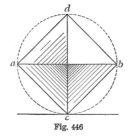

Fig. 446

XIX.—*One of the faces of an octahedron being given, coincident with the horizontal plane of projection, to construct the projections of the solid.*

Let the triangle A B C (fig. 447) be the given face. If A be considered to be the summit of one of the two pyramids[2] which compose the solid, B C will be one of the sides of the square base, k C B i. This base makes with the horizontal plane an angle, which is easily found. Let fall from A a perpendicular on B C, cutting it in d. With the length B C as a radius, and from d as a centre, describe the indefinite arc ef. The perpendicular A d will be the height of each of the faces, and, consequently, of that which, turning on A, should meet the side of the base which has already turned on d. Make this height turn on A, describing from that point as a centre, with the radius A d, an indefinite arc, cutting the first arc in G, the point of meeting of one of the faces with the square base: draw the lines G A, G d: the first is the profile or

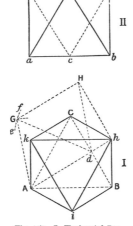

Fig. 447.—I. Horizontal Projection. II. Vertical Projection

[1] The octahedron is formed by the union of eight equilateral triangles; or, more correctly, by the union of two pyramids with square bases, opposed base to base, and of which all the solid angles touch a sphere in which they may be inscribed.

[2] It is essential that the diagram should be clearly *seen* as a solid, and not as a mere set of lines in one plane. Imagine h as the apex of one pyramid on the base k C B i, and A as the apex of the other pyramid on the opposite side of the same base. The octahedron is shown to be lying on its side A B C.

inclination of one of the faces on the given face A B C, according to the angle d A G; the second, d G, is the inclination of the square base, which separates the two pyramids in the angle A d G. The face adjacent to the side B C is found in the same manner. Through G, draw the horizontal line G H equal to the perpendicular A d. This line will be the profile of the superior face. Draw d H, which is the profile of the face adjacent to B C. From H let fall a perpendicular on A d produced, which gives the point h for the horizontal projection of H, or the summit of the superior triangle parallel to the first: draw hi parallel to C A, hk parallel to A B, A k and B h perpendicular to A B, and join k C, C h, B i, and A i, and the horizontal projection is complete. From the heights we have thus obtained, we can now draw the vertical projection shown in No. II, in which the parts have the same letters of reference.

The finding of the horizontal projection may be abridged by constructing a hexagon and inscribing in it the two triangles A C B, hik.

XX.—*Given in the horizontal plane the projection of one of the faces of a dodecahedron, to construct its projections.*

The dodecahedron is a twelve-sided solid, all the sides being regular and equal pentagons. It is necessary, in order to construct the projection, to discover the inclination of the faces among themselves. Let the pentagon A B C D E (fig. 448) be the side on which the body is supposed to be seated on the plane. Conceive two other faces, E F G H D and D I K L C, also in the horizontal plane, and then raised by being turned on their bases, E D, D C. By their movement they will describe in space arcs of circles, which will terminate by the meeting of the sides D H, D I.

To find the inclinations of these two faces.—From the points I and II let fall perpendiculars on their bases produced. If each of these pentagons were raised vertically on its base, the horizontal projections of H and I would be respectively in zz; but as both are raised together, the angles H and I would meet in space above h, where the perpendiculars intersect; therefore, h will be the horizontal projection of the point of meeting of the angles. To find the horizontal projection of K, prolong indefinitely z I, and set off from z on z I the length x K in k'; from z as centre, with radius z I, describe the arc I I' cutting the perpendicular h I' in I'; join z I'; then from z as a centre, with the radius $z k'$, describe an arc cutting z I' produced in the point K', from which let fall on $z k'$ a perpendicular K' k'', and produce it to k in x K. If, now, the right-angled triangle $z k''$ K', were raised on its base, k'' would be the projection of K'. Conceive now the pentagon C D I K L turned round on C D, until it makes an angle equal to $k'' z$ K' with the horizontal plane, the summit K will then be raised above k by the height k'' K', and will have for its horizontal projection the point k. In completing the figure practically;—from the centre o, describe two concentric circles passing through the points h, D. Draw the lines h D, hk, and

carry the last round the circumference in *m n o p r s t v*: through each of these points draw radially the lines *m* c, *o* B, *r* A, *t* E, and these lines will be the arrises analogous to *h* D. This being done, the inferior half of the solid is projected. By reason of the regularity

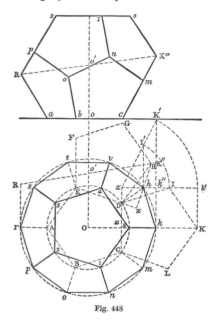

Fig. 448

of the figure, it is easy to see that the six other faces will be similar to those already drawn, only that although the superior pentagon will have its angles on the same circumference as the inferior pentagon, the angles of the one will be in the middle of the faces of the other. Therefore, to describe the superior half;—through the angles *n p s v k*, draw the radial lines *n* 1, *p* 2, *s* 3, *v* 4, *k* 5, and join them by the straight lines 1 2, 2 3, 3 4, 4 5, and 5 1.

To obtain the length of the axis of the solid, observe that the point *k* is elevated above the horizontal plane by the height *k″* K′: carry that height to *k* K″: the point *r*, analogous to *h*, is raised the same height as that point, that is to say *h* I′, which is to be carried from *r* to R; and the line R K″ is the length sought. As this axis should pass through the centre of the body, if a vertical line O *o′* is drawn, it will cut the vertical projection of the axis in *o′*, and therefore O *o′* is the half of the height of the solid vertically. By doubling this height, and drawing a horizontal line to cut the vertical lines of the angles of the superior pentagon, the vertical projection of the superior face is obtained, as in the upper portion of fig. 448, in which the same letters refer to the same parts.

XXI.—*One of the faces of a dodecahedron being given, to construct the projections of the solid, so that its axis may be perpendicular to the horizontal plane.*

Let A B E D C (fig. 449, I) be the given face. The solid angles of the dodecahedron are each formed by the meeting of three pentagonal planes. If there be conceived a plane B C passing through the extremities

of the arrises of the solid angle A, the result of the section would be a triangular pyramid, the sides of whose base would be equal to one of the diagonals of the face, such as B C. An equilateral triangle *b c f* (fig. 449, II) will represent the base of that pyramid inverted, that is, with its summit resting on the horizontal plane. In constructing the horizontal projection, it is required to find the height of that pyramid, or, which is the same thing, that of one of the three points of its base *b c f*, for as they are all equally elevated, the height of one of them gives the others. There is necessarily a proportion between the triangle A *b c* (No. II) and A B C (No. I), since the first is the horizontal projection of the second. A *g* is the horizontal projection of A G; but A G is a part of A H, and the projection of that line is required for one of the faces of the solid; therefore as A G : A *g* :: A H : *x*. In other words, the length of *x* may be obtained by drawing a fourth proportional to the three lines (Prob. IX, page 237); it will be found to be equal to A *h*; or it may be obtained graphically thus:—Raise on A *g* at *g* an indefinite perpendicular, take the length A G (No. I) and carry it from A to G′ (No. II); *g* is a point in the assumed pyramidal base *b c f*, elevated above the horizontal plane by the height *g* G′; its height gives also the heights of *b c f*. Since A G is a portion of A H, A G′ will be so also. Produce A G′, therefore, to H′, making A H′ equal to A H (No. I), and from H′ let fall a perpendicular on A *g* produced, which gives *h* the point sought. Produce H′ *h*, and carry on it the

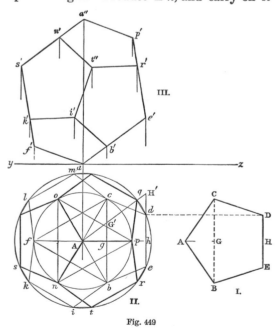

Fig. 449

length H D or H E from *h* to *d* and *h* to *e*; draw the lines *c d*, *b e*, and the horizontal projection of one of the faces is obtained inclined to the horizontal plane, in the angle H′ A *h*. As the two other inferior faces are similar to the one found, the three faces should be found on the circumference of a circle traced from A as a centre, and with A *d* or A *e* as a radius. Join *f* A. Prolong A *n*, A *o*, perpendiculars to

the sides of the triangle fcb, and make them equal to A h, and through their extremities draw perpendiculars, cutting the circumference in the points ik, lm. Draw the lines ib, kf, lf, mc, and the horizontal projections of the three inferior faces are obtained. The superior pyramid is similar and equal to the inferior, and solely opposed by its angles. Describe a circle passing through the three points of the first triangle, and draw within it a second equilateral triangle nop, of which the summits correspond to the middle of the faces of the former one. Each of these points will be the summit of a pentagon, as the points bcf. These pentagons have all their sides common, and it is only necessary therefore to determine one of these superior pentagons to have all the others. Six of the faces of the dodecahedron have now been projected; the remaining six are obtained by joining the angular points already found, as qd, er, ti, ks, &c.

To obtain the vertical projection (No. III), begin with the three inferior faces. The point A in the horizontal projection being the summit of the inferior solid angle, will have its vertical projection in a; the points bcf, when raised to the height g G$'$, will be in $b'c'f'$, or simply $b'f'$. The points bgc being in a plane perpendicular to the vertical plane, will necessarily have the same vertical projection, b'. The line af' will be the projection of the arris Af, and ab' will be that of the arrises Ab, Ac, and of the line Ag, or rather that of the triangle Abc, which is in a plane perpendicular to the vertical plane. But this triangle is only a portion of the given pentagonal face (No. I), of which A H is the perpendicular let fall from A on the side E D. Produce ab' to e', making ae' equal to A H; e' is the vertical projection of the arris ed. This arris is common to the inferior pentagon, and to the superior pentagon $edqpr$, which is also perpendicular to the vertical plane, and, consequently, its vertical projection will be $e'p'$, equal to ae'. This projection can be now obtained by raising a vertical line through p, the summit of the superior pentagon, and from e' as a centre, and with the radius A H$'$ or A H, describing an arc cutting this line in p', the point sought. But pno belong to the base of the superior pyramid; therefore, if a perpendicular is drawn from n through yz to n', and the height p' is transferred to n' by drawing through p' a line parallel to yz, n' will be the projection of the points n and o. Through n' draw $o'n'a''$ parallel to ae', cutting perpendiculars drawn through s and A in the horizontal projection. Through s' draw $s'f'$ parallel to $p'e'$, and join af', $a''p'$; set off on the perpendicular from r the height of s' above yz at r', and draw $r't''$ parallel to yz, cutting the perpendicular from t, and join $n't''$. Draw perpendiculars from k and i through yz to k' and i', make k' and i' the same height as e', and draw $k'i'$, and join $i'b'$, $i't''$. The vertical projection is now complete.

XXII.—*In a given sphere to inscribe a tetrahedron, a hexahedron or cube, an octahedron, and a dodecahedron.*

Let A B (fig. 450) be the diameter of the given sphere. Divide it into three equal parts, D B being one of these parts. Draw D E perpendicular to A B, and draw the chords A E, E B. A E is the arris of the tetrahedron, and E B the arris of the hexahedron or cube. From the centre C draw the perpendicular radius C F, and the chord F B is the arris of the octahedron. Divide B E in extreme and mean proportion in G, and B G is the arris of the dodecahedron. The arrises being known, the solids can be drawn by the help of the problems already solved. Draw the tangent A H equal to A B; join H C and A I; A I is the arris of an icosahedron which can be inscribed in the sphere, an icosahedron being a solid with twenty equal sides, all of which are equilateral triangles.

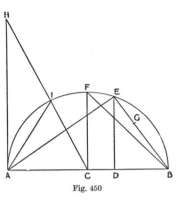

Fig. 450

4. THE CYLINDER, CONE, AND SPHERE

XXIII.—*The horizontal projection of a cylinder, the axis of which is perpendicular to the horizontal plane, being given, to find the vertical projection.*

Let the circle A B C D (fig. 451) be the base of the cylinder, and also its horizontal projection. From the points A and C raise perpendiculars to the ground-line ac, and produce them to the height of the cylinder—say, for example, ae, cf. Draw ef parallel to ac, and the rectangle $aefc$ is the projection required.

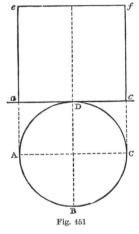

Fig. 451

XXIV.—*The horizontal projection of a cylinder, whose axis is parallel to the horizontal plane, being given, to construct its vertical projection.*

Let the rectangle uv (fig. 452) be the given horizontal projection. From each of the points a, b, c, d, draw perpendiculars to xy. On xy set off the height, which of course equals the diameter; and through the points obtained draw a line parallel to xy. Conceive ab, the horizontal projection of one of the bases or ends of the cylinder, to be turned down on the horizontal plane on the point E; it will be a circle E A F B; then the original of the point, of which a is the projection, will be A, which will be elevated above the horizontal plane by the height a A. To obtain the vertical projection of a or A, therefore, it is only necessary to carry from x to a', on the perpendicular

passing through a, the height a A. In the same way is found the vertical projection of any point in the base, as g. From g draw perpendicular to $a b$ a line cutting the circle in G and H. Draw also from g to the vertical projection the line $g g' h'$, and mark on

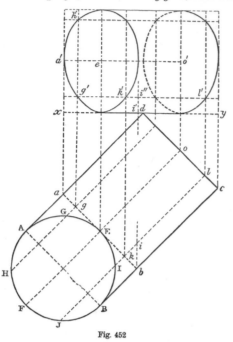

Fig. 452

it the heights g G, g H, in g' and h', which are the vertical projections of g. Thus any number of points can be found, and a curve traced through them. It is evident that as the base $d c$ is similar and equal to $a b$, its projections will also be similar and equal.

These circular bases being in planes which are not parallel to the vertical plane, their projections are ellipses, the two axes of which can always be readily found, and the operation of projecting them can thus be shortened.

Note.—In surfaces of revolution, any point on the surface belongs equally to the generating line and to the generating circle; consequently, if it is required to find the vertical projection of a point on the surface of a cylinder, it is only necessary to draw a line through the point parallel to the sides of the cylinder, cutting the line of projection of one or both of its bases; to draw, from these intersections, lines cutting the ellipses in the vertical projection; and from these the projection of the line passing through the point, and consequently the projection of the point itself, is easily found. Let i be the point in the horizontal projection[1]; through it draw $k i l$, parallel to $a b$ and $d c$ and cutting the horizontal projections of the generating circle in k and l; through k draw $k k'$, and through l draw $l l'$, and join $k' l'$, and the intersection of the lines $k' l'$, $i i''$, in the vertical projection, defines the point. But it can also be found without referring to the intersections, thus:—Through the point i draw $i k$ I J, parallel to $b c$, and through it draw also $i i'$ perpendicular to $x y$; then on the last line set up the height k I, which will give the vertical projection of the point in i''.

XXV.—*The base of a cylinder being given, and also the angles which the base makes with the planes of projection, to construct the projections of the cylinder.*

Let the circle A G B H (fig. 453) be the given base,

[1] The point is assumed to be in the inferior half of the cylinder.

and let each of the given angles be 45°. Draw the diameter A B, making an angle of 45° with the ground-line or vertical plane, and draw the line A B', making with A B the given angle; and from A as a centre, with A B and A C as radii, describe arcs cutting A B' in B' and C'. Then draw A D, B' E perpendicular to A B', and equal to the length of the cylinder; the rectangle A E is the vertical projection of the cylinder parallel to the vertical plane and inclined to the horizontal plane A B in an angle of 45°. Now prolong

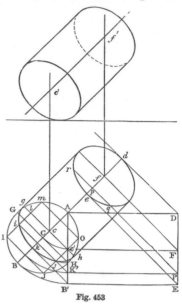

Fig. 453

indefinitely the diameter B A, and this line will represent the projection on the horizontal plane of the line in which the generating circle moves to produce the cylinder. If from B' and C' perpendiculars be let fall on A B, k will be the horizontal projection of B', A k that of the diameter A B, and c that of the centre C. Through c draw $h g$ perpendicular to A B, and make $c h$, $c g$ equal to C H, C G; and the two diameters of the ellipse, which is the projection of the base of the cylinder, will be obtained, namely, A k and $h g$.

In like manner, draw from D F E the lines D d, F f, E e, perpendicular to the diameter A B produced, and their intersections with the diameter and the sides of the cylinder will give the means of drawing the ellipse which forms the projection of the farther end of the cylinder. The ellipses may also be found by taking any number of points in the generating circle as I J, and obtaining their projections i, j. The method of doing this, and

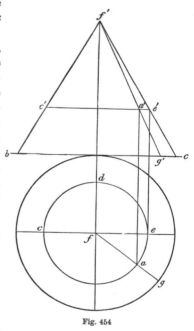

Fig. 454

also of drawing the vertical projection $c' f'$, will be understood without further explanation.

XXVI.—*A point in one of the projections of a cone being given, to find it in the other projection.*

Let a (fig. 454) be the given point. This point belongs equally to the circle which is the section of the cone by a plane passing through the point parallel to the base, and to a straight line forming one of the sides of a triangle which is the section of the cone by a plane perpendicular to its base and passing through its vertex and through the given point, and of which $f a g$ is the horizontal, and $f' a' g'$ the vertical projection. To find the vertical projection of a, through a draw $a a'$ perpendicular to $b c$, and its intersection with $f' g'$ is the point required; and reciprocally, a in the horizontal projection may be found from a' in the vertical projection, in the same manner.

Otherwise, through a, in the horizontal projection, describe the circle $a d c$, and draw $e e'$ or $c c'$, cutting the sides of the cone in e' and c'; draw $c' e'$ parallel to the base, and draw $a a'$, cutting it in a', the point required.

XXVII.—On a given cylinder to describe a helix.

Let $a b c d$, &c. (fig. 455), be the horizontal projection of the given cylinder. Take on this curve a series of equal distances, $a b$, $b c$, $c d$, &c., and through each of the points a, b, c, &c. draw a vertical line, and produce it along the vertical projection of the cylinder. Then conceive a curve cutting all these verticals in the points $a' b' c' d'$, in such a manner that the height of the point above the ground-line may be in constant relation to the arcs $a b$, $b c$, $c d$; for example, that a may be the zero of height, that $b b'$ may be 1, $c c'$ 2, $d d'$ 3, &c.; then this curve is named a helix. To construct this curve, carry on the vertical projection on each vertical line such a height as has been determined, as 1 on b, 2 on c, 3 on d; and through these points will pass the curve sought. It is easy to see that the curve so traced is independent of the cylinder on which it has been supposed to be traced; and that if it be isolated, its horizontal projection will be a circle. The helix is named after the curve which is its horizontal projection. Thus the helix in the example is a helix with a circular base. The vertical line $f n$ is the axis of the helix, and the height $b b'$, comprised between two consecutive intersections of the curve with a vertical, is the pitch of the helix.

XXVIII.—On a given cone to describe a helix.

Let the projections of the given cone be as shown in fig. 456. Divide the base of the cone in the horizontal projection into any number of equal parts,

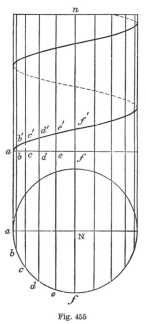

Fig. 455

as $a b$, $b c$, $c d$, &c., and draw lines from the vertex to the points thus obtained. Set off along these lines a series of distances increasing in constant ratio, as 1 at b, 2 at c, 3 at d, &c. The curve then drawn through these points, when supposed to be in the same plane, is called a spiral. If these points, in addition to approaching the centre in a constant ratio, are supposed also to rise above each other by a

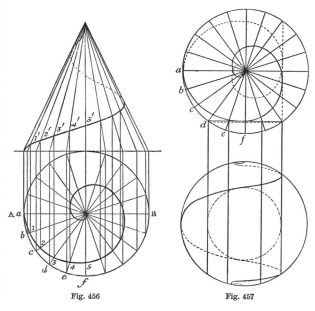

Fig. 456 Fig. 457

constant increase of height, a helical curve will be obtained on the vertical projection of the cone.

Note.—In fig. 457 the horizontal and vertical projections of a helix traced on a sphere are shown.

XXIX.—A point in one of the projections of the sphere being given, to find it in the other projection.

Let a be the given point in the horizontal projection of the sphere $h b c i$ (fig. 458). Any point on the surface of a sphere belongs to a circle of that sphere. Therefore, if a is the point, and a vertical plane $b c$ is made to pass through that point parallel to A B, the section of the sphere by this plane will be a circle, whose diameter will be $b c$, and the radius, consequently, $d b$ or $d c$; and the point a will necessarily be in the circumference of this circle. Since the centre d of this circle is situated on the horizontal axis of the sphere, and as this axis is perpendicular to the vertical plane, its vertical projection will be the point d'. It is evident

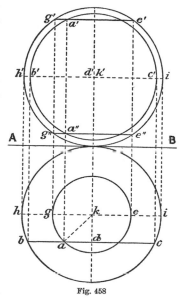

Fig. 458

that the vertical projection of the given point a will be found in the circumference of the circle described from d' with the radius db or dc, and at that point of it where it is intersected by the line drawn through a, perpendicular to A B. Its vertical projection will therefore be either a' or a'', according as the point a is on the superior or inferior semi-surface of the sphere.

The projection of the point may also be found thus:—Conceive the sphere cut by a plane parallel to the horizontal plane of projection passing through the given point a. The resulting section will be the horizontal circle described from k, with the radius ka; and the vertical projection of this section will be the straight line $g'e'$, or $g''e''$; and the intersections of these lines with the perpendicular drawn through a, will be the projection of a, as before.

5. SECTIONS OF SOLIDS

To draw sections of any solid requires little more than the application of the methods described in the foregoing problems. Innumerable examples might be given, but a few selected ones will suffice.

XXX.—*The projections of a regular tetrahedron being given, to draw the section made by a plane perpendicular to the vertical plane and inclined to the horizontal plane.*

Let A B C D and $abcd$ (fig. 459) be the given projections, and E F G the given plane perpendicular to the vertical plane and inclined to the horizontal plane at an angle of 30°. The horizontal projection efg of the section is easily found as shown. To find the correct section, draw through e, f, and g, lines parallel

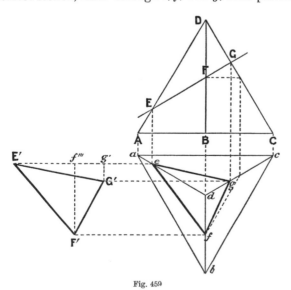

Fig. 459

to the ground-line A C, and on one of them as E′ e set off the distances E F, E G at E′ f''' and E′ g', and through f''' and g' draw perpendiculars cutting the other lines

in F′ and G′. Join E′ G′, G′ F′, and F′ E′. E′ F′ G′ is the correct section made by the plane.

XXXI.—*The projections of a hexagonal pyramid being given, to draw the section made by a plane*

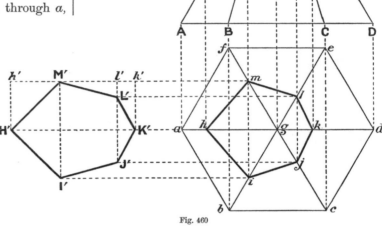

Fig. 460

perpendicular to the vertical plane and inclined to the horizontal plane.

Let A B C D G and $abcdefg$ (fig. 460) be the given projections, and H I J K the given plane. The horizontal projection $hijklm$ of the section is easily found as shown. Through m, l, h, j, and i draw lines parallel to the ground-line A D, and on one of them, as $h'm$, set off the distances H I, H J, H K, at h' M′, $h'l'$, $h'k'$. From h', M′, l', and k' draw perpendiculars meeting the other lines in H′, I′, L′, J′, and K′, and join the points of intersection. H′ I′ J′ K′ L′ M′ is the true section made by the plane.

XXXII.—*The projections of an octagonal pyramid being given, to draw the section made by a vertical plane.*

Let A B C D F and $abcdef$ (fig. 461) be the given projections, and $ghijk$ the given vertical section plane. The vertical projection $g'h'i'j'k'$ of the section made by the plane is easily found by drawing gg', hh', ii', &c. perpendicular to the ground-line A D. On A D produced set off the distances gh, hi, ij, and jk at G′ h'', $h''i''$, &c., and from the points thus found draw perpendiculars to G K′ meeting lines drawn from h', i', and j' parallel to A D, in H′, I′, and J. Join G′ H′, H′ I′, I′ J′, and J′ K′. G′ H′ I′ J′ K′ is the true section made by the plane.

A cylinder may be cut by a plane in three different ways—1st, the plane may be parallel to the axis;

2nd, it may be parallel to the base; 3rd, it may be oblique to the axis or the base.

In the first case, the section is a parallelogram, whose length will be equal to the length of the

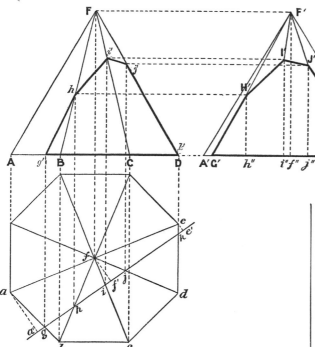

Fig. 461

cylinder, and whose width will be equal to the chord of the circle of the base in the line of section. Whence it follows, that the largest section of this kind will be that made by a plane passing through the axis; and the smallest will be when the section plane is a tangent—the section in that case will be a straight line.

When the section plane is parallel to the base, the section will be a circle equal to the base. When the section plane is oblique to the axis or the base, the section will be an ellipse.

XXXIII.—*To draw the section of a cylinder by a plane oblique to the axis.*

Let A B C D (fig. 462) be the projection of a cylinder, of which the circle E H F K represents the base divided

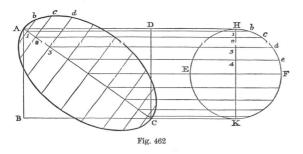

Fig. 462

into twenty equal parts at *b c d e*, &c., and let it be required to draw the section made by the plane A C. The circular base must be drawn in such a position that the axis of the cylinder when produced meets the centre of the circle. Through the centre of the

circle draw the diameter H K perpendicular to the axis produced. Then through the divisions of the base, *b, c, d*, &c. draw lines parallel to the axis, and meeting the section plane in 1, 2, 3, &c., and through these points draw perpendiculars to A C making them equal to the corresponding perpendiculars from H K, *i.e.* 1 *b*, 2 *c*, 3 *d*, &c. A curve drawn through the points thus found will be an ellipse, the true section of A B C D on the plane A C.

The Cone.—A cone may be cut by a plane in five different ways, producing what are called the conic sections:—1st. If it is cut by a plane passing through its axis, the section is a triangle, having the axis of the cone as its height, the diameter of the base for its base, and the sides for its sides. If the plane passes through the vertex, without passing through the axis, as *c e″* (fig. 463), the section will still be a triangle, having for its base the chord *c′ o*, for its altitude the line *c e″*, and for its sides the sides of the cone, of which the lines *c′ e, o e*, are the horizontal, and the line *c e″* the vertical projections. 2nd. If the cone is cut parallel to the base, as in *g′ h′*, the section will be a circle, of which *g′ h′* will be the diameter. 3rd. When the section plane is oblique to the axis, and passes

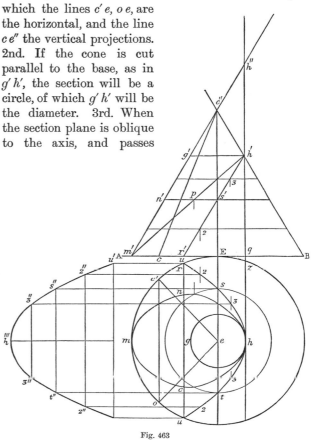

Fig. 463

through the opposite sides of the cone, as *m′ p h′*, the section will be an ellipse, *m n h*. 4th. When the plane is parallel to one of the sides of the cone, as *r′ h′*, the resulting section is a parabola *r s h t u*. 5th. When the section plane is such as to pass through the sides of another cone formed by producing the sides of the first beyond the vertex, as the plane *q h″*, the resulting curve in each cone is a hyperbola.

Several methods of drawing the curves of the conic sections have already been given in the chapter on Plane Geometry. Here their projections, as resulting from the sections of the solid by planes, are to be considered. If the mode of finding the projections of a point on the surface of a given cone be understood, the projections of the curves of the conic sections will offer no difficulty. Let the problem be:—First, to find the projections of the section made by the plane $m' h'$. Take at pleasure upon the plane several points, as p', &c. Let fall from these points perpendiculars to the horizontal plane, and on these will be found the horizontal projection of the points; thus, in regard to the point p'—Draw through p' a line parallel to A B: this line will be the vertical projection of a horizontal plane cutting the cone, and its horizontal projection will be a circle, with $s' n'$ for its radius. With this radius, therefore, from the centre e, describe a circle cutting, twice, the perpendicular let fall from p; the points of intersection will be two points in the horizontal projection of the circumference of the ellipse. In the same manner, any other points may be obtained in its circumference. The operation may often be abridged by taking the point p in the middle of the line $m' h'$; for then $m h$ will be the horizontal projection of the major axis, and the two points found on the perpendicular let fall from the central point p will give the minor axis.

To obtain the projections of the parabola, more points are required, such as r', 2, s', 3, h', but the mode of procedure is the same as for the ellipse. The vertical projection of the parabola $u s h t u$ is shown at $u' s'' h''' t'' u$.

The projections of the section plane which produces the hyperbola are in this case straight lines, $q h'$, $z h$.

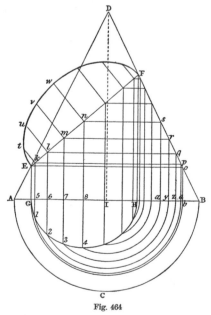

Fig. 464

XXXIV.—*To draw the section of a cone made by a plane cutting both its sides, i.e. an ellipse.*

Let A D B (fig. 464) be the vertical projection of the cone, A C B the horizontal projection of half its base,

and E F the line of section. From the points E and F let fall on A B the perpendiculars E G, F H. Take any points in E F, as k, l, m, n, &c., and from them draw

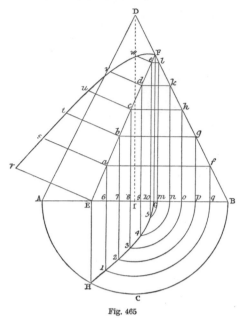

Fig. 465

lines parallel to A B, as $k p, l q, m r$, &c., and also lines perpendicular to A B, as $k 1, l 2, m 3$, &c. Also from p, q, r, &c., let fall perpendiculars on A B, namely, $p a$, $q z, r y$, &c. From the centre of the base of the cone, I, with radius I a, I z, I y, &c., describe arcs cutting the perpendiculars let fall from k, l, m, &c., in 1, 2, 3, &c. A curve traced through these points will be the horizontal projection of the section made by the plane E F. To find the true section,—Through k, l, m, &c., draw $k t, l u, m v, n w$, perpendicular to E F, and make them respectively equal to the corresponding ordinates, 5 1, 6 2, 7 3, &c., of the horizontal projection G 4 H and points will be obtained through which the hal E w F of the required ellipse can be traced. It is obvious that, practically, it is necessary only to find the minor axis of the ellipse, the major axis E F being given.

XXXV.—*To draw the section of a cone made by a plane parallel to one of its sides, i.e. a parabola.*

Let A D B (fig. 465) be the vertical projection of a right cone, and A C B half the plan of its base; and let E F be the line of section. In E F take any number of points, E, a, b, c, d, e, F, and through them draw lines E H, $a 6 1, b 7 2$, &c., perpendicular to A B, and also lines parallel to A B, meeting the side of the cone in f, g, h, k, l: from these let fall perpendiculars on A B, meeting it in m, n, o, p, q. From the centre of the base I, with the radii I m, I n, I o, &c., describe arcs cutting the perpendiculars let fall from the section line in the points 1, 2, 3, 4, 5; and through the points of intersection trace the line H 1 2 3 4 5 G, which is the horizontal projection of the section. To find the true section, from E, a, b, c, d, e, raise perpendiculars to E F, and make them respectively equal to the ordinates in the horizontal projection, as E r equal to E H, $a s$ equal to

PLATE XXIV

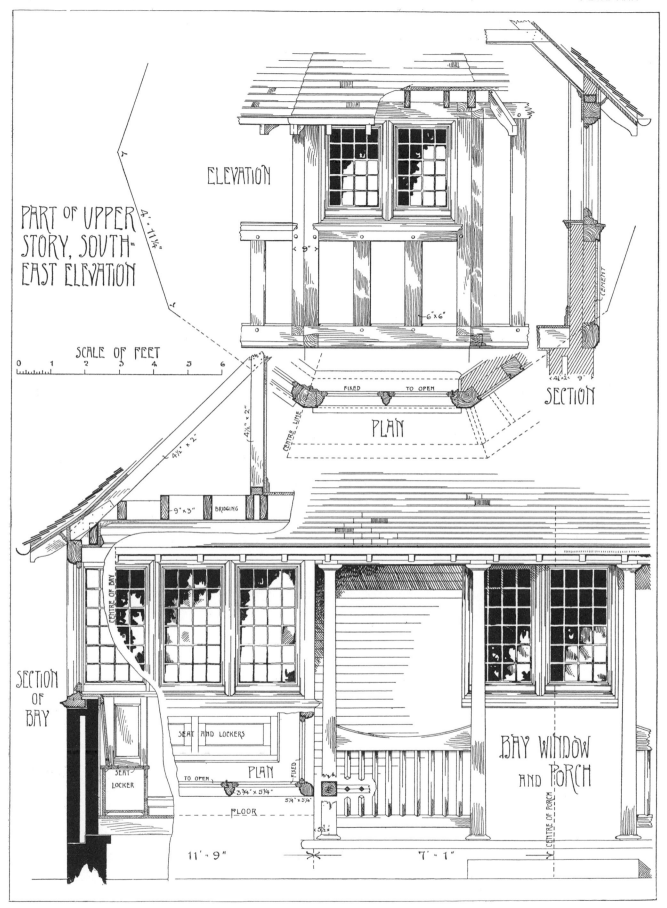

PART OF UPPER STORY, SOUTH-EAST ELEVATION

ELEVATION

SCALE OF FEET
0 1 2 3 4 5 6

SECTION

PLAN

SECTION OF BAY

SEAT AND LOCKERS

SEAT LOCKER

TO OPEN

PLAN

FLOOR

BAY WINDOW AND PORCH

CENTRE OF PORCH

11' 9"

7' 1"

DETAILS OF PARTS OF SOUTH-EAST ELEVATION OF SMALL COUNTRY HOUSE

PLATE XXIV

The lower group of illustrations gives the general details of the porch and drawing-room bay of the house illustrated in Plates XIX to XXIII. The roof of the porch is supported on square tapering posts with moulds planted on to form bases and capitals. The casements are shown to be of wood, some being made to open inwards. The principal advantage of an inward-opening casement is that it is easily cleaned; it is also less likely to be damaged by the wind. On the other hand, it cannot be so easily rendered water-tight, and interferes with the window-curtains. Wrought-iron casements, hung to the wood mullions, are now usually preferred. The seat in the bay takes the form of a series of lockers, suitable for the reception of musical publications.

The upper group of illustrations consists of a plan, section, and elevation of part of the upper story over the front of the dining-room. The sides of the timbers are grooved to receive the cement. The main horizontal members are united at the angles by dove-tailed halving, a mortise being cut through each joint to receive the tenons of the main uprights. The other joints are formed by mortises and tenons secured with 1-inch oak trenails projecting half an inch from the face of the work.

6 1, &c., and the points *r s t u v w* in the curve will be obtained. The other half of the parabola can be drawn by producing the ordinates *w e*, *v d*, &c., and setting the same distances to the right of E F.

XXXVI.—*To draw the section of a cone made by a plane parallel to the axis*, i.e. *an hyperbola*.

Let *d c' d'* (fig. 466) be the vertical projection of the cone, *d q r d'* one half of the horizontal projection of

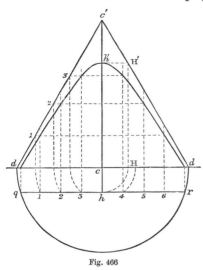

Fig. 466

the base, and *q r* the section plane. Divide the line *r q* into any number of equal parts in 1, 2, 3, *h*, &c., and through them draw lines perpendicular to *d d'*. From *c* as a centre, with the radii *c* 1, *c* 2, &c., describe arcs cutting *d d'*; and from the points of intersection draw perpendiculars cutting the sides of the cone in 1, 2, 3; and these heights transferred to the corresponding perpendiculars drawn directly from the points 1, 2, 3, &c., in *r q*, will give points in the curve.

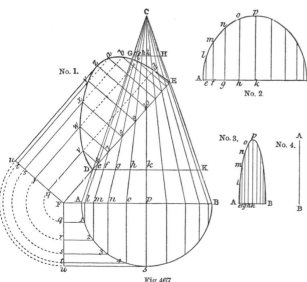

Fig 467

XXXVII.—*To draw the section of a cuneoid*[1] *made by a plane cutting both its sides.*

Let A C B (No. 1, fig. 467) be the vertical projection of the cuneoid, and A 5 B the plan of its base, and A B (No. 4) the length of the arris at C, and let D E be the line of section. Divide the semicircle of the base into any number of parts 1, 2, 3, 4, 5, &c., and through them draw perpendiculars to A B, cutting it in *l*, *m*, *n*, *o*, *p*, &c., and join C *l*, C *m*, C *n*, &c., by lines cutting the section line in 6, 7, 8, 9, &c. From these points draw lines perpendicular to D E, and make them equal to the corresponding ordinates of the semicircle, either by transferring the lengths by the compasses, or by proceeding as shown in the figure. The curve drawn through the points thus obtained will give the required section.

The section on the line D K is shown in No. 2, in which A B equals D K; and the divisions *e f g h k* in D K, &c., are transferred to the corresponding points on A B; and the ordinates *e l*, *f m*, *g n*, &c., are made equal to the corresponding ordinates *l* 1, *m* 2, *n* 3, of the semicircle of the base. In like manner, the section on the line G H, shown in No. 3, is drawn.

XXXVIII.—*To describe the section of a cylinder made by a curve cutting the cylinder.*

Let A B D E (fig. 468) be the projection of the cylinder, and C D the line of the section required. On A B describe a semicircle, and divide it into any number of parts. From the points of division draw ordinates 1 *h*, 2 *k*, 3 *l*, 4 *m*, &c., and produce them to meet the line of the section in *o*, *p*, *q*, *r*, *s*, *t*, *u*, *v*, *w*. Bend a rule or slip of paper to the line C D, and prick off on it the points C, *o*, *p*, *q*, &c.; then draw any straight line F G, and, unbending the rule, transfer the points C, *o*, *p*, *q*, &c., to F, *a*, *b*, *c*, *d*, &c. Draw the ordinates *a* 1, *b* 2, *c* 3, &c., and make them respectively equal to the ordinates *h* 1, *k* 2, *l* 3, &c., and through the points found trace the curve.

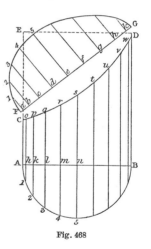

Fig. 468

Note.—The section of a cylinder made by an oblique plane is an ellipse, and the method of drawing it has been explained in Problem XXXIII, page 279.

XXXIX.—*To describe the section of a sphere.*

Let A B D C (fig. 469) be the great circle of a spnere, and F G the line of the section required. Then, since all the sections of a globe or sphere are circles, on F G describe a semicircle F 4 G, which will be the section required.

Or, in F G take any number of points, as *m*, *l*, *k*, H, and from the centre of the great circle E, describe the arcs H *n*, *k o*, *l p*, *m q*, and draw the ordinates H 4, *k* 3,

[1] A cuneoid is a solid ending in a straight line, in which, if any point be taken, a perpendicular from that point may be made to coincide with the surface. The base of the cuneoid may be of any form; but in architecture it is usually semicircular or semi-elliptical, and parallel to the straight line forming the other end.

$l\,2,\,m\,1$, and $n\,4,\,o\,3,\,p\,2,\,q\,1$; then make the ordinates on FG equal to those on BC, and the points so obtained will give the section required.

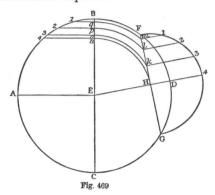

Fig. 469

Note.—The projections of sections of spheres are, if the section planes are oblique, either straight lines or ellipses, and are found as follows:—

Let $a\,b$ (fig. 470) be the horizontal projection of the section plane. On the line of section take any number of points, as $a,\,c,\,b$, and through each of them draw a line perpendicular to $y\,x$. As the point a is situated on the circumference of the great circle of the sphere, its vertical projection will be on the vertical projection of the circle at a'. The point b being the extremity of the axis of the sphere, will have its vertical projection b' in the centre of the vertical projection of the great circle $e\,f$. The vertical projection of c, or of any other point in the line $a\,b$, is found thus:—Through c draw $g\,c\,h$ parallel to $y\,x$, and also $c\,c'$ perpendicular to $y\,x$; then with the radius $i\,g$ or $i\,h$, and from the centre b' on the vertical projection, describe arcs of a circle, cutting the perpendicular $c\,c''c'$ in c' and c''.

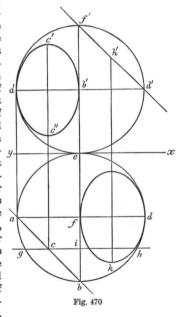

Fig. 470

Then c being in this case the middle of the line of section $a\,b$, the vertical projection will be an ellipse, whose major axis will be $c'\,c''$, and minor axis $a'\,b'$. In a similar manner $f\,k\,d$ is the horizontal projection of the section made by the plane $f'\,h'\,d'$.

XL.—*To describe the section of an ellipsoid when a section through the fixed axis, and the position of the line of the required section, are given.*

Let A B C D (fig. 471) be the section through the fixed axis of the ellipsoid, and F G the position of the line of the required section. Through the centre of the ellipsoid draw B D parallel to F G; bisect F G in H, and draw A C perpendicular to F G; join B C, and from F draw F K, parallel to B C, and cutting A C produced in K; then will H K be the height of the semi-ellipse forming the section on F G.

Or, the section may be found by the method of ordinates, thus:—As the section of the ellipsoid on the line A C is a circle, from the point of intersection of

B D and A C describe a semicircle A E C. Then on H G, the line of section, take any number of points $l,\,n,\,p$, and from them raise perpendiculars cutting the ellipse in $q,\,r,\,s$. From $q,\,r,\,s$, draw lines perpendicular to A C, cutting it in the points 4, 5, 6; and again, from the intersection of B D and A C as centre, draw the arcs $4\,l,\,5\,m,\,6\,n$, $c\,o$, cutting H G in l, $m,\,n,\,o$; then H o, set off on the perpendicular from H to K, is the height of the section; and the heights H n, H m, H l,

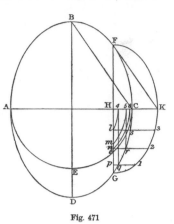

Fig. 471

set off on the perpendiculars from l to 3, n to 2, and p to 1, give the heights of the ordinates.

XLI.—*To find the section of a cylindrical ring perpendicular to the plane passing through the axis of the ring, the line of section being given.*

Let A B E D (fig. 472) be the section through the axis of the ring, A B a straight line passing through the concentric circles to the centre C, and D E be the line of section. On A B describe a semicircle; take in its circumference any points as 1, 2, 3, 4, 5, &c., and draw the ordinates $1\,f,\,2\,g,\,3\,h,\,4\,k$, &c. Through the points $f,\,g,\,h,\,k,\,l$, &c., where the ordinates meet the line A B, and from the centre C, draw concentric circles, cutting the section line in $m,\,n,\,o,\,p,\,q$, &c. Through these points draw the lines $m\,1,\,n\,2,\,o\,3$, &c., perpendicular to the section line, and transfer to them the heights of the ordinates of the semicircle $f\,1,\,g\,2$, &c.; then through the points 1, 2, 3, 4, &c., draw the curve D 5 E, which is the section required.

Again, let R S be the line of the required section; then from the points $t,\,u,\,v,\,w,\,c,\,x,\,d$, &c.. where the

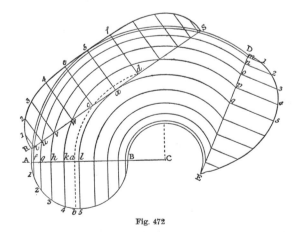

Fig. 472

concentric circles cut this line, draw the lines $t\,1,\,u\,2,$ $v\,3$, &c., perpendicular to R S, and transfer to them the corresponding ordinates of the semicircle; and through the points 1, 2, 3, 4, e, 5, f, &c., draw the curve R $e\,f$ S, which is the section required.

XLII.—*To describe the section of a solid of revolution, the generating curve of which is an ogee.*

Let A D B (fig. 473) be half the plan or base of the solid, A *a b* B the vertical section through its axis, and E F the line of section required. From G draw C 5 perpendicular to E F, and bisecting it in *m*. In E *m* take any number of points, *g, h, k,* &c., and through them draw the lines *g* 1, *h* 2, *k* 3, &c., perpendicular to E F. Then from C as a centre, through the points *g, h, k,* &c., draw concentric arcs cutting A B in *r, s, t, u, v,* and through these points draw the ordinates *r* 5, *s* 4, *t* 3, &c., perpendicular to A B.

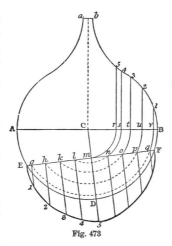

Fig. 473

Transfer the heights of the ordinates on A B to the corresponding ordinates on each side of the centre of E F; and through the points 1, 2, 3, 4, 5, &c., draw the curve E 5 F, which is the section required.

XLIII.—*To find the section of a solid of revolution, the generating curve of which is of a lancet form.*

Let A D B (fig. 474) be the plan of half the base, A E B the vertical section, and F G the line of the required section. The manner of finding the ordinates and transferring the heights is precisely the same as in the last problem.

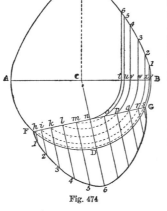

Fig. 474

XLIV.—*To find the section of an ogee pyramid with a hexagonal base.*

Let A D E F B (fig. 475) be the plan of the base of the pyramid, A *a b* B *a* vertical section through its axis, and G H the line of the required section. Draw the arrises C D, C E, C F. On the line of section G H, at the points of intersection of the arrises with it, and at some intermediate points *k, m, o, q* (the corresponding points *k* and *q*, and *m* and *o*, being equidistant from *n*), raise indefinite perpendiculars. Through these

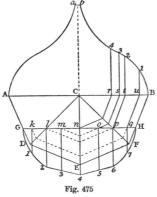

Fig. 475

points *k, l, m, n, o, p, q,* draw lines parallel to the sides of the base, as shown by dotted lines; and from the points where these parallels meet the line A B, draw *r* 4, *s* 3, *t* 2, *u* 1, perpendicular to A B. These perpendiculars transferred to the ordinates *n* 4, *m* 3, *o* 5, *l* 2, *p* 6, *k* 1, *q* 7, will give the points 1, 2, 3, 4, 5, 6, 7, through which the section can be drawn.

6. INTERSECTIONS OF CURVED SURFACES

When two solids having curved surfaces penetrate or intersect each other, the intersections of their surfaces form curved lines of various kinds. Some of these, as the circle, the ellipse, &c., can be contained in a plane; but the others cannot, and are named curves of double curvature. The solution of the following problems depends chiefly on the knowledge of how to obtain, in the most advantageous manner, the projections of a point on a curved surface; and is in fact the application of the principles elucidated in the preceding problems. The manner of constructing the intersections of these curved surfaces which is the simplest and most general in its application, consists in conceiving the solids to which they belong as cut by planes, according to certain conditions, more or less dependent on the nature of the surfaces. These section planes may be drawn parallel to one of the planes of projection; and as all the points of intersection of the surfaces are found in the section planes, or on one of their projections, it is always easy to construct the curves by transferring these points to the other projection of the planes.

XLV.—*The projection of two equal cylinders which intersect at right angles being given, to find the projections of their intersections.*

Conceive, in the horizontal projection (fig. 476), a series of vertical planes cutting the cylinders parallel

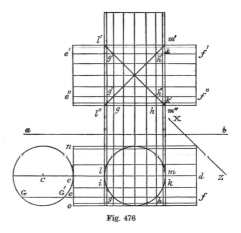

Fig. 476

to their axes. The vertical projections of all the sections will be so many right-angled parallelograms, similar to *e' f' e'' f''*, which is the result of the section of the cylinder by the vertical plane *e f*, for this plane cuts the cylinder from surface to surface. The circumference of the second cylinder, whose axis is vertical, is also cut by the same plane, which meets its upper

surface at the two points g, h, and its under surface
at two corresponding points. The vertical projections
of these points are on the lines perpendicular to $a\,b$,
raised on each of them, so that upon the lines $e'\,f'$,
$e''\,f''$, will be situated the intersections of these lines
at the points g', h', and g'', h'', and the same with the
other points i, k, l, m. It is
not necessary to draw a plan
to find these projections. All
that is actually required is
to draw the circle represent-
ing one of the bases (as $n\,o$)
of the cylinder laid flat on
the horizontal plane. Then
to produce $g\,h$ till it cuts the
circle at the superior and in-
ferior points G', G, and to take
the heights eG', eG, and carry them, upon $a\,b$, from
g to g', g'', and from h to h', h''.

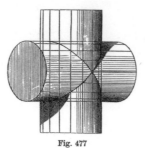

Fig. 477

Fig. 477 is the vertical projection made on the line
X Z.

XLVI.—*To construct the projections of two unequal
cylinders whose axes intersect each other obliquely.*

Let A (fig. 478) be the vertical projection of the two
cylinders, and $h\,s\,d\,e$ the horizontal projection of their

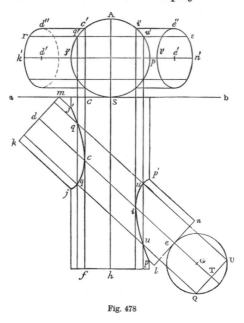

Fig. 478

axes. Conceive, in the vertical projection, the cylinders
cut by any number of horizontal planes: the horizon-
tal projections of these planes will be rectangles, as in
the preceding example, and their sides will be parallel
to the axes of the cylinders. The points of intersec-
tion of these lines will be the points sought. Without
any previous operation, six of those points of inter-
section can be obtained. For example, the point c'
is situated on $d''\,e''$, the highest point of the smaller
cylinder; consequently, the horizontal projection of
c' is on $d\,e$, the horizontal projection of $d''\,e''$, and it
is also on the perpendicular let fall from c', that is
to say, on the line $c\,f$ parallel to the axis of the

cylinder $s\,h$. The point sought will, therefore, be
the intersection of those lines at c. In the same
way i is obtained. The point j' is on the line $k'\,l'$,
which is in the horizontal plane passing through
the axis $d'\,e'$: the horizontal projections of $k'\,l'$ are
$k\,l$, and its opposite $m\,n$; therefore, in letting fall
perpendiculars from $j'\,p'$, the intersections of these
with $k\,l$, $m\,n$, give the points jj', pp'. Thus six
points are obtained. Take at pleasure an intermediate
point q'; through this point draw a line $r\,s$ parallel
to $a\,b$, which will be the vertical projection of a hori-
zontal plane cutting the cylinder in q'. The horizontal
projection of this section will be, as in the preceding
examples, a rectangle which is obtained by taking, in
the vertical projection, the height of the section plane
above the axis $d'\,e'$, and carrying it on the base in the
horizontal projection from G to T. Through T is then
to be drawn the line Q U perpendicular to G T; and
through Q and U the lines parallel to the axis; and
the points in which these lines are intersected by the
perpendiculars let fall from $q'\,u'$ are the intermediate
points required. Any number of intermediate points
can be thus obtained; and the curve being drawn
through them, the operation is completed.

XLVII.—*To find the intersections of a sphere and
a cylinder.*

Let $e\,f\,c\,d$ and $i\,k\,g\,h$ (fig. 479) be the horizontal
projections of the sphere and cylinder respectively.
Draw, parallel to A B, as many
vertical section planes as are
considered necessary, as ef, cd.
These planes cut at the same
time both the sphere and the
cylinder, and the result of each
section will be a circle in the
case of the sphere, and a rec-
tangle in the case of the cylinder.
Through each of the points of
intersection g, h, i, k, and from
the centre l, draw indefinite lines
perpendicular to A B. Take the
radius of the circles of the sphere
proper to each of these sections,
and with them, from the centre
l', cut the correspondent per-
pendiculars in $g'\,g''$, $h'\,h''$, $i'\,i''$,
&c., and draw through these points the curves of
intersection.

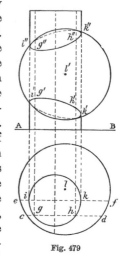

Fig. 479

XLVIII.—*To construct the intersection of two right
cones with circular bases.*

The solution of this problem is founded on the
knowledge of the means of obtaining on one of the
projections of a cone a point given on the other.

No. 1.—Let A B (fig. 480) be the common section of
the two planes of projection, the circles $g\,d\,e\,f$ and
$g\,h\,i\,k$ the horizontal projections of the given cones,
and the triangles $d'\,i'\,f'$ and $h'\,l'\,k'$ their vertical
projections. Suppose these cones cut by a series of
horizontal planes: each section will consist of two

circles, the intersections of which will be points of intersection of the conical surfaces. For example, the section made by a plane $m'n'$ will have for its horizontal projections two circles of different diameters, the radius of the one being im, and of the other lo.

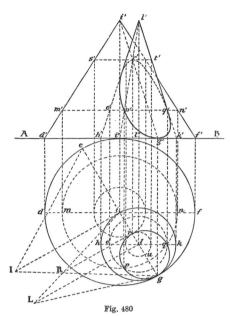

Fig. 480

The intersecting points of these are p and q, and these points are common to the two circumferences; and their vertical projection on the plane $m'n'$ will be in $p'q'$. Thus, as many points may be found as is necessary to complete the curve.

But there are certain points of intersection which cannot be rigorously established by this method without a great deal of manipulation. The point r in the figure is one of those; for it will be seen that at that point the two circles must be tangents to each other, and it would be difficult to fix the place of the section plane $s't'$ so exactly by trial, that it would just pass through that point.

It will be seen that the point r must be situated in the horizontal projection of the line gi, which passes through the summits of both cones. From i in the horizontal projection raise on gi a perpendicular iI equal to the height of the cone $d'i'f'$, and draw Ig, which will be the side of that cone. From l raise a perpendicular, and make it equal to the height of the second cone, and draw its side Li; and from the point of intersection R let fall a perpendicular on gi, meeting it in r; and through r draw an indefinite line perpendicular to A B, and set up on it from A B to r' the height rR. The point r' can also be obtained directly in the vertical projection by joining $i'g'$ and $l'i''$ as shown.

Bisect rg in u, and from u as a centre, with the radius ur, describe a circle, the circumference of which will be the horizontal projection of the intersection of the two cones. The vertical projection of this circle will be $g'p'r'q'$, and can be found by the method indicated above.

No. 2.—Conceive, in the horizontal projection (fig.

481, No. 1), a vertical plane C D cutting both cones through their axes: the sections will be two triangles, having the diameters of the bases of the cones as their bases, and the height of the cones as their height. And as in the example the cones are equal, the triangles will also be equal, as the triangles $ce'f$, $gf'd$, in the vertical projection. Conceive now a number of inclined planes, as cnm, ckp, &c., passing through

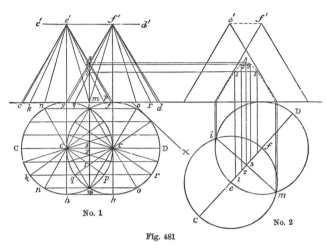

No. 1 No. 2

Fig. 481

the different points of the base, but still passing through the summits of the cones: the sections which result will still be triangles (as has already been demonstrated), whose bases diminish in proportion as the planes recede from the centres of the bases of the cones, until at length the plane becomes a tangent to both cones, and the result is a tangent line whose projections are hc, hc, ge', ff'. It will be observed that the circumferences of the bases cut each other at m and i, which are the first points of their intersections, and whose vertical projections are the point m merely. If the projections of the other points of intersection on the lines of the section planes are found (an operation presenting no difficulty, and easily understood by the inspection of the figure), it will be seen that the triangles ncm, mco, kcp, qcr, &c., in the horizontal projection, have for their vertical projections the triangles $ne'm$, $mf'o$, $ke'p$, &c., and that the intersections of the cones are in a plane perpendicular to both planes of projection, and the projections of the intersections are the right lines im, $m3$. From the known properties of the conic sections, the curve produced by this plane will be a hyperbola. Fig. 481, No. 2, gives the projections of the cones on the line o X.

No. 3.—The next example (fig. 482) differs from the last in the inequality of the size of the cones. Suppose an indefinite line C D to be the horizontal projection of the vertical section plane, cutting the two cones through their axes ef. Conceive in this plane an indefinite line efD, passing through the summits of the cones, the vertical projection of this line will be $e'f'd'$: from d' let fall on C D a perpendicular meeting it in D: this will be the point in which the line passing through the summits of the cones will meet

the horizontal plane; and it is through this point, and through the summits *e* and *f*, that the inclined section planes should be made to pass. The horizontal traces of these planes are O D, G D, &c.: O D is then the trace of a tangent plane to the two conical surfaces O *e*, P *f*; and the plane *e* G D cuts the greater cone, and forms by the section the triangles G *e* H in the horizon-

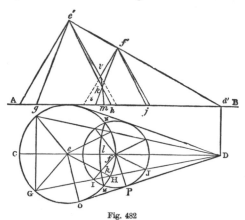

Fig. 482

tal, and *g e' h* in the vertical projection; and it cuts the lesser cone, and forms the triangles I*f*J, *if'j*. In the horizontal projection it is seen that the sides H *e*, I*f* of the triangle intersect in *k*, which is therefore the horizontal projection of one of the points of intersection; and its vertical projection is *k*. In the same manner, other points can be found. It is seen at once that M, N, *l'*, are also points in the intersection. The curves traced through the points M *k l* N in the horizontal, and *m k l'* in the vertical projection, are the projections of the intersection of the two cones.

7. COVERINGS OF SOLIDS

I. *Regular Polyhedrons.*—A solid angle cannot be formed with fewer than three plane angles. The simplest solid is therefore the *tetrahedron*, or pyramid having an equilateral triangle for its base, and its other three sides formed of similar triangles.

The development of this figure (fig. 483) is made by drawing the triangular base A B C, and then drawing round it the triangles forming the inclined sides. If the diagram is made on flexible material, such as paper, then cut out, and the triangles folded on the lines A B, B C, C A, the solid figure will be constructed.

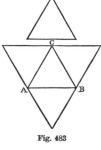

Fig. 483

The *hexahedron*, or cube, is composed of six equal squares (fig. 484); the *octahedron* (fig. 485) of eight equilateral triangles; the *dodecahedron* (fig. 486) of twelve pentagons; the *icosahedron* (fig. 487) of twenty equilateral triangles. In these figures, A is the elevation, and B the development.

The elements of these solids are the equilateral triangle, the square, and the pentagon. The ir-

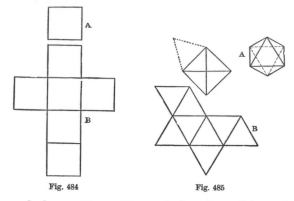

Fig. 484 Fig. 485

regular polyhedrons may be formed from those named, by cutting off, regularly, the solid angles. Thus, in cutting off the angles of the tetrahedron, there results a polyhedron of eight faces, composed of four hexagons and four equilateral triangles. The cutting off the angles of the cube, in the same manner, gives a polyhedron of fourteen faces, composed of six octagons, united by eight equilateral triangles.

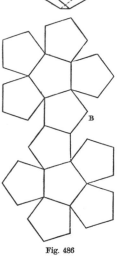

The same operation performed on the octahedron produces fourteen faces, of which eight are hexagonal and six square; on the dodecahedron it gives thirty-two sides, namely, twelve decagons, and twenty triangles; on the icosahedron it gives thirty-two sides— twelve pentagons and twenty hexagons. This last approaches almost to the globular form, and can be rolled like a ball.

Fig. 486

The other solids which have plane surfaces are the *pyramids* and *prisms*. These may be regular or

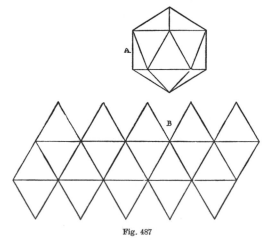

Fig. 487

irregular: they may have their axes perpendicular or inclined: they may be truncated or cut with a section, parallel or oblique, to their base.

II. *Pyramids.*—The development of a right pyramid, of which the base and the height are given, offers no difficulty. The operation consists (fig. 488) in elevating, on each side of the base, a triangle having its height equal to the inclined height of each side, or, otherwise, connecting the sides together, as shown by the dotted lines.

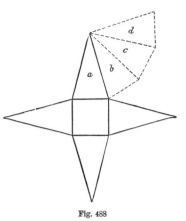

Fig. 488

In an oblique pyramid the development is found as follows:—

Let $a\,b\,c\,d$ (fig. 489) be the plan of the base of the pyramid, $a\,b\,c\,\mathrm{P}\,d$ its horizontal projection, and E F G its vertical projection. Then on the side $d\,c$ construct the triangle $c\,\mathrm{R}\,d$, making its height equal to the sloping side of the pyramid F G. This triangle is the development of the side $d\,\mathrm{P}\,c$ of the pyramid. Then from d, with the radius E F, describe an arc O; and from R, with the radius equal to the true length $e'\,\mathrm{G}$ of the arris E G, describe another arc intersecting the last at O. Join R O, d O; the triangle $d\,\mathrm{R}\,\mathrm{O}$ will be the development of the side $a\,\mathrm{P}\,d$. In the same way, describe the triangle $c\,\mathrm{R}\,\mathrm{T}$, for the development of the side $b\,\mathrm{P}\,c$. From R, again, with the same radius R O, describe an arc S, which intersect by an arc described from O with the radius $a\,b$; and the triangle O R S will be the development of the side $a\,\mathrm{P}\,b$.

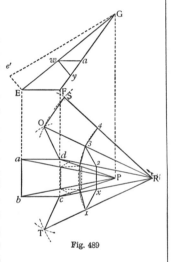

Fig. 489

If the pyramid is truncated by a plane $w\,a$ parallel to the base, the development of that line is obtained by setting off from R on R c, and R d, the true length of the arris G a in x and 2, and on R S, R O, and R T, the true length of the arris G w in 4, 3, 1; and drawing the lines $1\,x$, $x\,2$, $2\,3$, $3\,4$, parallel to the bases of the respective triangles T R c, c R d, d R O, O R S. If it is truncated by a plane $w\,y$, perpendicular to the axis, then from the point R, with the radius equal to the true length of the arris G w, or G y, describe an arc $1\,4$, and inscribe in it the sides of the polygon forming the pyramid.

III. *Prisms.*—In a right prism, the faces being all perpendicular to the bases which truncate the solid, it results that their development is a rectangle composed of all the faces joined together, and bounded by

two parallel lines equal in length to the contour of the bases. Thus, in fig. 490, $a\,b\,c\,d$ is the base, and $b\,e$ the height of the prism; the four sides will form

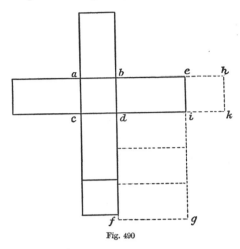

Fig. 490

the rectangle $b\,e\,f\,g$, and $e\,h\,i\,k$ will be the top of the prism. The full lines show another method of development.

When a prism is inclined, the faces form different angles with the lines of the contours of the bases; whence there results a development, the extremities of which are bounded by lines forming parts of polygons.

After having drawn the line C C (fig. 491), which indicates the axis of the prism, and the lines A B, D E,

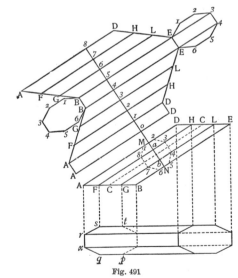

Fig. 491

the surfaces which terminate it, describe on the middle of the axis the polygon forming the plan of the prism, taken perpendicularly to the axis, and indicated by the figures 1 to 8. Produce the sides 1 2, 6 5, parallel to the axis, until they meet the lines A B, D E. These lines then indicate the four arrises of the prism, corresponding to the angles 1 2 5 6. Through the points 8 3 7 4 draw lines parallel to the axis meeting A B, D E in F H, G L. These lines represent the four arrises 8 3 7 4.

In this profile the sides of the plan of the polygon

1 2 3 4 5 6 7 8 give the width of the faces of the prism, and the lines A D, F H, G L, B E their length. From this profile can be drawn the horizontal projection, in the manner shown below. To trace the development of this prism on a sheet of paper, so that it can be folded together to form the solid, proceed thus:—On the middle of C C raise an indefinite perpendicular M N. On that line set off the width of the faces of the prism, indicated by the polygon, in the points 0 1 2 3 4 5 6 7 8. Through these points draw lines parallel to the axis, and upon them set off the lengths of the lines in profile, thus:—From the points 0, 1, and 8, set off the length M D in the points D D D; from 2 and 7, set off a H in H and H; from 3 and 6, set off b L in L and L; and so on; draw the lines D D, D H L E, E E, E L H D, for the contour of the upper part of the prism. To obtain the contour of the lower portion, set off the length M A from 0, 1, and 8 to A A A, the length a F from 2 and 7 to F and F, the length b G from 3 and 6 to G and G, and so on; and draw A A, A F G B, B B, B G F A, to complete the contour. The development is completed by making on B B and E E the polygons 1 2 3 4 5 6 B B, 1 2 3 4 5 6 E E, similar to the polygons of the horizontal projection.

IV. *Cylinders.*—Cylinders may be considered as prisms, of which the base is composed of an infinite number of sides. Thus we shall obtain graphically the development of a right cylinder by a rectangle of the same height, and of a length equal to the circumference of the circle, which serves as its base.

To find the covering of a right cylinder.

Let A B C D (fig. 492) be the seat or generating section. On A D describe the semicircle A 5 D, representing the vertical section of half the cylinder, and divide its circumference into any number of parts, 1, 2, 3, 4, 5, &c., and transfer those divisions to the

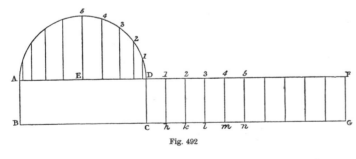

Fig. 492

lines A D and B C produced; then the parallelogram D C G F will be the covering of one half the cylinder.

To find the edge of the covering when it is oblique in regard to the sides of the cylinder.

Let A B C D (fig. 493) be the seat of the generating section, the edge B C being oblique to the sides A B, D C. Draw the semicircle A 5 D, and divide it into any number of parts, as before; and through the

divisions draw lines at right angles to A D, producing them to meet B C in r, s, t, u, v, &c. Produce A D, and

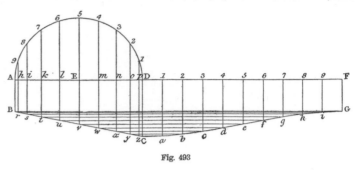

Fig. 493

transfer to it the divisions of the circumference, 1, 2, 3, 4, 5, 6, &c.; and through them draw indefinitely

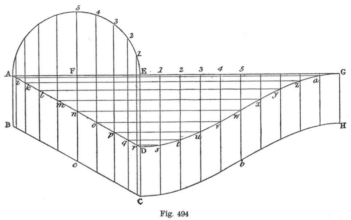

Fig. 494

the lines 1 a, 2 b, 3 c, &c., perpendicular to D F. To these lines transfer the length of the corresponding lines intercepted between A D and B C, that is, to 1 a transfer the length $p z$, to 2 b transfer $o y$, and so on, by drawing the lines $z a$, $y b$, $x c$, &c., parallel to A F. Through the points thus obtained, draw the curved line $c a b c$, &c., to G; then shall D F C G be the development of the covering of the semi-cylinder A B C D.

To find the covering of a cylinder contained between two oblique parallel planes.

Let A B C D (fig. 494) be the seat of the generating section. From A draw A G perpendicular to A B, and produce C D to meet it in E. On A E describe the semicircle, and transfer its perimeter to E G, by dividing it into equal parts, and setting off corresponding divisions on E G. Through the divisions of the semicircle draw lines at right angles to A E, producing them to meet the lines A D and B C, in i, k, l, m, &c. Through the divisions on E G draw lines perpendicular to it; then through the intersections of the ordinates of the semicircle, with the line A D, draw the lines $i a$, $k z$, $l y$, &c., parallel to A G, and where these intersect the perpendiculars from E G, in the points a, z, y, x, w, v, u, &c., trace a curved line G D, and draw parallel to it the curved line H C; then will D C H G be the development of the covering of the semi-cylinder A B C D.

Note.—In fig. 495 another example is given, but as the method of procedure is the same as in fig. 491, detailed description is unnecessary. The only novelty is in the development of the two

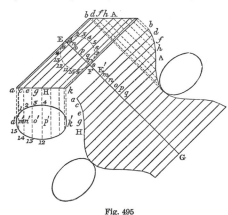

Fig. 495

ends of the cylinder, these being of course ellipses. It ought to be pointed out that the developments of the surfaces in the four examples (figs. 492–495) are not absolutely accurate, as the chords of the arcs (D 1, fig. 492) have been used instead of the arcs themselves; if, however, the number of divisions is ample, the amount of the error will, for practical purposes, be inappreciable.

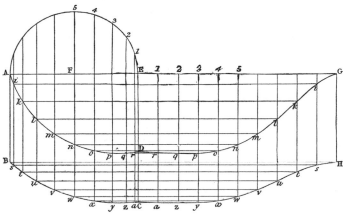

Fig. 496

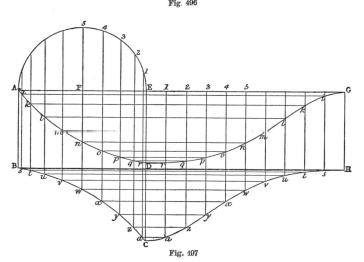

Fig. 497

To find the covering of a semi-cylindric surface bounded by two curved lines.

The construction to obtain the developments of

these coverings (figs. 496 and 497) is precisely similar to that described for fig. 494.

V. *Cones.*—We have considered cylinders as prisms

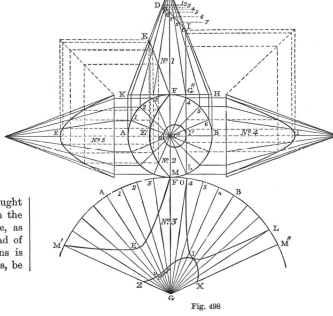

Fig. 498

with polygonal bases. In a similar manner we may regard cones as pyramids.

In right pyramids, with regular and symmetrical bases, as the lines of the arrises extending from the summit to the base are equal, and as the sides of the polygons forming the base are also equal, their developed surfaces will be composed of similar and equal isosceles triangles, which, as we have seen (fig. 488, *a,b,c,d*), will, when united, form a part of a regular polygon inscribed in a circle, of which the inclined sides of the polygon form the radii. Thus, in considering the base of the cone K H (fig. 498) as a regular polygon of an infinite number of sides, its development will be found in the sector of a circle, M′ A F B M″ (No. 3), of which the radius equals the side of the cone K G′ (No. 1), and the arc equals the circumference of the circle forming its base (No. 2).

To trace on the development of the covering, the curves of the ellipse, parabola, and hyperbola, which are the result of the sections of the cone by the lines D I, E F, I G″, it is necessary to divide the circumference of the base A F B M (No. 2) into equal parts, as 1, 2, 3, &c., and from these to draw radii to the centre c″, which is the horizontal projection of the vertex of the cone; then to carry these divisions to the common intersection line K H, and from their terminations there to draw lines to the vertex G′, in the vertical projection No. 1. These lines cut the intersecting planes, forming the ellipse, parabola, and hyperbola, and by the aid of the intersections we obtain the horizontal projection of these

figures in No. 2—the parabola passing through ME'F, the hyperbola through G"I'L, and the ellipse through D'I'.

To obtain points in the circumference of the ellipse upon the development, through the points of intersec-

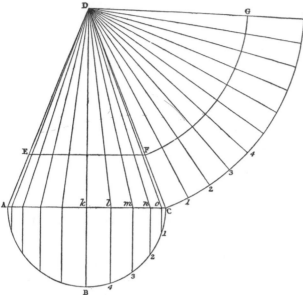

Fig. 499

tion o, p, q, r, &c., draw lines parallel to KH, carrying the heights to the side of the cone G'H, in the points 1, 2, 3, 4, 5, 6, 7, and transfer the lengths G'1, G'2, G'3, &c., to G1, G2, G3, G4, &c., on the radii of the development in No. 3; and through the points thus obtained draw the curve ZDIX.

To obtain the parabola and hyperbola, proceed in the same manner, by drawing parallels to the base KH, through the points of intersection; and trans-

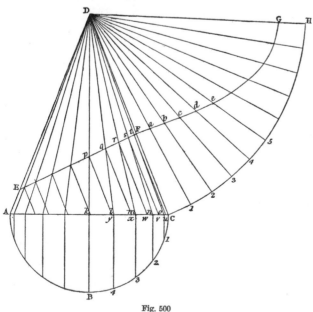

Fig. 500

ferring the lengths thus obtained on the sides of the cone G'K, G'H, to the radii in the development.

Nos. 4 and 5 give the vertical projections of the hyperbola and parabola respectively.

To find the covering of the frustum of a cone, the section being made by a plane perpendicular to the axis.

Let A C E F (fig. 499) be the generating section of the frustum. On A C describe the semicircle A B C, and produce the sides AE and CF to D. From the centre D, with the radius D C, describe the arc C H; and from the same centre, with the radius D F, describe the arc FG. Divide the semicircle ABC into any number of equal parts, and run the same divisions along the arc

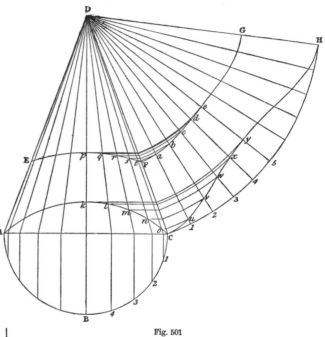

Fig. 501

C H; draw the line H D, cutting E G in G; then shall C H G F be half the development of the covering of the frustum A C F E.

To find the covering of the frustum of a cone, the section being made by a plane not perpendicular to the axis.

Let A C F E (fig. 500) be the frustum. Proceed as in the last problem to find the development of the covering of the semi-cone. Then,—to determine the edge of the covering on the line E F,—from the points p, q, r, s, t, &c., draw lines perpendicular to E F, cutting A C in y, x, w, v, u; and the length u t transferred from 1 to a, v s transferred from 2 to b, and so on, will give a, b, c, d, e, &c., points in the edge of the covering.

To find the covering of the frustum of a cone, when cut by two cylindrical surfaces perpendicular to the generating section.

Let A E F C (fig. 501) be the given frustum, and A k C, E p F, the given cylindrical surfaces. Produce A E, C F, till they meet in the point D. Describe the semicircle ABC, and divide it into any number of equal parts, and transfer the divisions to the arc C H, described from D, with the radius D C. Through the divisions in the

semicircle 1, 2, 3, 4, &c., draw lines perpendicular to A C, and through the points where they intersect A C draw lines to the summit D. Draw lines also through the points 1, 2, 3, 4, 5, &c., of the arc C H, to the summit

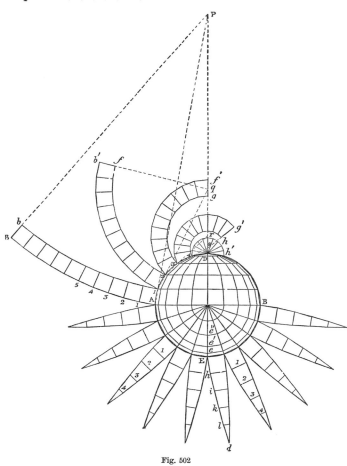

Fig. 502

D; then through the intersections of the lines from A C to D, with the seats of the cylindrical surfaces k, l, m, n, o, and p, q, r, s, t, draw lines parallel to A C, cutting C D; and from the points of intersection in

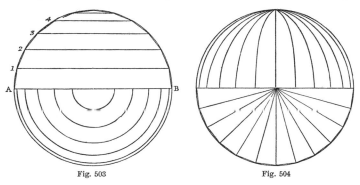

Fig. 503 Fig. 504

C D, and from the centre D, describe arcs cutting the radial lines in the sector D C H in u, v, w, x, y, &c., and a, b, c, d, e, &c.; and curves traced through the intersections will give the form of the covering.

VI. *Spheres, Ellipsoids, &c.*—The development of the sphere, and of other surfaces of double curvature, is impossible, except on the supposition of their being composed of a great number of small faces, either plane, or of a simple curvature, as the cylinder and the cone. Thus, a sphere or spheroid may be considered as a polyhedron, terminated, 1st, by a great number of plane faces, formed by truncated pyramids, of which the base is a polygon, as in fig. 502; 2nd, by parts of truncated cones forming zones, as in fig. 503, the part above A B being the vertical projection, and the part below A B the horizontal projection; 3rd, by parts of cylinders cut in gores, forming flat sides, which diminish in width, as in fig. 504.

In reducing the sphere, or spheroid, to a polyhedron with flat sides, two methods may be adopted, which differ only in the manner of arranging the developed faces.

The most simple method is by parallel circles, and others perpendicular to them, which cut them in two opposite points, as in the lines on a terrestrial globe. If we suppose that these divisions, in place of being circles, are polygons of the same number of sides, there will result a polyhedron, like that represented in fig. 502, of which the half, A D B, shows the geometrical elevation, and the other half, A E B, the plan.

To find the development, first obtain the summits P, q, r, s, of the truncated pyramids, which form the demi-polyhedron A D B, by producing the sides A 1, 1 2, 2 3, 3 4, until they meet the axis E D produced; then from the points P, q, r, s, and with the radii P A, P 1, q 1, q 2, r 2, r 3, and s 3, s 4, describe the indefinite arcs A B, 1 b, 1 b', 2 f, 2 f', 3 g, 3 g', 4 h, and from D describe the arc 4 h'; upon all these arcs set off the divisions of the demi-polygons A E B, and draw the lines to the summits P, q, r, s, and D, from all the points so set out, as A, 1, 2, 3, 4, &c., for each truncated pyramid. These lines will represent for every band or zone the faces of the truncated pyramids of which they constitute a part.

The development can also be made by drawing through the centre of each side of the polygon A E B, indefinite perpendiculars, and setting out upon them the heights of the faces in the elevation, A 1 2 3 4 D, and through the points thus obtained drawing parallels to the base. On each of these parallels then set out the widths h, i, k, l, d, of the corresponding faces (e, e', e'', &c.) in the plan, and there will be thus formed trapeziums and triangles, as in the first development, but arranged differently. This method is used in constructing geographical globes, the other is more convenient in finding the stones of a spherical dome.

The development of the sphere by reducing it to conical zones (fig. 503) is accomplished in the same manner as the reduction to truncated pyramids, with this difference, that the developments of the arrises, indicated by A 1 2 3 4 5 B in fig. 502, are arcs of circles described from the summits of cones, in place of being polygons.

The development of the sphere reduced into parts of cylinders, cut in gores (fig. 504), is produced by the second method described, but in place of joining, by straight lines, the points E, h, i, k, l, d (fig. 502), we unite them by curves. This last method is used in tracing the development of caissons in spherical or spheroidal vaults.

To find the covering of a segmental dome.

In fig. 505, No. 1 is the plan, and No. 2 the elevation of a segmental dome. Through the centre of the plan E draw the diameter A C, and the diameter B D perpendicular to A C, and produce B D to I. Let D E represent the base of a semi-section of the dome; upon D E describe the arc D k with the same radius as the arc F G H (No. 2); divide the arc D k into any number of equal parts, 1, 2, 3, 4, 5, and extend the divisions upon the right line D I, making the right line D I equal in length, and similar in its divisions, to the arc D k: from the points of division, 1, 2, 3, 4, 5, in the arc D k, draw lines perpendicular to D E, cutting it in the points q, r, s, &c. Upon the circumference of the plan No. 1, set off the breadth of the gores or boards l m, m n, n o, o p, &c.; and from the points, l, m, n, o, p, draw right lines through the centre E: from E describe concentric arcs q v, r u, s t, &c., and from I describe concentric arcs through the points D, 1, 2, 3, 4, 5: l m being the given breadth at the base, make 1 w equal to q v, 2 x equal to r u, 3 y equal to s t, &c.; draw the curved line through the points l, w, x, y, &c., to I, which will give one edge of the board or gore to coincide with the line l E. The other edge being similar, it will be found by making the

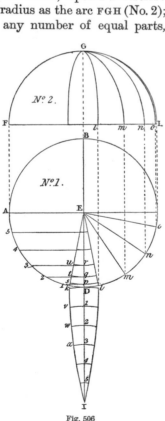

Fig. 505

Fig. 506

distances from the centre line D I respectively equal. The seats of the different boards or gores on the elevation are found by the perpendicular dotted lines p p, o o, n n, m m, &c.

To find the covering of a semicircular dome.

Fig. 506, Nos. 1 and 2.—The procedure here is more simple than in the case of the segmental dome, as, the

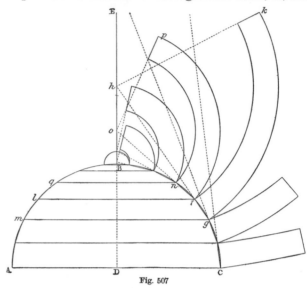

Fig. 507

horizontal and vertical sections being alike, the ordinates are obtained at once.

To find the covering of a semicircular dome when it is required to cover the dome horizontally.

Let A B C (fig. 507) be a vertical section through the axis of a circular dome, and let it be required to cover this dome horizontally. Bisect the base in the point D, and draw D B E perpendicular to A C, cutting the circumference in B. Now divide the arc B C into equal parts, so that each part will be rather less than the width of a board; and join the points of division by straight lines, which will form an inscribed polygon of so many sides; and through these points draw lines parallel to the base A C, meeting the opposite sides of the circumference. The trapezoids formed by the sides of the polygon and the horizontal lines may then be regarded as the sections of so many frustums of cones; whence results the following mode of procedure, in accordance with the introductory illustration, fig. 502:—Produce, until they meet the

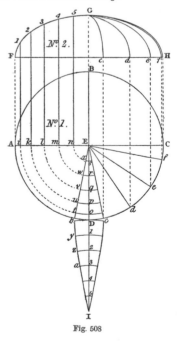

Fig. 508

line D E, the lines g f, f n, &c., forming the sides of the polygon. Then, to describe a board which corresponds to the surface of one of the zones, as f g, of which the trapezoid m l f g is a section,—from the point h, where the line f g produced meets D E, with the radii h f, h g, describe two arcs, and cut off the end of the board k on the line of a radius h k. To obtain the true length of the board, proceed as in fig. 502. The other boards are described in the same manner.

To find the covering of an elliptic dome.

Let A B C D (fig. 508) be the plan, and F G H the elevation of the dome. Divide the elliptical quadrant F G (No. 2) into any number of equal parts in 1, 2, 3, 4, 5, and draw through the points of division lines perpendicular to F H, and produced to A C (No. 1), meeting it in i, k, l, m, n: these divisions are transferred by the dotted arcs to the gore b E c, and the remainder of the process is as in figs. 505 and 506.

To find the covering boards of an ellipsoidal dome.

Let A B C D (No. 1, fig. 509) be the plan of the dome, and F G H (No. 2) the vertical section through its major axis. Produce F H indefinitely to n; divide the circum-

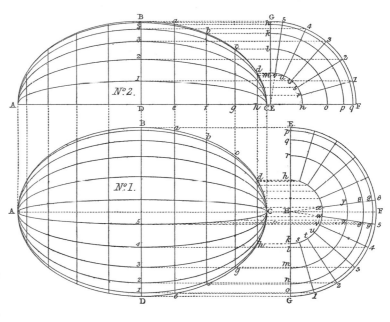

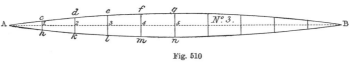

Fig. 510

Then, to describe any board, produce the line forming one of the sides of the polygon, such as l m, to meet F n in n; and from n, with the radii n m, n l, describe two arcs forming the sides of the board, and cut off the board on the line of the radius n o. Lines drawn through the points of the divisions at right angles to the axis, until they meet the circumference A D C of the plan, will give the plan of the boarding.

To find the covering of an ellipsoidal dome in gores.

Let the ellipse A B C D (fig. 510, No. 1) be the plan of the dome, A C its major and B D its minor axis; and let A B C (No. 2) be its elevation. Then, first, to describe on the plan and elevation the lines of the gores, proceed thus:—Through the line A C (No. 1) produced at H, draw the line E G perpendicular to it, and draw B E, D G, parallel to the axis A C, cutting E G; then will E G be the length of the axis minor, on which is to be described the semicircle E F G, representing a section of the dome on a vertical plane passing through the axis minor.

Divide the circumference of the semicircle into any number of equal parts, representing the widths of the covering boards on the line B D; and through the points of division, 1, 2, 3, 4, 5, draw lines parallel to the axis A C, cutting the line B D in 1, 2, 3, 4, 5. Divide the quadrant of the ellipse C D (No. 1) into any number of equal parts in e, f, g, h; and through these points

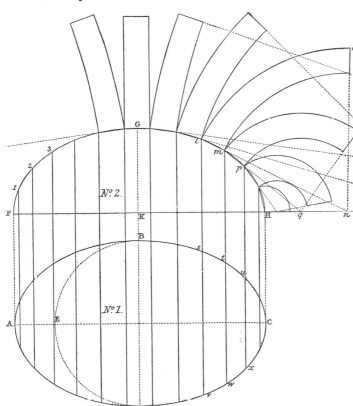

Fig. 509

ference, as before, into any number of equal parts, and join the divisions by straight lines, as p m, m l, &c.

draw the lines ea, fb, gc, hd, in both diagrams, perpendicular to AC, and these lines will then be the seats of vertical sections through the dome, parallel to EFG. Through the points e, f, g, h (No. 1) draw lines parallel to the axis AC, cutting EG in o, n, m, k; and from H,

In No. 2 the intersections of the lines are more clearly shown. The quadrant EGF is half the end elevation of the dome, and is divided as in No. 1. The parallel lines 5 5, 4 4, 3 3, show how the divisions of the arc of the quadrant are transferred to the line DB, and the other parallels ah, bk, cl, dm, are drawn from the divisions in the circumference of the ellipse to the line EG, and give the radii of the arcs mn, lo, kp, hq.

To describe one of the gores, draw any line AB (No. 3), and make it equal in length to the circumference of the semi-ellipse ADC, by setting out on it the divisions 1, 2, 3, 4, 5, &c., corresponding to the divisions ch, hg, gf, &c., of the ellipse: draw through those divisions lines perpendicular to AB. Then from the semicircle (No. 1), transfer to these perpendiculars the widths 6 5 to gn, 9 9 to fm, 8 8 to el, yz to dk, and xw to ch, and join Ac, cd, de, ef, fg, and Ah, hk, kl, lm, and mn; which will give the boundary-lines of one half of the gore, and the other half is obtained in the same manner.

Fig. 511

To describe the covering of an ellipsoidal dome with horizontal boards of equal width.

Let ABCD (No. 1, fig. 511) be the plan of the dome, ABC (No. 2) the section on its major axis, and LMN the section on its minor axis. Draw the circumscribing parallelogram of the ellipse, namely, FGHK (No. 1), and its diagonals FH, GK. In No. 2 divide the circumference into equal parts, 1, 2, 3, 4, representing the number of covering boards, and through the points of division draw lines 1 8, 2 7, &c., parallel to AC. Through the points of division draw $1p, 2t, 3x$, &c., perpendicular to AC, cutting the diagonals of the circumscribing parallelogram of the ellipse (No. 1), and meeting its major axis in p, t, x, &c. Complete the parallelograms, and inscribe ellipses therein corresponding to the lines of the covering. Produce the sides of the parallelograms to intersect the circumference of the section on the minor axis of the ellipse in 1, 2, 3, 4, and lines drawn through these, parallel to LN, will give the representation of the covering boards in that section. To find the development of the covering, produce the axis DB, in No. 2, indefinitely. Join by a straight line the divisions 1 2 in the circumference, and produce the line indefinitely, making ek equal to $e2$, and kg equal to 1 2; 1 2 ekg will be the axis major of the ellipses of the covering 1 2 7 8. Join also the corresponding divisions in the circum-

with the radii Ho, Hn, Hm, Hk, describe the concentric circles $o99p$, $n88q$, $mzyr$, &c. To find the diminished width of each gore at the sections ae, bf, cg, dh:—Through the divisions of the semicircle, 1, 2, 3, 4, 5, draw the radii $1s, 2t, 3u, 4v, 5w, 6x$; then by drawing through the intersections of these radii with the concentric circles, lines parallel to HF, to meet the section lines corresponding to the circles, the width of the gores at each section will be obtained; and curves drawn through these points will give the representation of the lines of the gores on the plan.

ference of the section on the minor axis, and produce the line 12 *b* to meet the axis produced; and the length of this line will be the semi-axis minor, *e h*, of the ellipse, 2 *h k*, while the width *f h* will be equal to the division 12 in N M L.

To find the covering of an annular vault.

Let ACKGEFA (fig. 512) be the generating section of the vault. On A C describe a semicircle A B C, and

divide its circumference into equal parts, representing the boards of the covering. From the divisions of the semicircle, *b, m, t,* &c., let fall perpendiculars on A C, cutting it in *r, s,* &c.; from the centre D of the annulus, with the radii D *r,* D *s,* &c., describe the concentric circles, *s q,* &c., representing the covering boards in plan. Through the centre D draw H K perpendicular to G C, indefinitely extending it through K. Join the points of division of the semicircle, A *b, b m, m t,* by

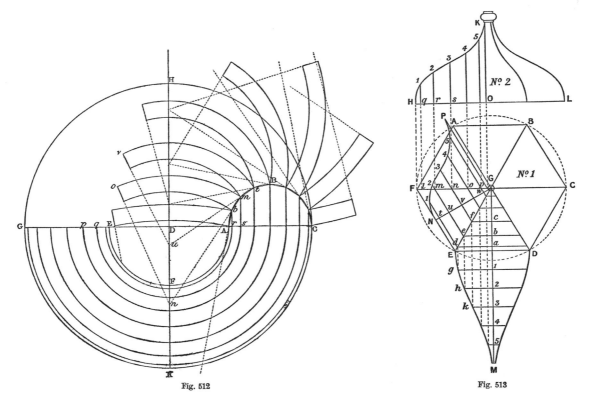

Fig. 512 Fig. 513

straight lines, and produce them until they cut the line K H, as *m b n, t m u,* when the points *n, u,* &c., are the centres from which the curves of the covering boards *m o, t v,* &c., are described.

To find the covering of an ogee dome, hexagonal in plan.

Let A B C D E F (No. 1, fig. 513) be the plan of the dome, and H K L (No. 2) the elevation, on the diameter F C. Divide H K into any number of equal parts in 1, 2, 3, 4, 5, K, and through these draw perpendiculars

to H L, and produce them to meet F C (No. 1), in *l, m, n, o, p,* G. Through these points draw lines *l d, m e, n f,* &c., parallel to the side F E of the hexagon: bisect the side F E in N, and draw G N, which will be the seat of a section of the dome, at right angles to the side E F. To find this section nothing more is required than to set up on N G, from the points *t, u, v,* &c., the heights of the corresponding ordinates *q* 1, *r* 2, *s* 3, &c., of the elevation (No. 2), to draw the ogee curve N 1 2 3 4 5 P, and then to use the divisions in this curve to form the gore or covering of one side E *g h k* M D.